MASTERFUL MARKS
CARTOONISTS WHO CHANGED THE WORLD

MONTE BEAUCHAMP

WITHDRAWN

SIMON & SCHUSTER
NEW YORK LONDON TORONTO SYDNEY NEW DELHI

90

Simon & Schuster
1230 Avenue of the Americas
New York, NY 10020

First Simon & Schuster hardcover edition September 2014

Simon & Schuster and colophon are registered trademarks
of Simon & Schuster, Inc.

For information about special discounts for bulk purchases,
please contact Simon & Schuster Special Sales at
1-866-506-1949 or business@simonandschuster.com.

Designed by Monte Beauchamp

Manufactured in the United States of America

1 3 5 7 9 10 8 6 4 2

Library of Congress Cataloging-in-Publication Data

Masterful Marks: Cartoonists Who Changed the World / [edited by] Monte Beauchamp.
pages cm
1. Cartoonists—Biography—Comic books, strips, etc. I. Beauchamp, Monte, editor of compilation.
NC1305.M37 2014
741.5'9—dc23
[B]
2014000657

ISBN 978-1-4516-4919-2
ISBN 978-1-4516-4921-5 (ebook)

For Jem, Scout, Callie, and Sebas

Alice laughed. "There's no use trying," she said
"one can't believe impossible things."

"I daresay you haven't had much practice," said the Queen.
"When I was your age, I always did it for half-an-hour a day.
Why, sometimes I've believed as many as
six impossible things before breakfast."

—*Alice in Wonderland*

CONTENTS

MASTERFUL MARKS

INTRODUCTION

Who could have predicted that two Depression-era teenagers from Cleveland, Ohio, with an unbridled passion for creating comic strips would change the world! The birth of Superman, America's first superhero, was not easy. There was plenty of failure along the way. Because of the undying commitment to their vision, history was made.

On the road to becoming a global icon, Walt Disney became a four-time business failure. In the midst of a stinging betrayal, the determined animator gave birth to a legend—Mickey Mouse.

A midwestern dreamer tried to carve out a career as a gag cartoonist but didn't have the artistic chops to pull it off. Hugh Marston Hefner soon found himself trapped in a bad marriage and a career he didn't like.

Then, in the winter of '52, the distraught 26-year-old stood on a bridge staring out over the Chicago River and, with tears in his eyes, said to himself, "I've gotta do something."

Weeks later he conceived of a men's lifestyle magazine called *Playboy*—and utilized it as a forum to champion cartoons.

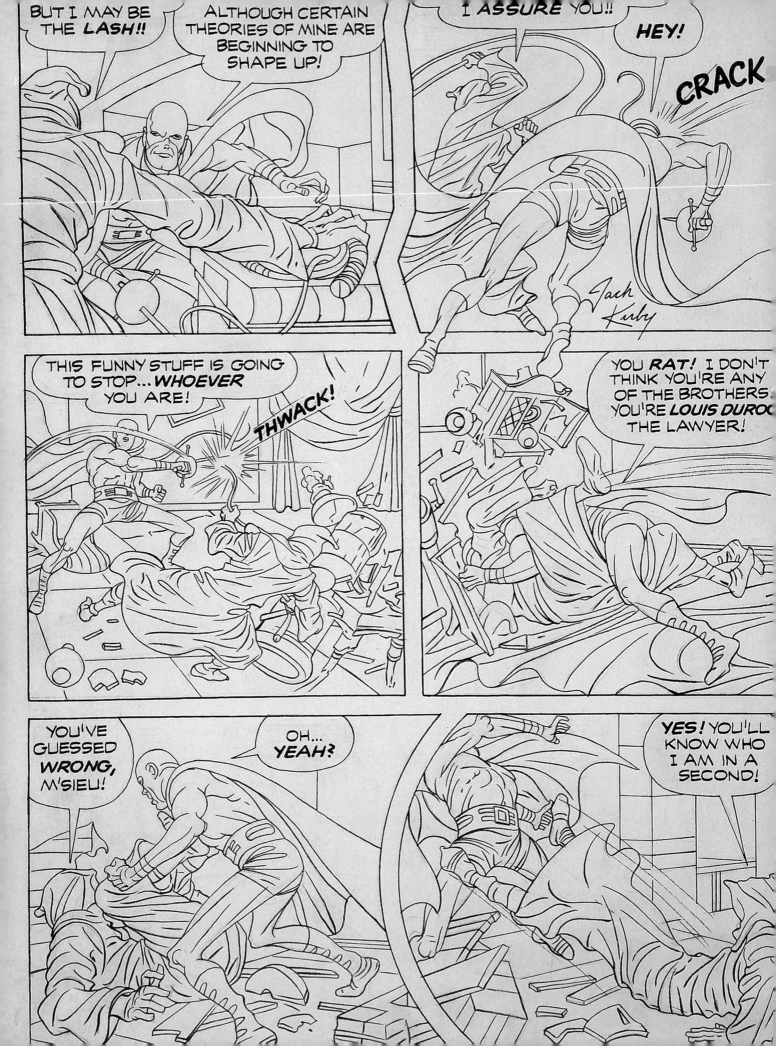

This book began with a question: Who were the original comic artists that left an indelible mark upon the world, paving the way for those who followed?

The story of cartoons—the multibillion-dollar industry that has affected all corners of our culture, from high to low—is ultimately the story of the artists who pioneered the form, and the story of the enduring characters they created: Mickey Mouse, Superman, and The Cat in the Hat, to name a few.

I began the work of this book by piecing together a list of cartoon genres—comic books, syndicated comic strips, animated cartoons, anime, manga, graphic novels, caricature, gag cartoons, and children's picture books—and identified the creators who most influenced or brought 'trash' art into the cultural mainstream and made it respectable."

"Crumb is like Johnny Appleseed," commented Gary Arlington, the owner and operator of the San Francisco Comic Book Company. "He's spreading the seeds of the new consciousness. You'd have to say that he's in the same category as Bob Dylan."

The influence of comix on comics gave way to a hybrid, alternative comics, from which arose a vibrant new genre: the graphic novel.

Or did it?

During the grim years of the Great Depression, struggling New York City illustrator Lynd Kendall Ward passionately authored and wood-engraved six wordless

"In my opinion, Crumb is the best comic book artist who ever lived. The first several issues of *Zap*, even as 'lowly comic books,' compete with the best art and literature of the last couple decades. Crumb is a national treasure alongside James Thurber, Rockwell Kent, John Ford, and Elzie Segar."
—Frank Stack, *The Life and Times of R. Crumb*, 1998

revolutionized each category. That's how the story of this book began to unfold.

Under "comic book," for instance, Siegel and Shuster—the creators of Superman—held court. In the subgenre of underground comix, Robert Crumb is the acknowledged father. No one could have known that when the struggling young illustrator self-published *Zap Comix* #1 in 1968 and began hawking copies in San Francisco's Haight-Ashbury district, history would be made. Crumb's *Zap* gave rise to an entire generation of comix artists who challenged the tyrannical editorial grip of mainstream comic book publishers.

In the October 1, 1972, edition of *The New York Times Magazine*, Thomas Maremaa wrote that "Crumb books—now cited as prototypes of today's graphic novel.

.

When all was said and done, sixteen trailblazers comprised the list. And then it dawned on me: Why not tell their stories in their own medium—the cartoon?

And thus began my quest in search of sixteen sublime talents—each of whom had been deeply affected by their subject—to contribute.

In "R. Crumb and Me," the brilliant American caricaturist Drew Friedman reflects: "In 1968, I was a nine-year-old kid innocently sifting through comic book bins in New York's East Village, when I picked up a copy of *Zap Comix* #1. My life would be forever altered . . ."

"Schulz certainly did have a big impact on me,"

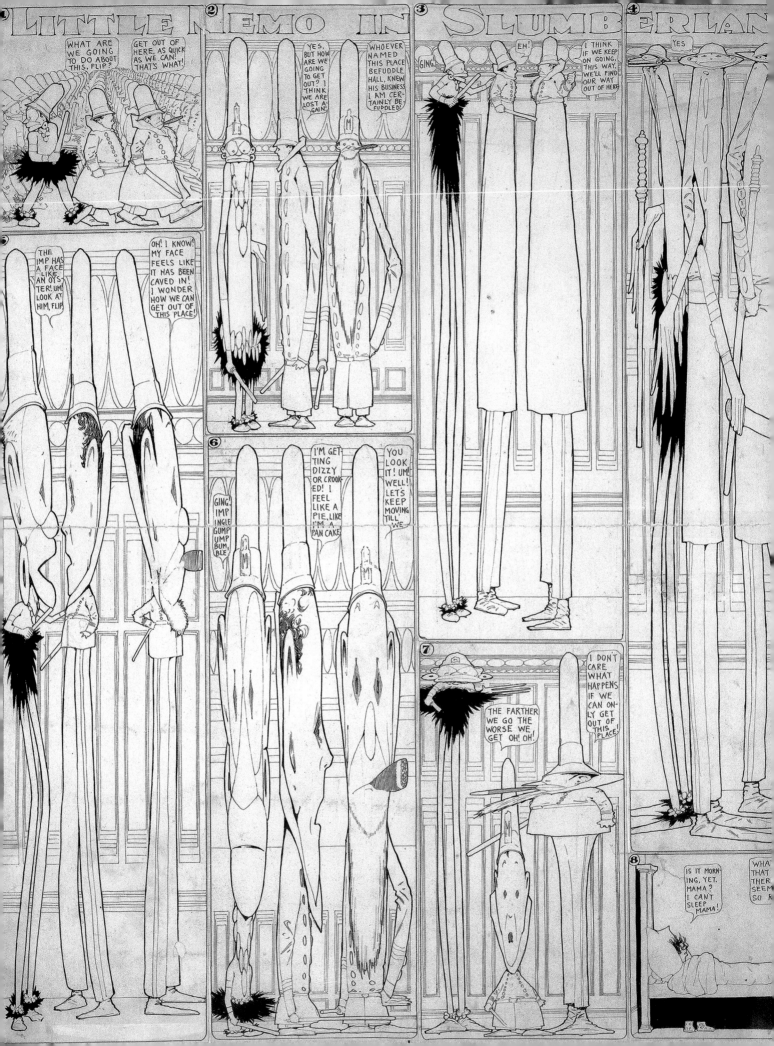

recalls children's picture book author and illustrator Sergio Ruzzier. "He was my idol when I was nine or ten. I don't normally use the word *idol*, but I actually built a shrine under my desk with images of his characters. My love for *Peanuts* was one of the main reasons I began to think I wanted to draw and tell stories. I spent hours looking closely at his lines, which made me understand how to use pen and ink."

When graphic novelist Peter Kuper discovered *Mad* magazine as a child, little did he realize that one day he would grow up to be a *Mad* artist. Reflecting on the magazine's creator, Kuper recalls, "What Kurtzman did through *Mad* has had an impact that can't even be calculated, but it really was his war stories that meant the most to me directly. When I saw his story 'Corpse on the Imjin,' I don't think I looked at comics the same way ever again. Kurtzman opened the door to a world of possibilities for the comics medium. He's a *furshlugginer* genius!"

Re-creating the story of Siegel and Shuster was both exhausting and exhilarating for pop surrealist artist Ryan Heshka: "Riding the huge ups and downs of their lives and careers on paper, unable to control their fate, I could not help but want to write a different ending for the boys. I almost felt guilty for once again grinding them up and spitting them out."

Heshka added: "Their legacy needs to include not only Superman but also the countless bizarre char-acters and subgenres of pop culture they inadvertently fathered. The world is literally a more colorful place due to the contribution of these two lads from Cleveland. Their hand in the creation of the comics industry is, to me, their greatest achievement."

.

Toward the close of the forties, an estimated 60 million comic books were consumed each month. The ever-popular children's genre, however, did have its share of detractors.

In his 1947 survey of syndicated comic strips *The Comics*, historian Coulton Waugh included a chapter on comic books in which he described them as having "a soulless emptiness, an outrageous vulgarity to them."

"In the closing decade of the twentieth century, comics had finally earned the status of art, which they had deserved all along, and had begun to be published more respectfully. Kurtzman's own best work pointed the way, decades earlier, and it stands as a benchmark for all that follows."

—Denis Kitchen, *The Art of Harvey Kurtzman*

Theater critic and author John Mason Brown declared comic books as "not only trash, but the lowest, most despicable, and most harmful form of trash."

German-born psychiatrist Fredric Wertham M.D., director and founder of Harlem's Lafargue Clinic, began lambasting comic books as the corrupters of youth. "Comic book reading was a distinct influencing factor in the case of every single delinquent or disturbed child we studied," he decried in Judith Crist's lengthy article, "Horror in the Nursery," published in the March 27, 1948 issue of *Collier's* magazine.

Seduction of the Innocent, Wertham's 397-page scathing indictment of the comics industry, hit bookstore shelves in April 1954. That same month, the United States

Senate Subcommittee on Juvenile Delinquency conducted televised hearings on comic books, fanning the flames of anti-comics sentiment further. Amid plummeting sales—and vicious attacks on the comics industry by parents, teachers, politicians, and the police—frenzied publishers banded together and formed the Comics Magazine Association of America. By October, they implemented a stringent comic book code. Any title the committee deemed to be in violation of good taste and decency was prohibited from being published.

By 1956, nearly 400 titles were slashed and scores of comic book professionals found themselves out of work. Popular page-turners such as *The Haunt of Fear*, *Tales from the Crypt*, and *The Vault of Horror*, whose combined monthly sales totaled two million copies, were nowhere to be found. The social stigma of comic book readers as hooligans, cretins, and "not the brightest bulbs in the box" would take decades to shake.

Here in the twenty-first century, comic books are now celebrated culturally worldwide.

Dismissed for decades by contemporary art critics, historians, and curators alike, cartoonists are now lauded by art museums around the globe. The name R. Crumb has become a part of the art world vernacular. Luminaries such as Charles M. Schulz, Edward Gorey, and Hergé have museums unto themselves!

Whereas teachers once doled out detentions to students who brought comic books to class, today they are handing out grades.

Thanks to the advent of the graphic novel, comics are heralded by academia. Any number of colleges across the country offer courses. Harvard, Stanford, UCLA, to name a few.

.

Disney, McCay, Kurtzman, and Crumb . . . Tezuka, Schulz, and Siegel and Shuster . . . Hergé, Hefner, Kirby, and Hirschfeld . . . Töpffer, Ward, Chas Addams, and Seuss. Imagine a world without Edward Gorey.

These giants made masterful marks, forging legacies both groundbreaking and enduring, shaping the zeitgeist of cartoon art for the past one hundred years.

—*Monte Beauchamp*

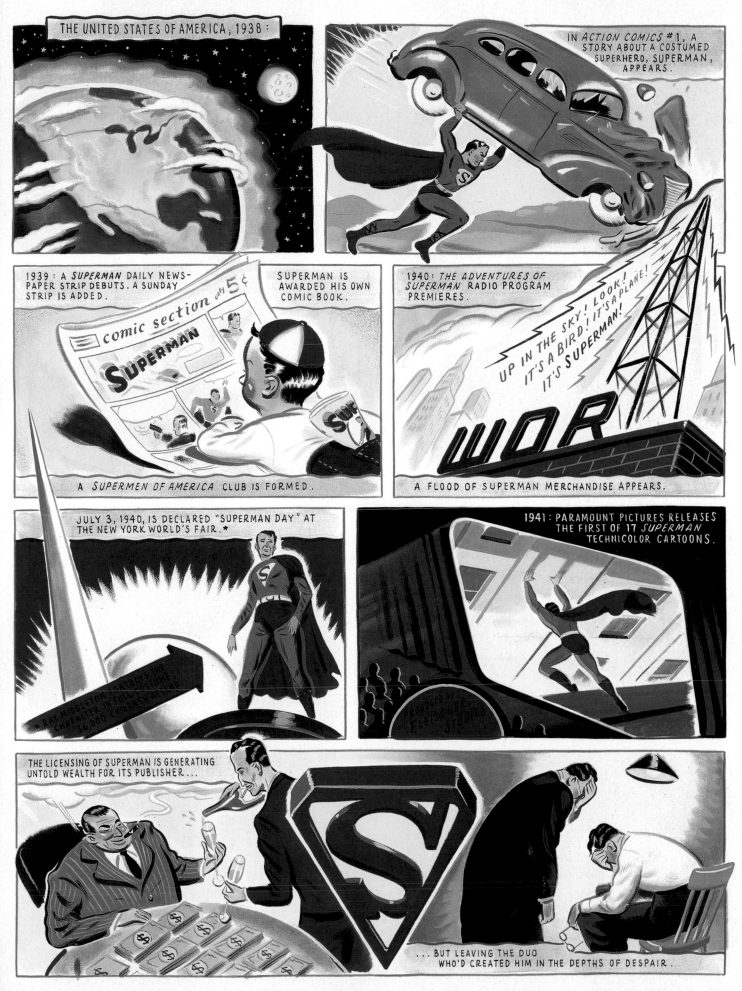

THE UNITED STATES OF AMERICA, 1938:

IN *ACTION COMICS #1*, A STORY ABOUT A COSTUMED SUPERHERO, SUPERMAN, APPEARS.

1939: A *SUPERMAN* DAILY NEWSPAPER STRIP DEBUTS. A SUNDAY STRIP IS ADDED.

SUPERMAN IS AWARDED HIS OWN COMIC BOOK.

comic section only 5¢

SUPERMAN

A *SUPERMEN OF AMERICA* CLUB IS FORMED.

1940: *THE ADVENTURES OF SUPERMAN* RADIO PROGRAM PREMIERES.

UP IN THE SKY! LOOK! IT'S A BIRD! IT'S A PLANE! IT'S SUPERMAN!

WOR

A FLOOD OF SUPERMAN MERCHANDISE APPEARS.

JULY 3, 1940, IS DECLARED "SUPERMAN DAY" AT THE NEW YORK WORLD'S FAIR.*

* RAY MIDDLETON PORTRAYS THE CHARACTER IN FULL COSTUME. 36,000 CHILDREN ATTEND.

1941: PARAMOUNT PICTURES RELEASES THE FIRST OF 17 *SUPERMAN* TECHNICOLOR CARTOONS.

PRODUCED BY FLEISCHER STUDIOS

THE LICENSING OF SUPERMAN IS GENERATING UNTOLD WEALTH FOR ITS PUBLISHER...

...BUT LEAVING THE DUO WHO'D CREATED HIM IN THE DEPTHS OF DESPAIR.

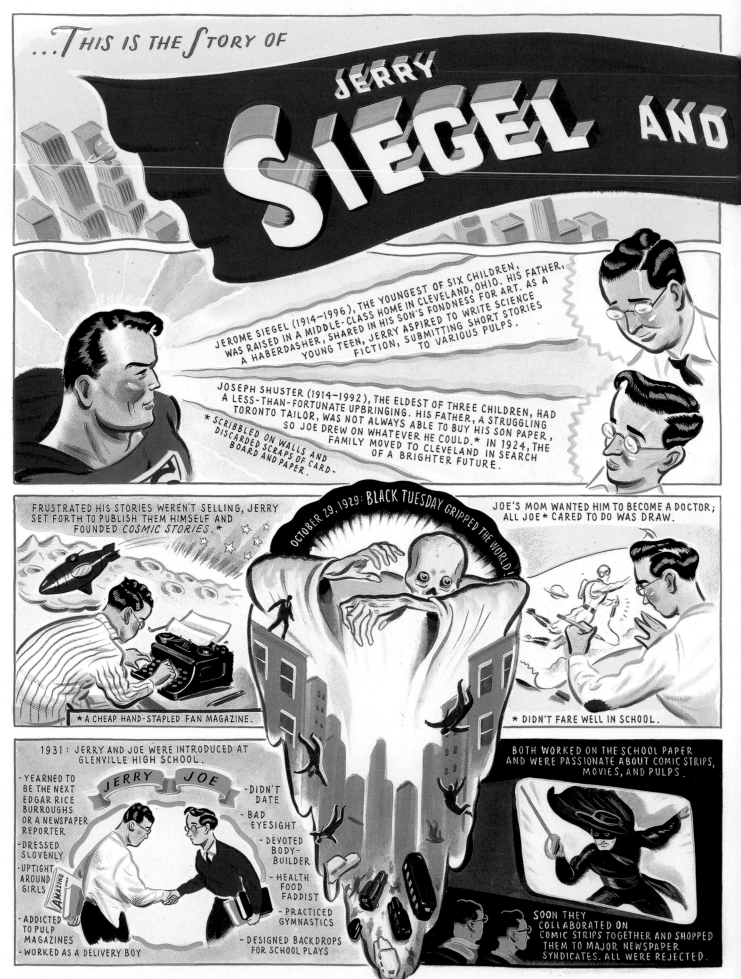

...THIS IS THE STORY OF

JERRY SIEGEL AND

JEROME SIEGEL (1914–1996), THE YOUNGEST OF SIX CHILDREN, WAS RAISED IN A MIDDLE-CLASS HOME IN CLEVELAND, OHIO. HIS FATHER, A HABERDASHER, SHARED IN HIS SON'S FONDNESS FOR ART. AS A YOUNG TEEN, JERRY ASPIRED TO WRITE SCIENCE FICTION, SUBMITTING SHORT STORIES TO VARIOUS PULPS.

JOSEPH SHUSTER (1914–1992), THE ELDEST OF THREE CHILDREN, HAD A LESS-THAN-FORTUNATE UPBRINGING. HIS FATHER, A STRUGGLING TORONTO TAILOR, WAS NOT ALWAYS ABLE TO BUY HIS SON PAPER, SO JOE DREW ON WHATEVER HE COULD. * IN 1924, THE FAMILY MOVED TO CLEVELAND IN SEARCH OF A BRIGHTER FUTURE.

* SCRIBBLED ON WALLS AND DISCARDED SCRAPS OF CARD-BOARD AND PAPER.

FRUSTRATED HIS STORIES WEREN'T SELLING, JERRY SET FORTH TO PUBLISH THEM HIMSELF AND FOUNDED *COSMIC STORIES.* *

OCTOBER 29, 1929: BLACK TUESDAY GRIPPED THE WORLD!

JOE'S MOM WANTED HIM TO BECOME A DOCTOR; ALL JOE * CARED TO DO WAS DRAW.

* A CHEAP HAND-STAPLED FAN MAGAZINE.

* DIDN'T FARE WELL IN SCHOOL.

1931: JERRY AND JOE WERE INTRODUCED AT GLENVILLE HIGH SCHOOL.

JERRY

- YEARNED TO BE THE NEXT EDGAR RICE BURROUGHS OR A NEWSPAPER REPORTER
- DRESSED SLOVENLY
- UPTIGHT AROUND GIRLS
- ADDICTED TO PULP MAGAZINES
- WORKED AS A DELIVERY BOY

AMAZING

JOE

- DIDN'T DATE
- BAD EYESIGHT
- DEVOTED BODY-BUILDER
- HEALTH FOOD FADDIST
- PRACTICED GYMNASTICS
- DESIGNED BACKDROPS FOR SCHOOL PLAYS

BOTH WORKED ON THE SCHOOL PAPER AND WERE PASSIONATE ABOUT COMIC STRIPS, MOVIES, AND PULPS.

SOON THEY COLLABORATED ON COMIC STRIPS TOGETHER AND SHOPPED THEM TO MAJOR NEWSPAPER SYNDICATES. ALL WERE REJECTED.

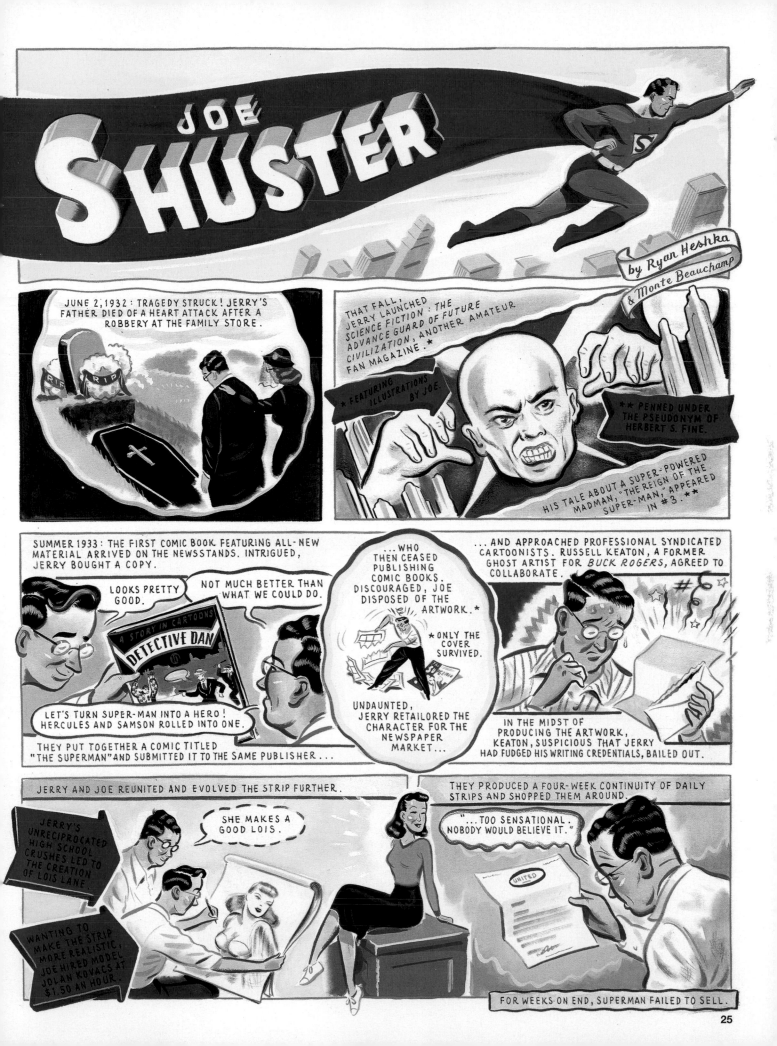

JOE SHUSTER

by Ryan Heshka & Monte Beauchamp

JUNE 2, 1932: TRAGEDY STRUCK! JERRY'S FATHER DIED OF A HEART ATTACK AFTER A ROBBERY AT THE FAMILY STORE.

THAT FALL, JERRY LAUNCHED: *THE SCIENCE FICTION: ADVANCE GUARD OF FUTURE CIVILIZATION*, ANOTHER AMATEUR FAN MAGAZINE.*

*** FEATURING ILLUSTRATIONS BY JOE.**

**** PENNED UNDER THE PSEUDONYM OF HERBERT S. FINE.**

HIS TALE ABOUT A SUPER-POWERED MADMAN, "THE REIGN OF THE SUPER-MAN," APPEARED IN #3. **

SUMMER 1933: THE FIRST COMIC BOOK FEATURING ALL-NEW MATERIAL ARRIVED ON THE NEWSSTANDS. INTRIGUED, JERRY BOUGHT A COPY.

LOOKS PRETTY GOOD.

NOT MUCH BETTER THAN WHAT WE COULD DO.

A STORY IN CARTOONS
DETECTIVE DAN

LET'S TURN SUPER-MAN INTO A HERO! HERCULES AND SAMSON ROLLED INTO ONE.

THEY PUT TOGETHER A COMIC TITLED "THE SUPERMAN" AND SUBMITTED IT TO THE SAME PUBLISHER...

...WHO THEN CEASED PUBLISHING COMIC BOOKS. DISCOURAGED, JOE DISPOSED OF THE ARTWORK.*

*** ONLY THE COVER SURVIVED.**

UNDAUNTED, JERRY RETAILORED THE CHARACTER FOR THE NEWSPAPER MARKET...

...AND APPROACHED PROFESSIONAL SYNDICATED CARTOONISTS. RUSSELL KEATON, A FORMER GHOST ARTIST FOR *BUCK ROGERS*, AGREED TO COLLABORATE.

IN THE MIDST OF PRODUCING THE ARTWORK, KEATON, SUSPICIOUS THAT JERRY HAD FUDGED HIS WRITING CREDENTIALS, BAILED OUT.

JERRY AND JOE REUNITED AND EVOLVED THE STRIP FURTHER.

JERRY'S UNRECIPROCATED HIGH SCHOOL CRUSHES LED TO THE CREATION OF LOIS LANE.

SHE MAKES A GOOD LOIS.

WANTING TO MAKE THE STRIP MORE REALISTIC, JOE HIRED MODEL JOLAN KOVACS AT $1.50 AN HOUR.

THEY PRODUCED A FOUR-WEEK CONTINUITY OF DAILY STRIPS AND SHOPPED THEM AROUND.

"...TOO SENSATIONAL. NOBODY WOULD BELIEVE IT."

UNITED

FOR WEEKS ON END, SUPERMAN FAILED TO SELL.

25

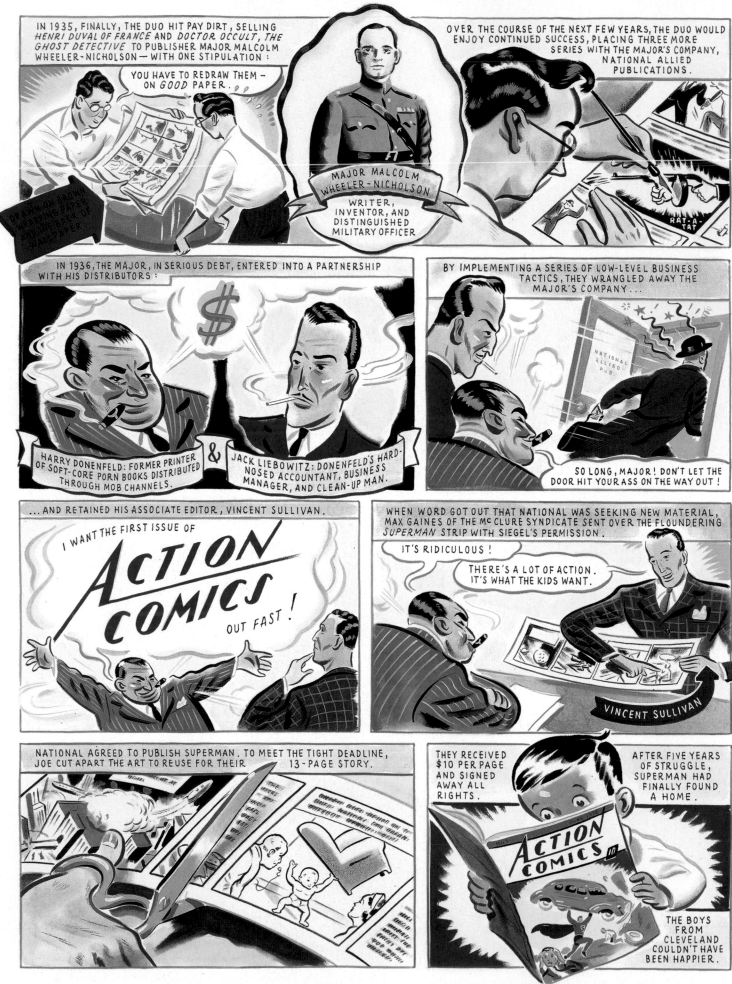

IN 1935, FINALLY, THE DUO HIT PAY DIRT, SELLING *HENRI DUVAL OF FRANCE* AND *DOCTOR OCCULT, THE GHOST DETECTIVE* TO PUBLISHER MAJOR MALCOLM WHEELER-NICHOLSON — WITH ONE STIPULATION:

YOU HAVE TO REDRAW THEM — ON *GOOD* PAPER.

DRAWN ON BROWN WRAPPING PAPER AND THE BACK OF WALLPAPER.

MAJOR MALCOLM WHEELER-NICHOLSON
WRITER, INVENTOR, AND DISTINGUISHED MILITARY OFFICER

OVER THE COURSE OF THE NEXT FEW YEARS, THE DUO WOULD ENJOY CONTINUED SUCCESS, PLACING THREE MORE SERIES WITH THE MAJOR'S COMPANY, NATIONAL ALLIED PUBLICATIONS.

RAT-A-TAT

IN 1936, THE MAJOR, IN SERIOUS DEBT, ENTERED INTO A PARTNERSHIP WITH HIS DISTRIBUTORS:

$

HARRY DONENFELD: FORMER PRINTER OF SOFT-CORE PORN BOOKS DISTRIBUTED THROUGH MOB CHANNELS.

&

JACK LIEBOWITZ: DONENFELD'S HARD-NOSED ACCOUNTANT, BUSINESS MANAGER, AND CLEAN-UP MAN.

BY IMPLEMENTING A SERIES OF LOW-LEVEL BUSINESS TACTICS, THEY WRANGLED AWAY THE MAJOR'S COMPANY...

NATIONAL ALLIED PUB.

SO LONG, MAJOR! DON'T LET THE DOOR HIT YOUR ASS ON THE WAY OUT!

...AND RETAINED HIS ASSOCIATE EDITOR, VINCENT SULLIVAN.

I WANT THE FIRST ISSUE OF *ACTION COMICS* OUT FAST!

WHEN WORD GOT OUT THAT NATIONAL WAS SEEKING NEW MATERIAL, MAX GAINES OF THE MᶜCLURE SYNDICATE SENT OVER THE FLOUNDERING *SUPERMAN* STRIP WITH SIEGEL'S PERMISSION.

IT'S RIDICULOUS!

THERE'S A LOT OF ACTION. IT'S WHAT THE KIDS WANT.

VINCENT SULLIVAN

NATIONAL AGREED TO PUBLISH SUPERMAN. TO MEET THE TIGHT DEADLINE, JOE CUT APART THE ART TO REUSE FOR THEIR 13-PAGE STORY.

THEY RECEIVED $10 PER PAGE AND SIGNED AWAY ALL RIGHTS.

ACTION COMICS 10

AFTER FIVE YEARS OF STRUGGLE, SUPERMAN HAD FINALLY FOUND A HOME.

THE BOYS FROM CLEVELAND COULDN'T HAVE BEEN HAPPIER.

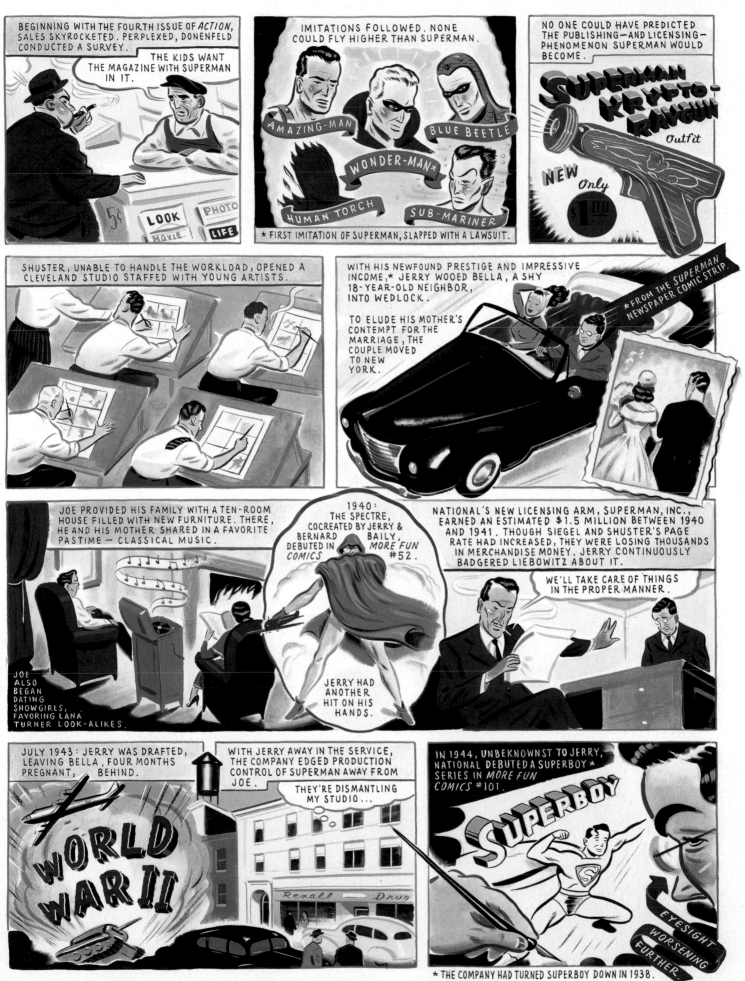

BEGINNING WITH THE FOURTH ISSUE OF *ACTION*, SALES SKYROCKETED. PERPLEXED, DONENFELD CONDUCTED A SURVEY.

THE KIDS WANT THE MAGAZINE WITH SUPERMAN IN IT.

IMITATIONS FOLLOWED. NONE COULD FLY HIGHER THAN SUPERMAN.

AMAZING-MAN
WONDER-MAN*
BLUE BEETLE
HUMAN TORCH
SUB-MARINER

* FIRST IMITATION OF SUPERMAN, SLAPPED WITH A LAWSUIT.

NO ONE COULD HAVE PREDICTED THE PUBLISHING—AND LICENSING—PHENOMENON SUPERMAN WOULD BECOME.

SUPERMAN KRYPTO-RAYGUN Outfit
NEW Only $1.00

SHUSTER, UNABLE TO HANDLE THE WORKLOAD, OPENED A CLEVELAND STUDIO STAFFED WITH YOUNG ARTISTS.

WITH HIS NEWFOUND PRESTIGE AND IMPRESSIVE INCOME,* JERRY WOOED BELLA, A SHY 18-YEAR-OLD NEIGHBOR, INTO WEDLOCK.

TO ELUDE HIS MOTHER'S CONTEMPT FOR THE MARRIAGE, THE COUPLE MOVED TO NEW YORK.

*FROM THE SUPERMAN NEWSPAPER COMIC STRIP.

JOE PROVIDED HIS FAMILY WITH A TEN-ROOM HOUSE FILLED WITH NEW FURNITURE. THERE, HE AND HIS MOTHER SHARED IN A FAVORITE PASTIME — CLASSICAL MUSIC.

JOE ALSO BEGAN DATING SHOWGIRLS, FAVORING LANA TURNER LOOK-ALIKES.

1940: THE SPECTRE, COCREATED BY JERRY & BERNARD BAILY, DEBUTED IN *MORE FUN COMICS* #52.

JERRY HAD ANOTHER HIT ON HIS HANDS.

NATIONAL'S NEW LICENSING ARM, SUPERMAN, INC., EARNED AN ESTIMATED $1.5 MILLION BETWEEN 1940 AND 1941. THOUGH SIEGEL AND SHUSTER'S PAGE RATE HAD INCREASED, THEY WERE LOSING THOUSANDS IN MERCHANDISE MONEY. JERRY CONTINUOUSLY BADGERED LIEBOWITZ ABOUT IT.

WE'LL TAKE CARE OF THINGS IN THE PROPER MANNER.

JULY 1943: JERRY WAS DRAFTED, LEAVING BELLA, FOUR MONTHS PREGNANT, BEHIND.

WORLD WAR II

WITH JERRY AWAY IN THE SERVICE, THE COMPANY EDGED PRODUCTION CONTROL OF SUPERMAN AWAY FROM JOE.

THEY'RE DISMANTLING MY STUDIO...

Rexall Drug

IN 1944, UNBEKNOWNST TO JERRY, NATIONAL DEBUTED A SUPERBOY * SERIES IN *MORE FUN COMICS* #101.

SUPERBOY

EYESIGHT WORSENING FURTHER.

* THE COMPANY HAD TURNED SUPERBOY DOWN IN 1938.

27

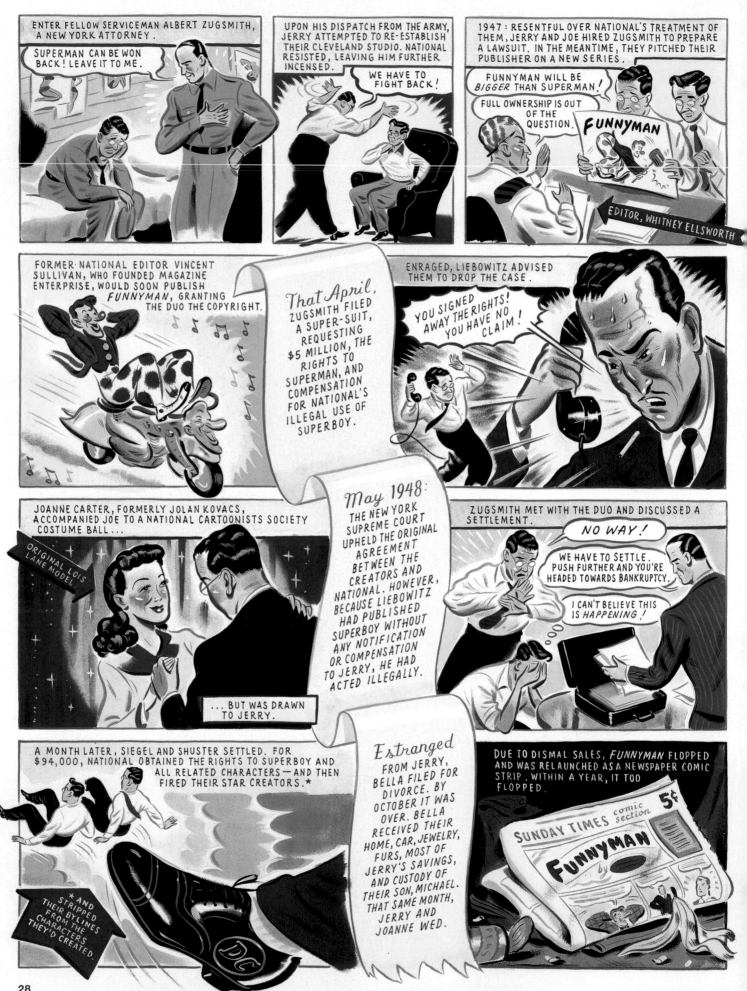

ENTER FELLOW SERVICEMAN ALBERT ZUGSMITH, A NEW YORK ATTORNEY.

SUPERMAN CAN BE WON BACK! LEAVE IT TO ME.

UPON HIS DISPATCH FROM THE ARMY, JERRY ATTEMPTED TO RE-ESTABLISH THEIR CLEVELAND STUDIO. NATIONAL RESISTED, LEAVING HIM FURTHER INCENSED.

WE HAVE TO FIGHT BACK!

1947: RESENTFUL OVER NATIONAL'S TREATMENT OF THEM, JERRY AND JOE HIRED ZUGSMITH TO PREPARE A LAWSUIT. IN THE MEANTIME, THEY PITCHED THEIR PUBLISHER ON A NEW SERIES.

FUNNYMAN WILL BE *BIGGER* THAN SUPERMAN!

FULL OWNERSHIP IS OUT OF THE QUESTION.

FUNNYMAN

EDITOR, WHITNEY ELLSWORTH

FORMER NATIONAL EDITOR VINCENT SULLIVAN, WHO FOUNDED MAGAZINE ENTERPRISE, WOULD SOON PUBLISH *FUNNYMAN*, GRANTING THE DUO THE COPYRIGHT.

That April, ZUGSMITH FILED A SUPER-SUIT, REQUESTING $5 MILLION, THE RIGHTS TO SUPERMAN, AND COMPENSATION FOR NATIONAL'S ILLEGAL USE OF SUPERBOY.

ENRAGED, LIEBOWITZ ADVISED THEM TO DROP THE CASE.

YOU SIGNED AWAY THE RIGHTS! YOU HAVE NO CLAIM!

JOANNE CARTER, FORMERLY JOLAN KOVACS, ACCOMPANIED JOE TO A NATIONAL CARTOONISTS SOCIETY COSTUME BALL...

ORIGINAL LOIS LANE MODEL

May 1948: THE NEW YORK SUPREME COURT UPHELD THE ORIGINAL AGREEMENT BETWEEN THE CREATORS AND NATIONAL. HOWEVER, BECAUSE LIEBOWITZ HAD PUBLISHED SUPERBOY WITHOUT ANY NOTIFICATION OR COMPENSATION TO JERRY, HE HAD ACTED ILLEGALLY.

...BUT WAS DRAWN TO JERRY.

ZUGSMITH MET WITH THE DUO AND DISCUSSED A SETTLEMENT.

NO WAY!

WE HAVE TO SETTLE. PUSH FURTHER AND YOU'RE HEADED TOWARDS BANKRUPTCY.

I CAN'T BELIEVE THIS IS HAPPENING!

A MONTH LATER, SIEGEL AND SHUSTER SETTLED. FOR $94,000, NATIONAL OBTAINED THE RIGHTS TO SUPERBOY AND ALL RELATED CHARACTERS — AND THEN FIRED THEIR STAR CREATORS.*

*AND STRIPPED THEIR BYLINES FROM THE CHARACTERS THEY'D CREATED.

DC

Estranged FROM JERRY, BELLA FILED FOR DIVORCE. BY OCTOBER IT WAS OVER. BELLA RECEIVED THEIR HOME, CAR, JEWELRY, FURS, MOST OF JERRY'S SAVINGS, AND CUSTODY OF THEIR SON, MICHAEL. THAT SAME MONTH, JERRY AND JOANNE WED.

DUE TO DISMAL SALES, *FUNNYMAN* FLOPPED AND WAS RELAUNCHED AS A NEWSPAPER COMIC STRIP. WITHIN A YEAR, IT TOO FLOPPED.

SUNDAY TIMES comic section 5¢

FUNNYMAN by

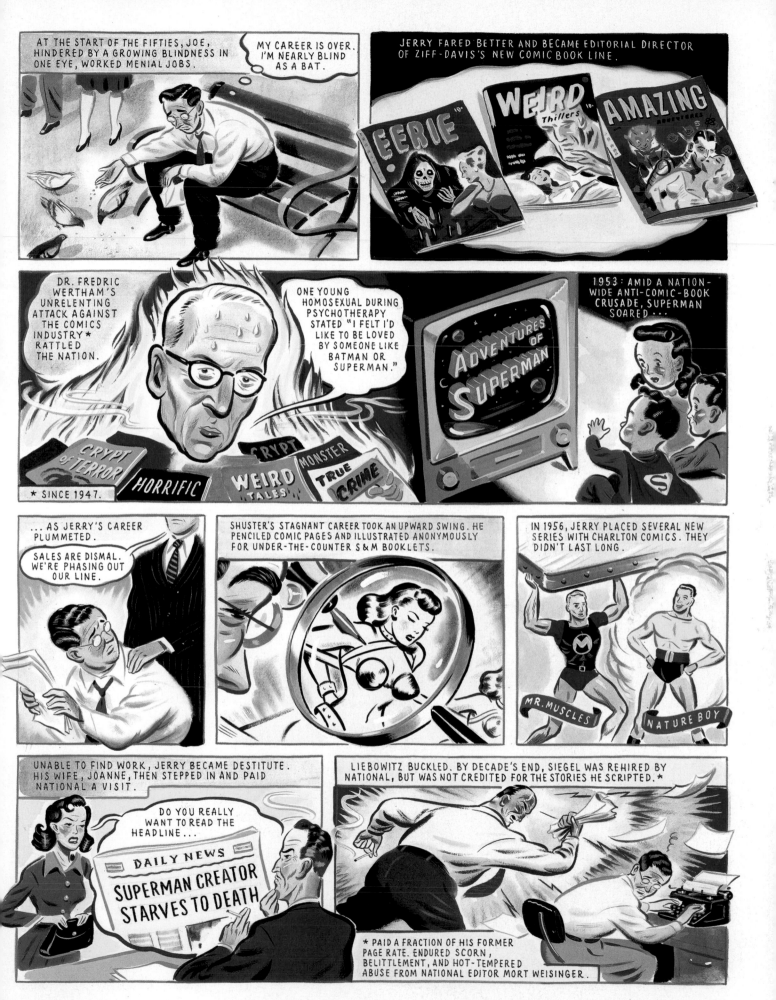

AT THE START OF THE FIFTIES, JOE, HINDERED BY A GROWING BLINDNESS IN ONE EYE, WORKED MENIAL JOBS.

MY CAREER IS OVER. I'M NEARLY BLIND AS A BAT.

JERRY FARED BETTER AND BECAME EDITORIAL DIRECTOR OF ZIFF-DAVIS'S NEW COMIC BOOK LINE.

DR. FREDRIC WERTHAM'S UNRELENTING ATTACK AGAINST THE COMICS INDUSTRY* RATTLED THE NATION.

ONE YOUNG HOMOSEXUAL DURING PSYCHOTHERAPY STATED "I FELT I'D LIKE TO BE LOVED BY SOMEONE LIKE BATMAN OR SUPERMAN."

1953: AMID A NATION-WIDE ANTI-COMIC-BOOK CRUSADE, SUPERMAN SOARED...

* SINCE 1947.

...AS JERRY'S CAREER PLUMMETED.

SALES ARE DISMAL. WE'RE PHASING OUT OUR LINE.

SHUSTER'S STAGNANT CAREER TOOK AN UPWARD SWING. HE PENCILED COMIC PAGES AND ILLUSTRATED ANONYMOUSLY FOR UNDER-THE-COUNTER S&M BOOKLETS.

IN 1956, JERRY PLACED SEVERAL NEW SERIES WITH CHARLTON COMICS. THEY DIDN'T LAST LONG.

MR. MUSCLES

NATURE BOY

UNABLE TO FIND WORK, JERRY BECAME DESTITUTE. HIS WIFE, JOANNE, THEN STEPPED IN AND PAID NATIONAL A VISIT.

DO YOU REALLY WANT TO READ THE HEADLINE...

DAILY NEWS
SUPERMAN CREATOR STARVES TO DEATH

LIEBOWITZ BUCKLED. BY DECADE'S END, SIEGEL WAS REHIRED BY NATIONAL, BUT WAS NOT CREDITED FOR THE STORIES HE SCRIPTED.*

* PAID A FRACTION OF HIS FORMER PAGE RATE. ENDURED SCORN, BELITTLEMENT, AND HOT-TEMPERED ABUSE FROM NATIONAL EDITOR MORT WEISINGER.

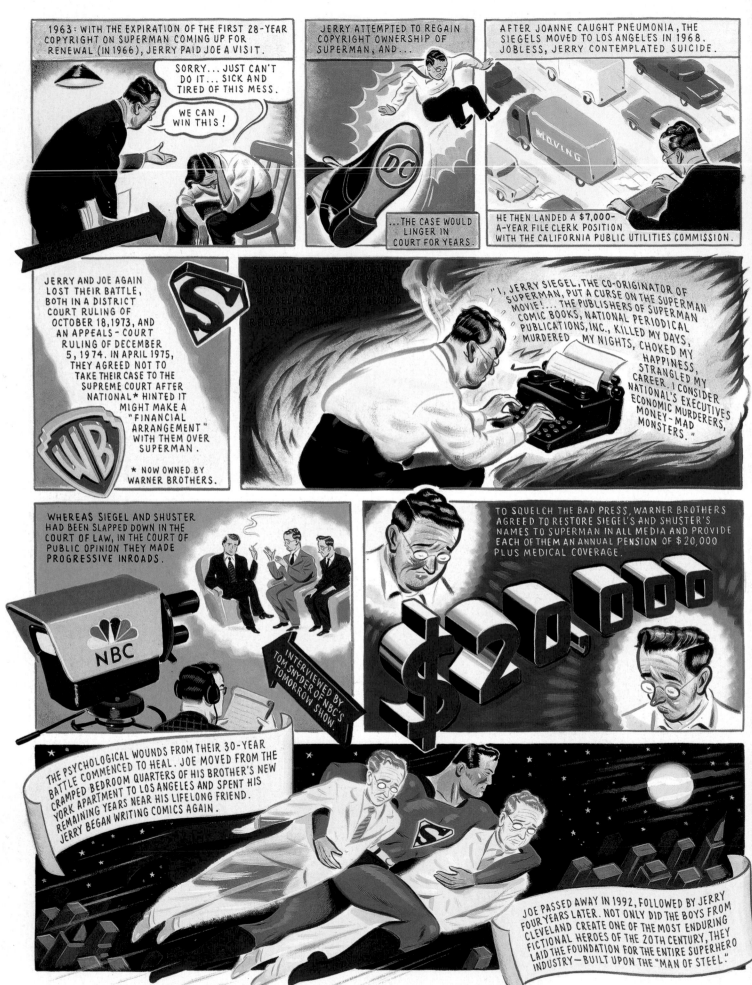

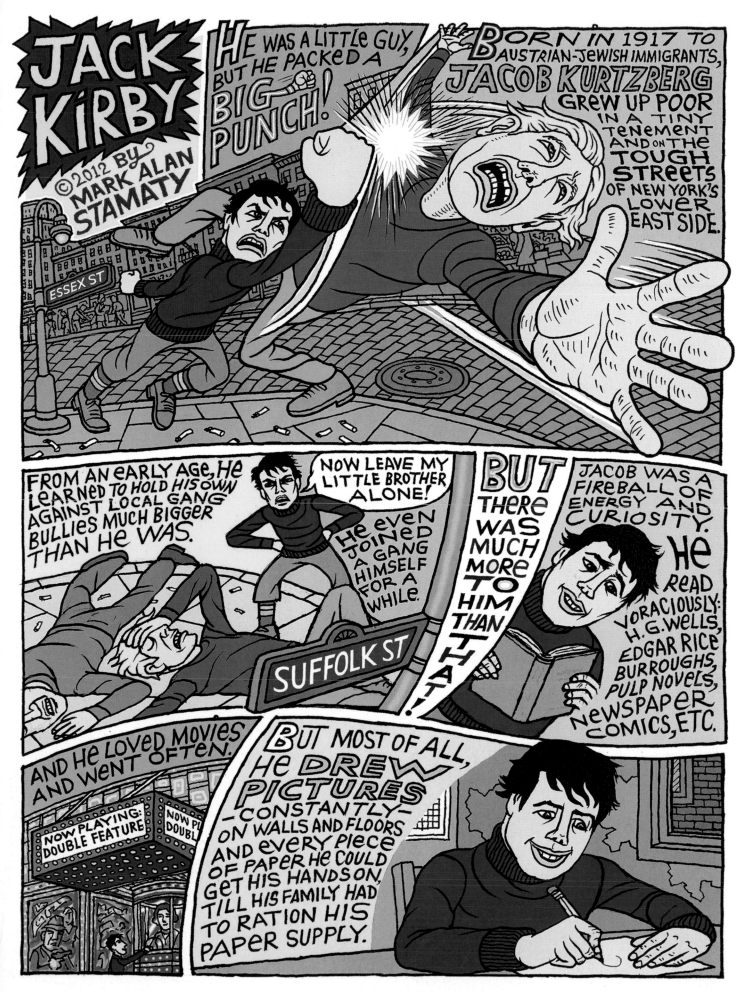

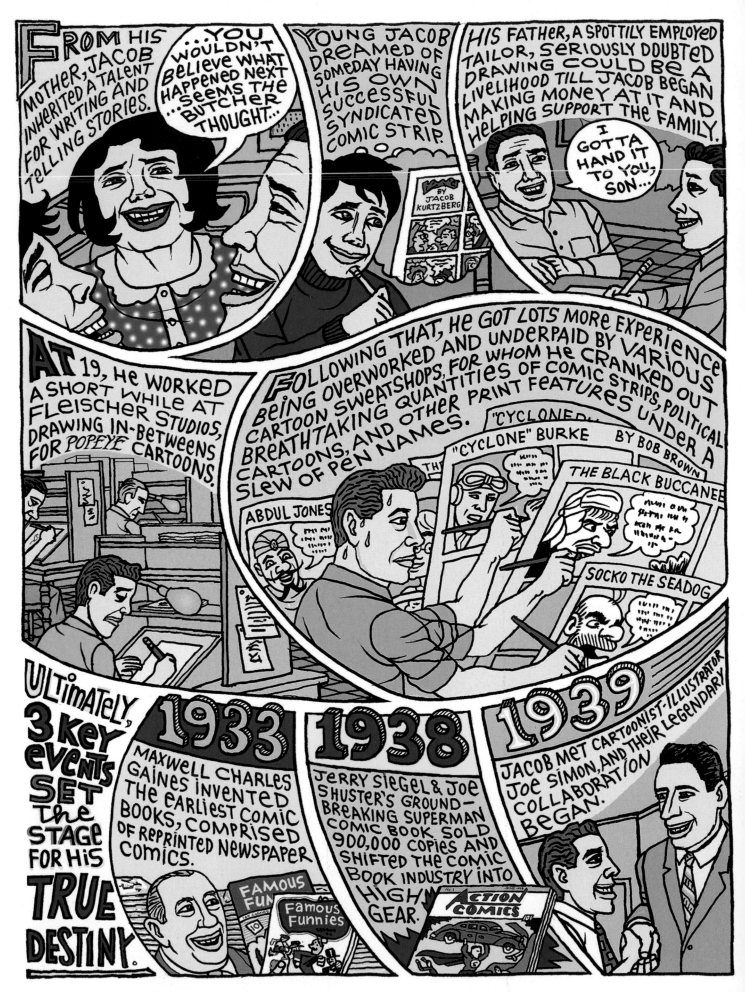

FROM HIS MOTHER, JACOB INHERITED A TALENT FOR WRITING AND TELLING STORIES.

"...YOU WOULDN'T BELIEVE WHAT HAPPENED NEXT... SEEMS THE BUTCHER THOUGHT..."

YOUNG JACOB DREAMED OF SOMEDAY HAVING HIS OWN SUCCESSFUL SYNDICATED COMIC STRIP.

BY JACOB KURTZBERG

HIS FATHER, A SPOTTILY EMPLOYED TAILOR, SERIOUSLY DOUBTED DRAWING COULD BE A LIVELIHOOD TILL JACOB BEGAN MAKING MONEY AT IT AND HELPING SUPPORT THE FAMILY.

I GOTTA HAND IT TO YOU, SON...

AT 19, HE WORKED A SHORT WHILE AT FLEISCHER STUDIOS, DRAWING IN-BETWEENS FOR POPEYE CARTOONS.

FOLLOWING THAT, HE GOT LOTS MORE EXPERIENCE BEING OVERWORKED AND UNDERPAID BY VARIOUS CARTOON SWEATSHOPS, FOR WHOM HE CRANKED OUT BREATHTAKING QUANTITIES OF COMIC STRIPS, POLITICAL CARTOONS, AND OTHER PRINT FEATURES UNDER A SLEW OF PEN NAMES.

ABDUL JONES

"CYCLONE" BURKE

"CYCLONE" BY BOB BROWN

THE BLACK BUCCANEE

SOCKO THE SEADOG

ULTIMATELY, 3 KEY EVENTS SET THE STAGE FOR HIS TRUE DESTINY.

1933 MAXWELL CHARLES GAINES INVENTED THE EARLIEST COMIC BOOKS, COMPRISED OF REPRINTED NEWSPAPER COMICS.

FAMOUS FUN
Famous Funnies

1938 JERRY SIEGEL & JOE SHUSTER'S GROUND-BREAKING SUPERMAN COMIC BOOK SOLD 900,000 COPIES AND SHIFTED THE COMIC BOOK INDUSTRY INTO HIGH GEAR.

ACTION COMICS

1939 JACOB MET CARTOONIST-ILLUSTRATOR JOE SIMON, AND THEIR LEGENDARY COLLABORATION BEGAN.

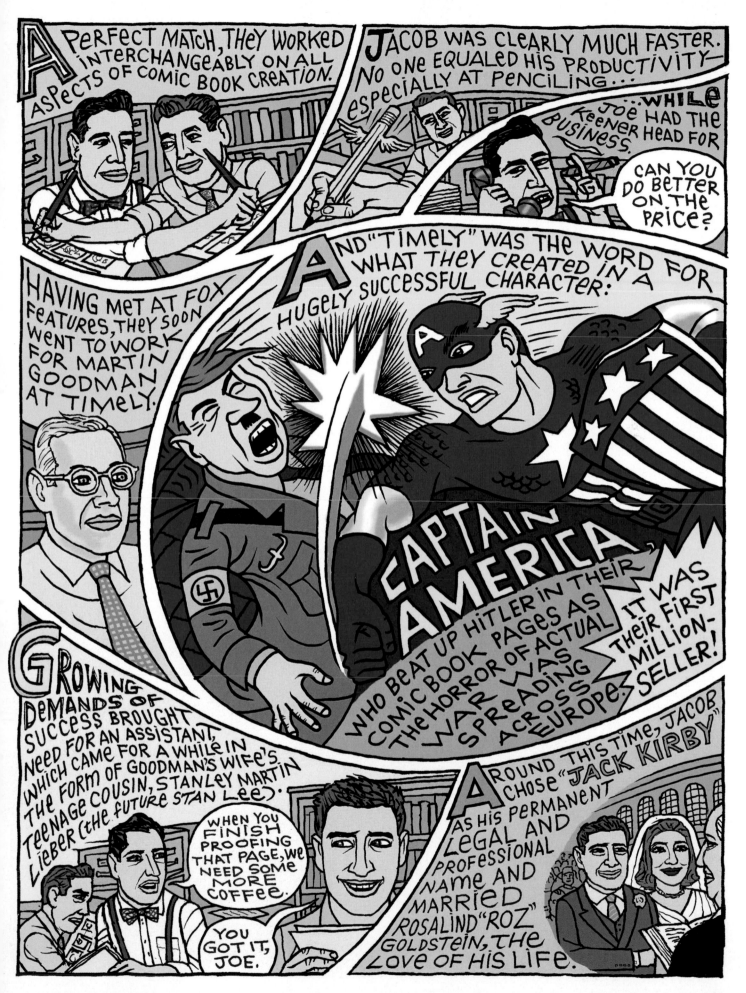

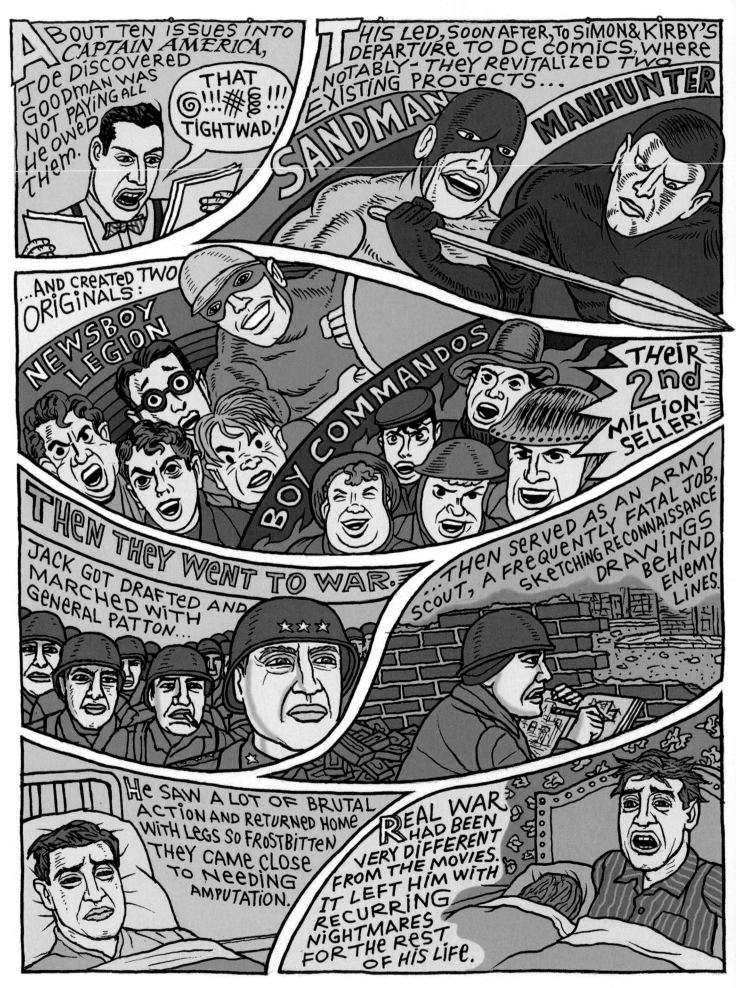

ABOUT TEN ISSUES INTO CAPTAIN AMERICA, JOE DISCOVERED GOODMAN WAS NOT PAYING ALL HE OWED THEM.

THAT @!!!#&!!! TIGHTWAD!

THIS LED, SOON AFTER, TO SIMON & KIRBY'S DEPARTURE TO DC COMICS, WHERE -NOTABLY- THEY REVITALIZED TWO EXISTING PROJECTS...

SANDMAN

MANHUNTER

...AND CREATED TWO ORIGINALS:

NEWSBOY LEGION

BOY COMMANDOS

THEIR 2nd MILLION-SELLER!

THEN THEY WENT TO WAR.

JACK GOT DRAFTED AND MARCHED WITH GENERAL PATTON...

...THEN SERVED AS AN ARMY SCOUT, A FREQUENTLY FATAL JOB, SKETCHING RECONNAISSANCE DRAWINGS BEHIND ENEMY LINES.

HE SAW A LOT OF BRUTAL ACTION AND RETURNED HOME WITH LEGS SO FROSTBITTEN THEY CAME CLOSE TO NEEDING AMPUTATION.

REAL WAR HAD BEEN VERY DIFFERENT FROM THE MOVIES. IT LEFT HIM WITH RECURRING NIGHTMARES FOR THE REST OF HIS LIFE.

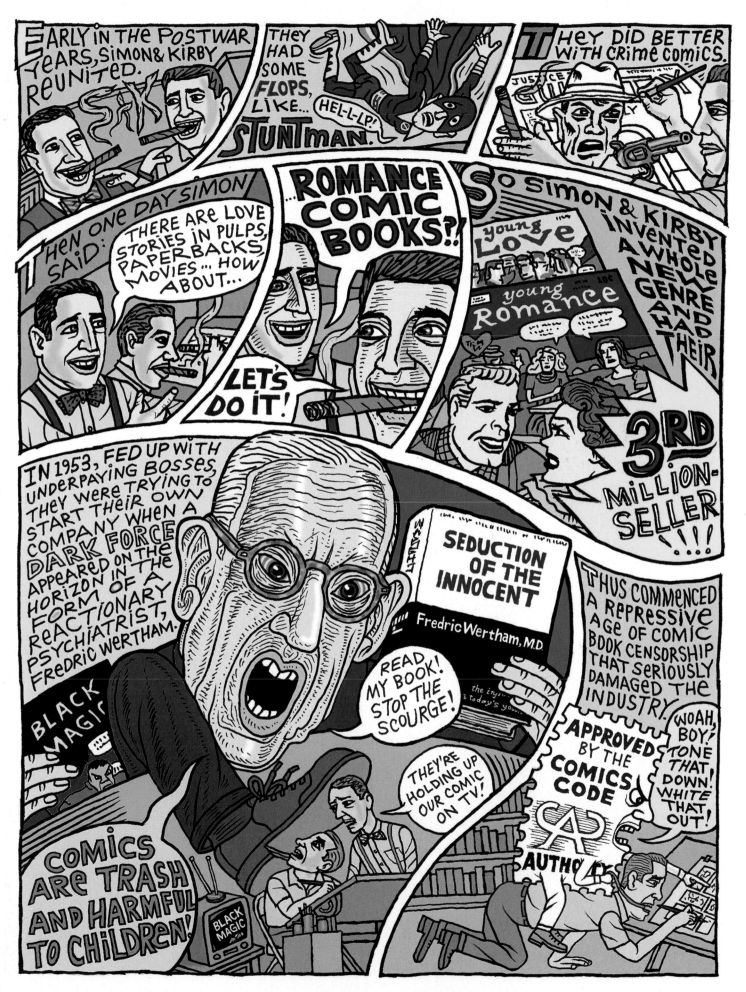

35

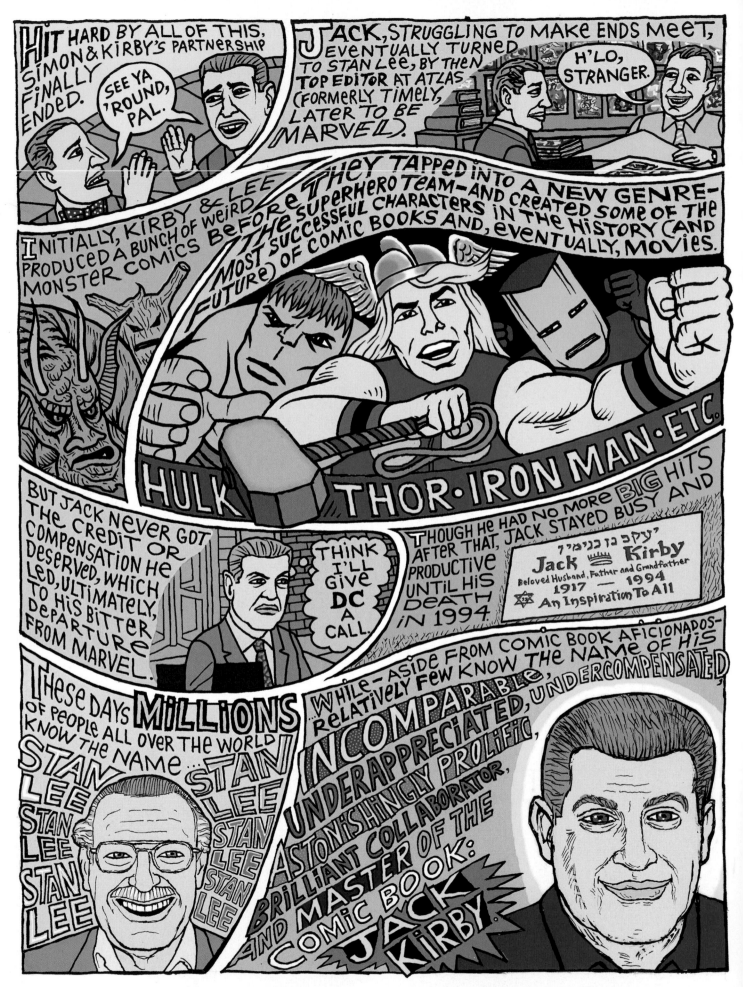

HIT HARD BY ALL OF THIS, SIMON & KIRBY'S PARTNERSHIP FINALLY ENDED.

SEE YA 'ROUND, PAL.

JACK, STRUGGLING TO MAKE ENDS MEET, EVENTUALLY TURNED TO STAN LEE, BY THEN TOP EDITOR AT ATLAS (FORMERLY TIMELY, LATER TO BE MARVEL).

H'LO, STRANGER.

INITIALLY, KIRBY & LEE PRODUCED A BUNCH OF WEIRD MONSTER COMICS BEFORE THEY TAPPED INTO A NEW GENRE—THE SUPERHERO TEAM—AND CREATED SOME OF THE MOST SUCCESSFUL CHARACTERS IN THE HISTORY (AND FUTURE) OF COMIC BOOKS AND, EVENTUALLY, MOVIES.

HULK · THOR · IRON MAN · ETC.

BUT JACK NEVER GOT THE CREDIT OR COMPENSATION HE DESERVED, WHICH LED, ULTIMATELY, TO HIS BITTER DEPARTURE FROM MARVEL.

THINK I'LL GIVE **DC** A CALL.

THOUGH HE HAD NO MORE BIG HITS AFTER THAT, JACK STAYED BUSY AND PRODUCTIVE UNTIL HIS DEATH IN 1994

"עקיבא בן כנעמ"
Jack ⬥ Kirby
Beloved Husband, Father and Grandfather
1917 — 1994
✡ An Inspiration To All

THESE DAYS **MILLIONS** OF PEOPLE ALL OVER THE WORLD KNOW THE NAME...

STAN LEE STAN LEE STAN LEE STAN LEE STAN LEE STAN LEE

WHILE—ASIDE FROM COMIC BOOK AFICIONADOS—RELATIVELY FEW KNOW THE NAME OF HIS **INCOMPARABLE,** UNDERAPPRECIATED, UNDERCOMPENSATED, ASTONISHINGLY PROLIFIC, BRILLIANT COLLABORATOR, AND MASTER OF THE COMIC BOOK: **JACK KIRBY.**

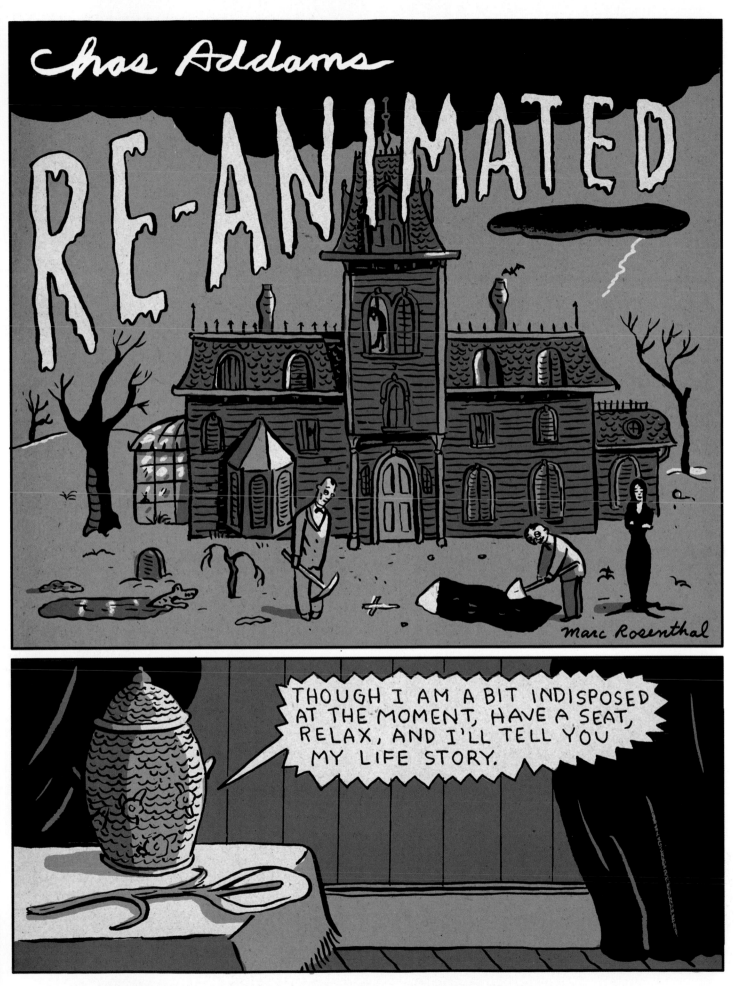

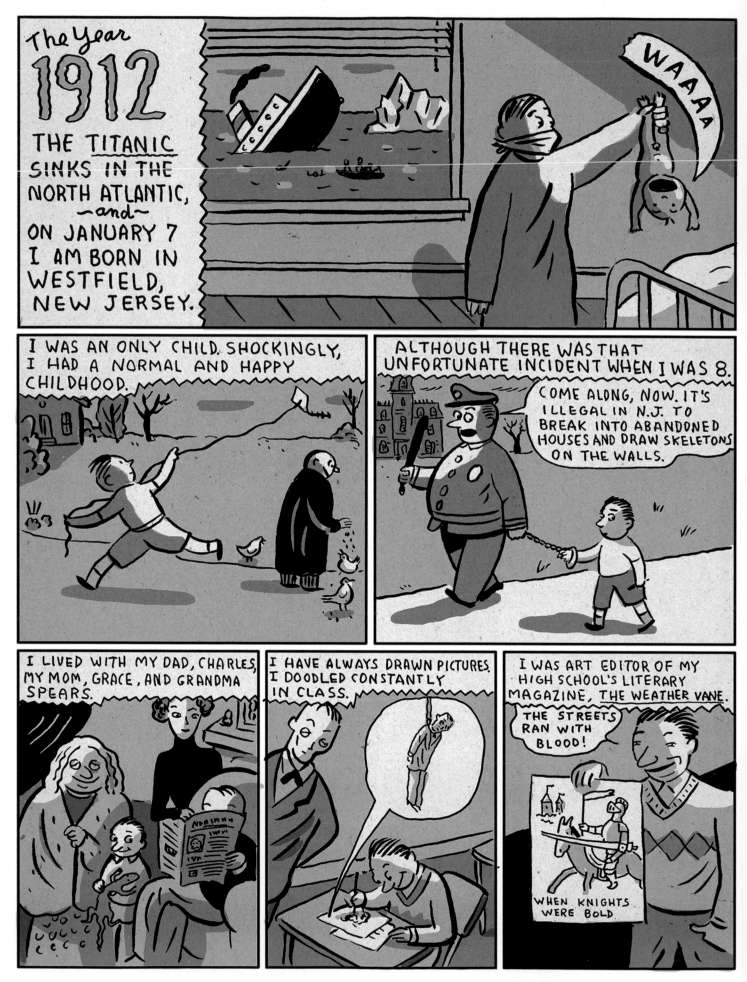

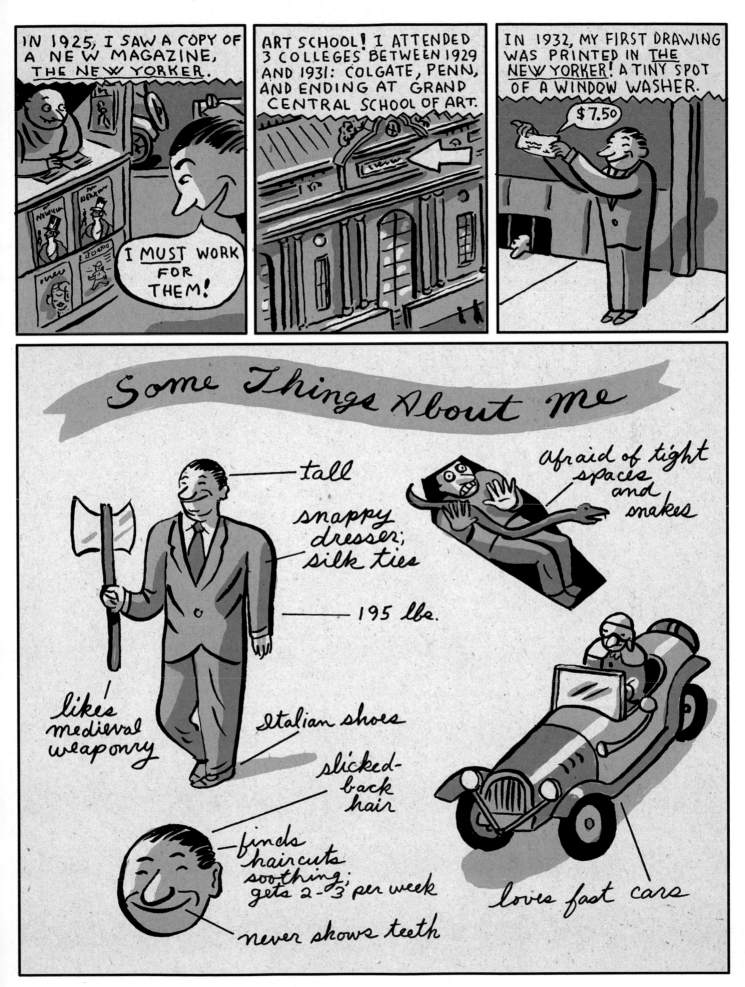

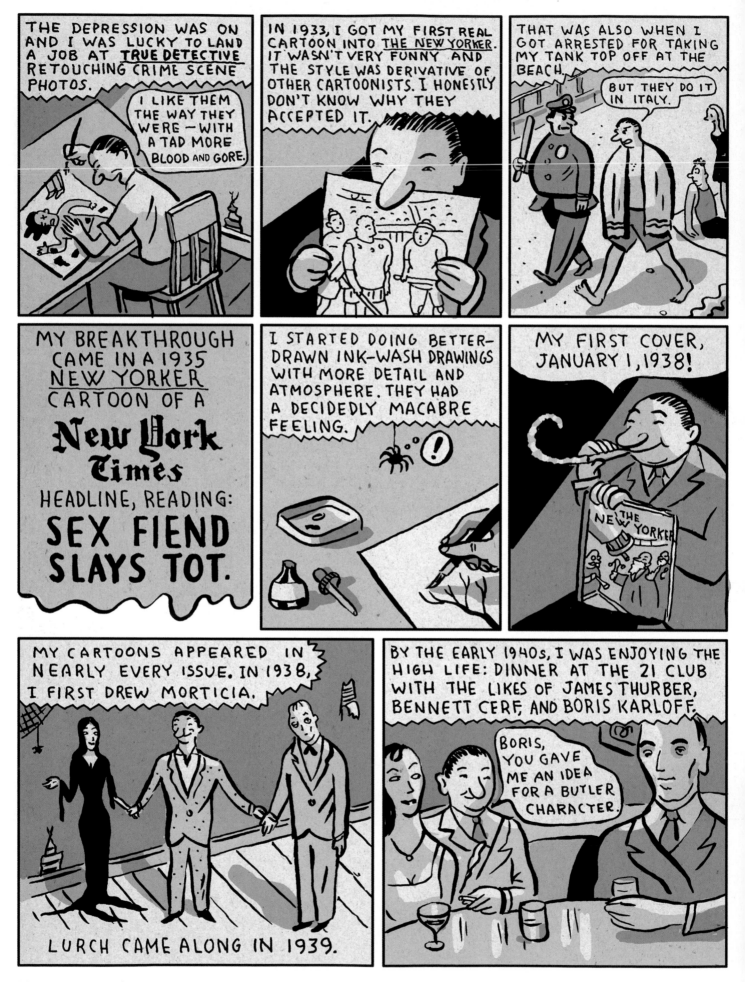

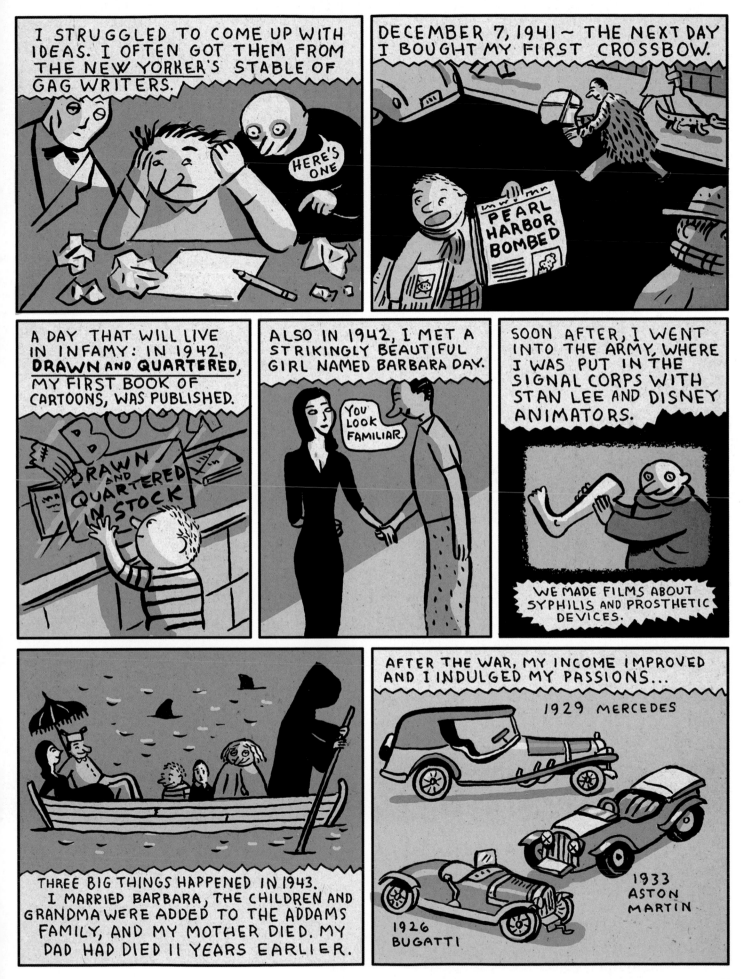

YES, IT WAS A LUXURIOUS LIFE. WE BOUGHT A VICTORIAN CARRIAGE HOUSE ON EASTERN LONG ISLAND.

BARBARA WANTED KIDS. I WASN'T SO SURE. WHEN I REFUSED TO ADOPT IN 1951, SHE LEFT.

Some More Things About me

I didn't crave kids

I occasionally wore a yellow flannel waistcoat and sword

I collected suits of armor and crossbows

I found the captionless cartoon the highest form of cartoon art

In the winter I wore a black bearskin coat

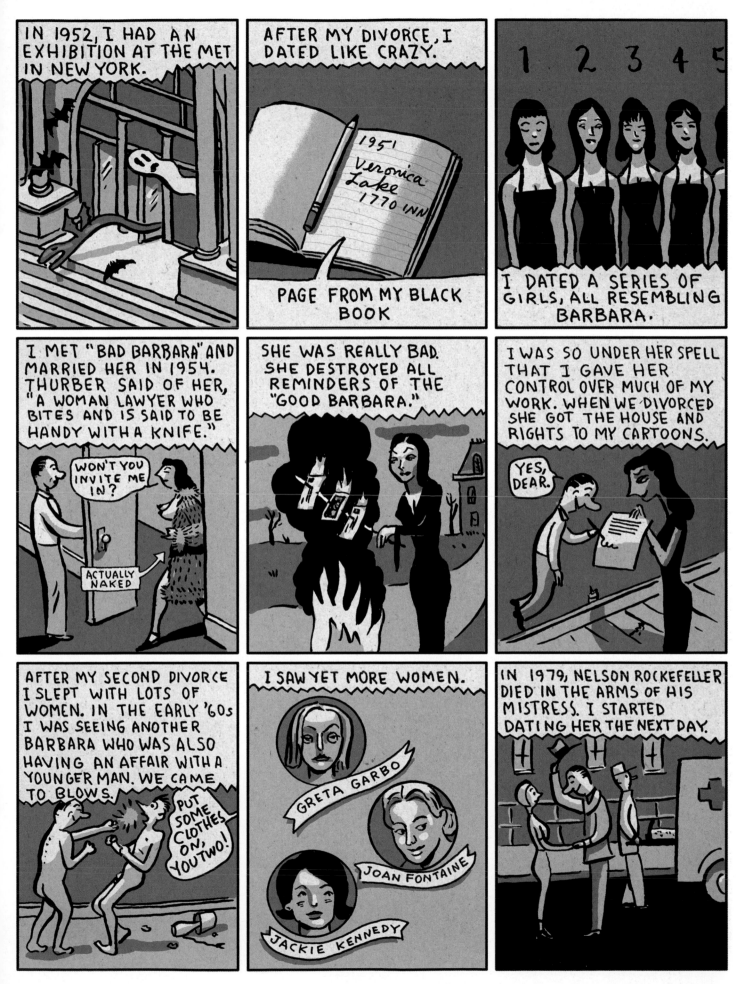

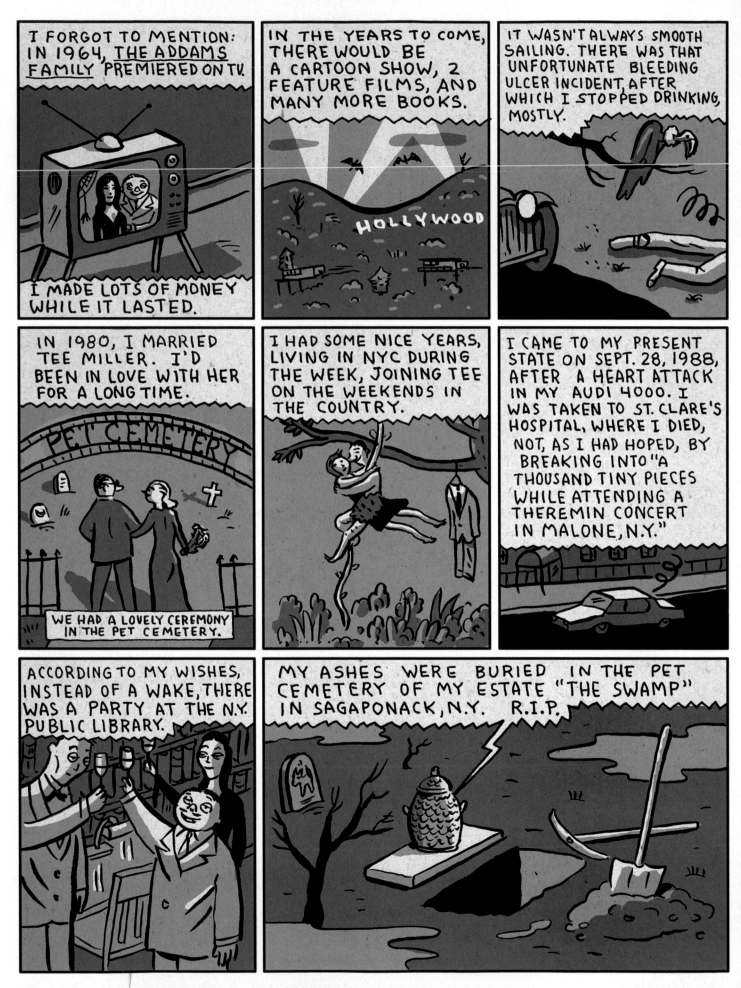

I FORGOT TO MENTION: IN 1964, THE ADDAMS FAMILY PREMIERED ON T.V.

I MADE LOTS OF MONEY WHILE IT LASTED.

IN THE YEARS TO COME, THERE WOULD BE A CARTOON SHOW, 2 FEATURE FILMS, AND MANY MORE BOOKS.

HOLLYWOOD

IT WASN'T ALWAYS SMOOTH SAILING. THERE WAS THAT UNFORTUNATE BLEEDING ULCER INCIDENT, AFTER WHICH I STOPPED DRINKING, MOSTLY.

IN 1980, I MARRIED TEE MILLER. I'D BEEN IN LOVE WITH HER FOR A LONG TIME.

PET CEMETERY

WE HAD A LOVELY CEREMONY IN THE PET CEMETERY.

I HAD SOME NICE YEARS, LIVING IN NYC DURING THE WEEK, JOINING TEE ON THE WEEKENDS IN THE COUNTRY.

I CAME TO MY PRESENT STATE ON SEPT. 28, 1988, AFTER A HEART ATTACK IN MY AUDI 4000. I WAS TAKEN TO ST. CLARE'S HOSPITAL, WHERE I DIED, NOT, AS I HAD HOPED, BY BREAKING INTO "A THOUSAND TINY PIECES WHILE ATTENDING A THEREMIN CONCERT IN MALONE, N.Y."

ACCORDING TO MY WISHES, INSTEAD OF A WAKE, THERE WAS A PARTY AT THE N.Y. PUBLIC LIBRARY.

MY ASHES WERE BURIED IN THE PET CEMETERY OF MY ESTATE "THE SWAMP" IN SAGAPONACK, N.Y. R.I.P.

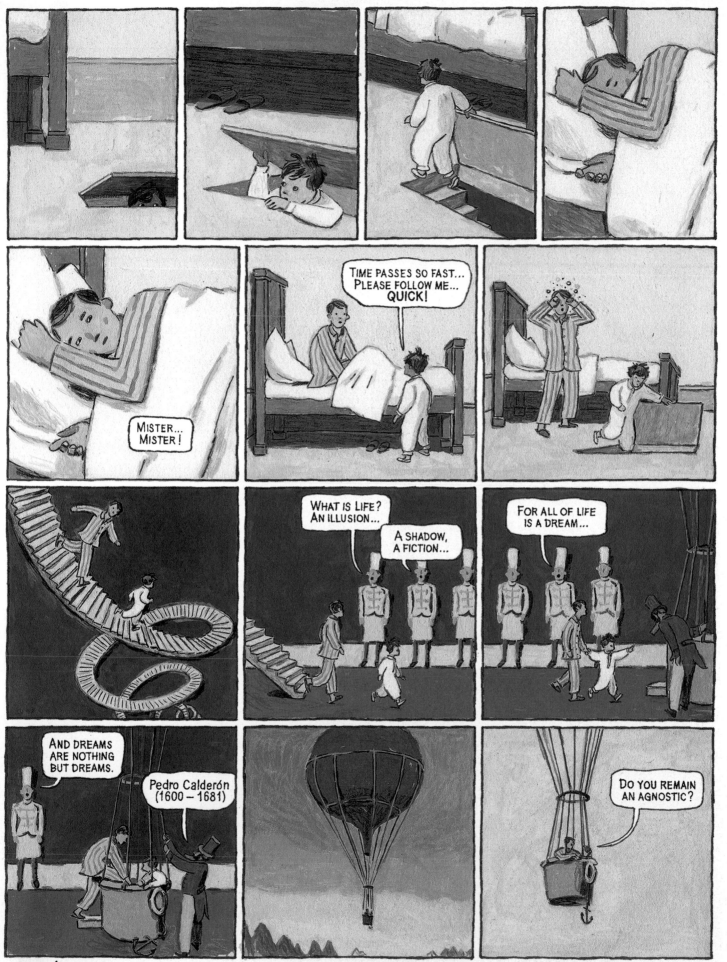

Nicolas Debon

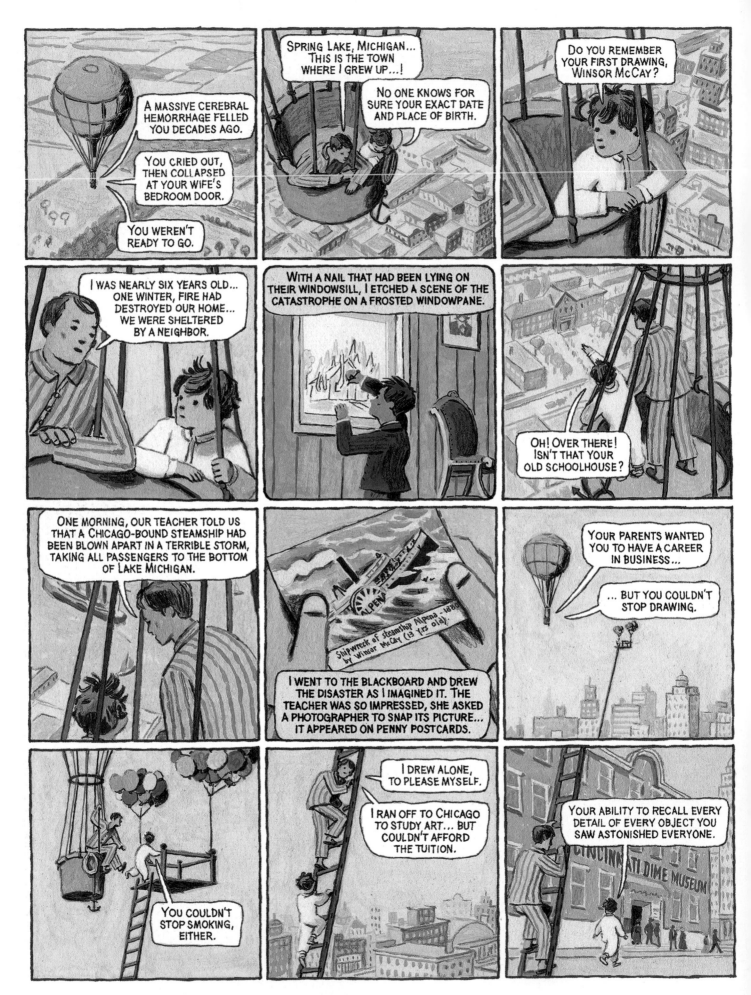

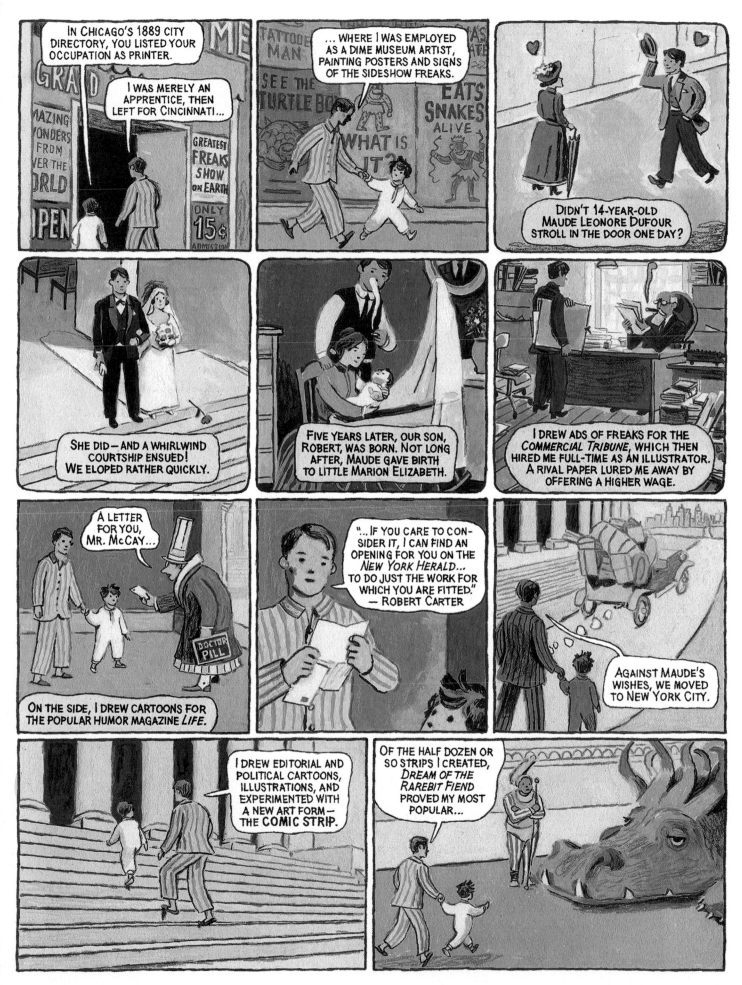

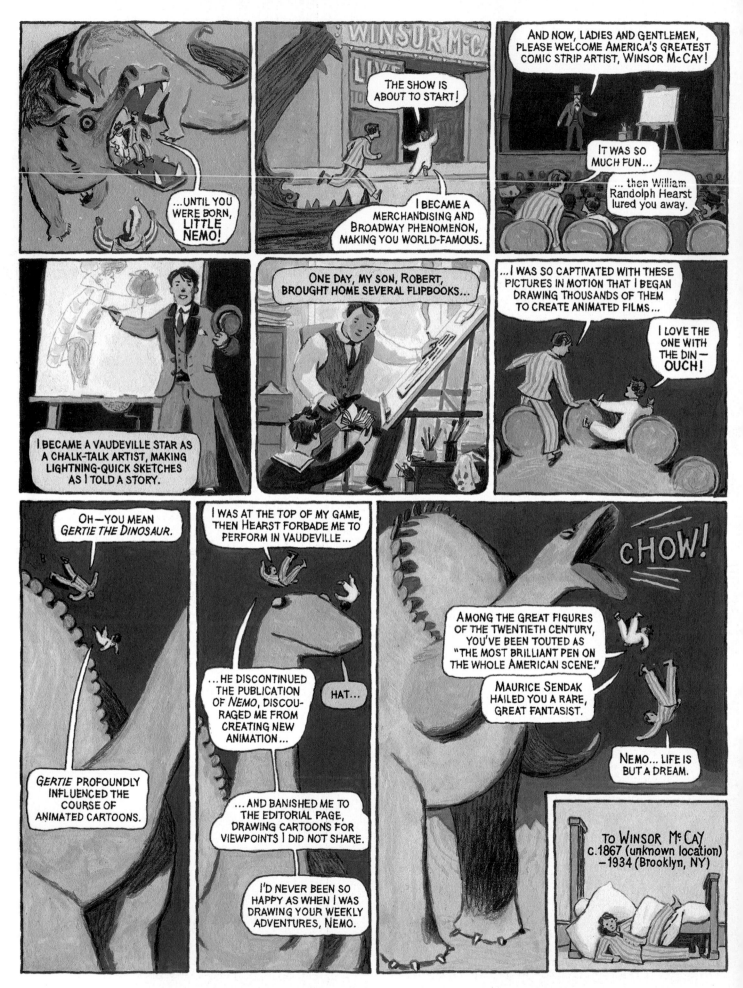

Charles M. Schulz

by Sergio Ruzzier

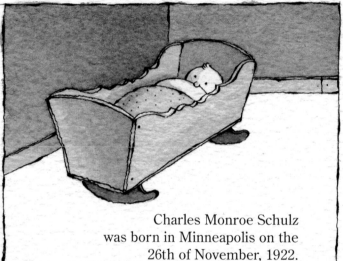

Charles Monroe Schulz
was born in Minneapolis on the
26th of November, 1922.

In 1927, his
father moved
the family across
the river to
St. Paul, where
he owned and
operated a
barber shop.

Sparky, nicknamed after a
racehorse in *Barney Google*,
loved his mother very much.

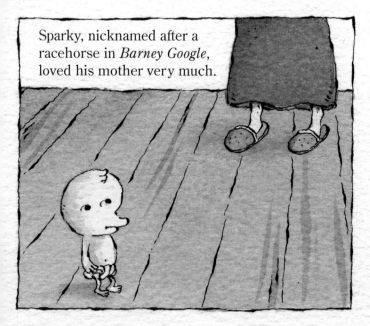

He was an only child, neat and well behaved.

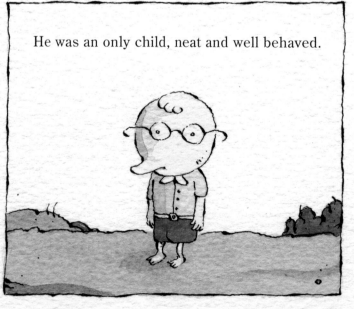

As with most kids in Minnesota, Sparky liked ice skating and hockey, a passion he kept all his life.

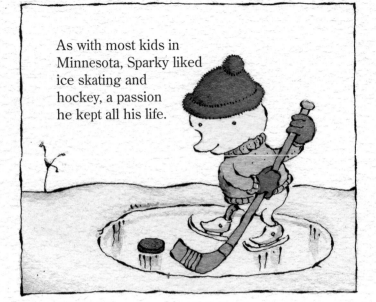

An avid reader of comic strips, he dreamed of becoming a cartoonist as great as *Popeye*'s Segar or *Krazy Kat*'s Herriman.

The young Schulz spent many hours at the dining table, drawing and inking.

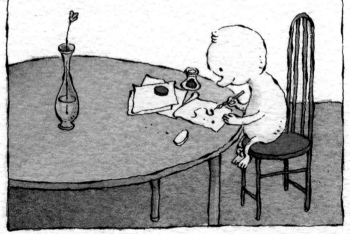

In 1937, a sketch he made of the family dog, Spike, saw print in *Believe It or Not!*, a syndicated comic panel.

It was Sparky's first published drawing.

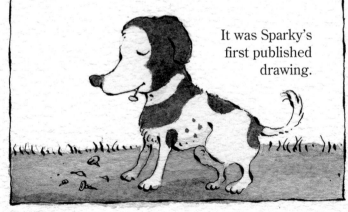

That same year, he entered St. Paul's Central High School.

He felt excluded and rejected.

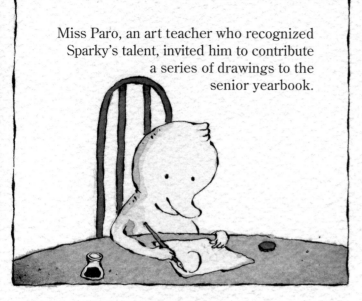

Miss Paro, an art teacher who recognized Sparky's talent, invited him to contribute a series of drawings to the senior yearbook.

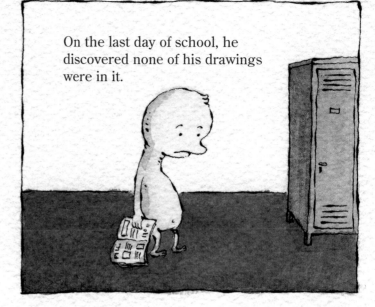

On the last day of school, he discovered none of his drawings were in it.

Meanwhile, his mother was diagnosed with cervical cancer. She spent most of the time in her bedroom, fighting back the pain.

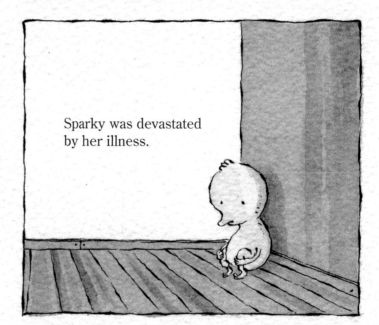

Sparky was devastated by her illness.

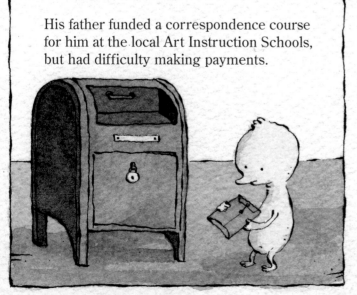

His father funded a correspondence course for him at the local Art Instruction Schools, but had difficulty making payments.

Thanks to these classes, Sparky learned the value of good pen work, and how a line can be expressive.

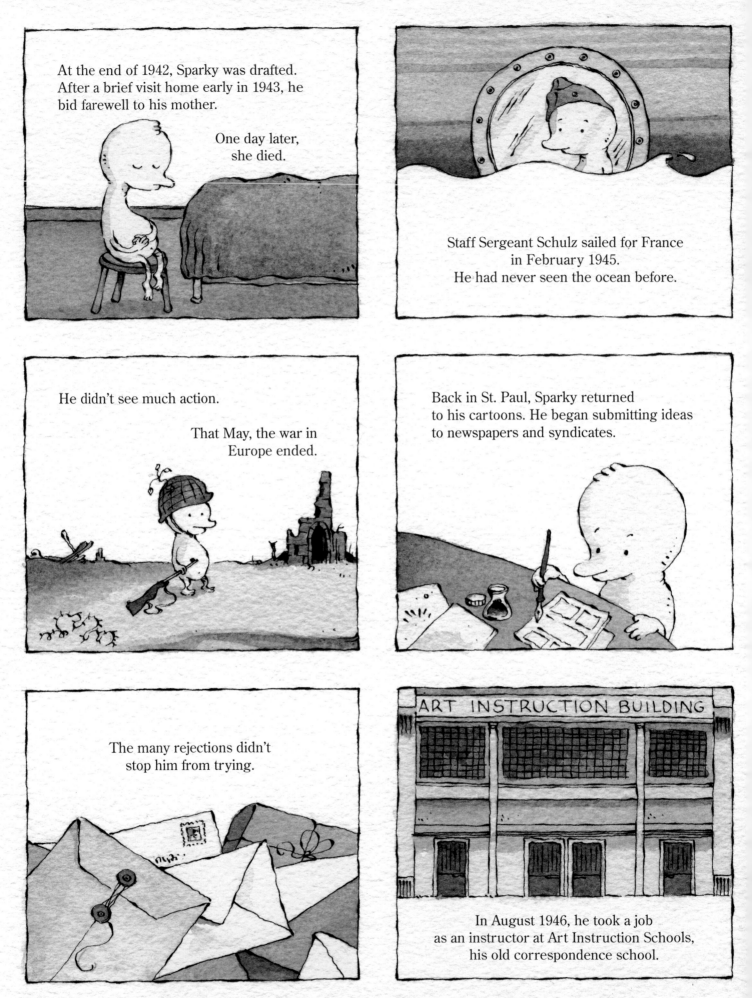

At the end of 1942, Sparky was drafted. After a brief visit home early in 1943, he bid farewell to his mother.

One day later, she died.

Staff Sergeant Schulz sailed for France in February 1945. He had never seen the ocean before.

He didn't see much action.

That May, the war in Europe ended.

Back in St. Paul, Sparky returned to his cartoons. He began submitting ideas to newspapers and syndicates.

The many rejections didn't stop him from trying.

ART INSTRUCTION BUILDING

In August 1946, he took a job as an instructor at Art Instruction Schools, his old correspondence school.

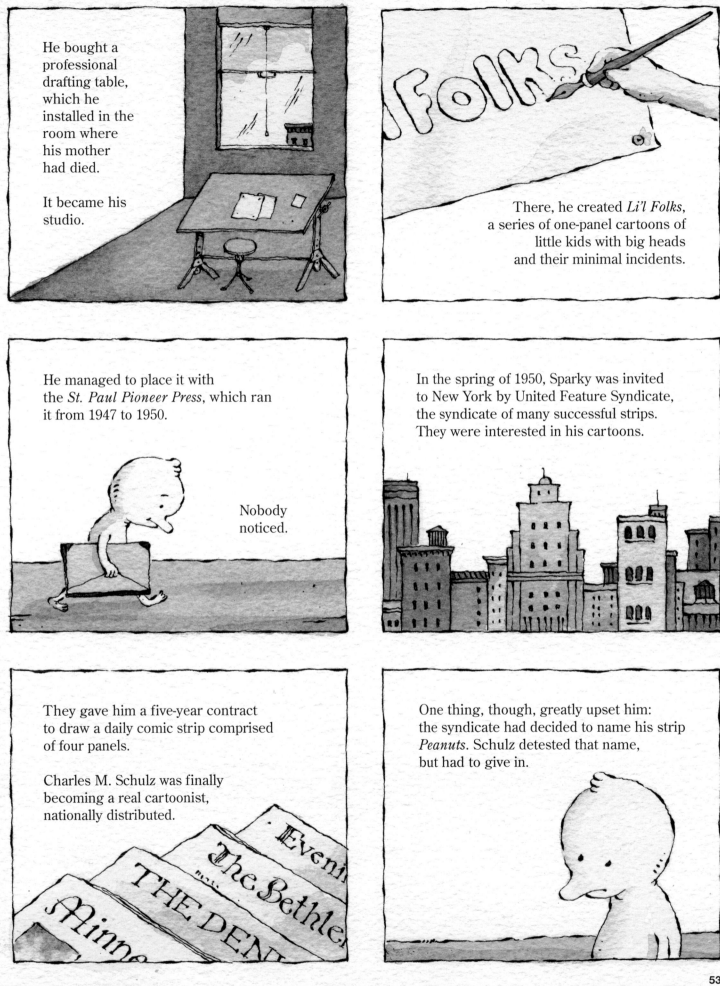

He bought a professional drafting table, which he installed in the room where his mother had died.

It became his studio.

There, he created *Li'l Folks*, a series of one-panel cartoons of little kids with big heads and their minimal incidents.

He managed to place it with the *St. Paul Pioneer Press*, which ran it from 1947 to 1950.

Nobody noticed.

In the spring of 1950, Sparky was invited to New York by United Feature Syndicate, the syndicate of many successful strips. They were interested in his cartoons.

They gave him a five-year contract to draw a daily comic strip comprised of four panels.

Charles M. Schulz was finally becoming a real cartoonist, nationally distributed.

One thing, though, greatly upset him: the syndicate had decided to name his strip *Peanuts*. Schulz detested that name, but had to give in.

The new strip debuted on
October 2, 1950.

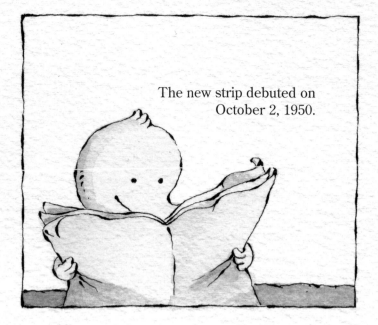

After one year,
only a few newspapers
had taken it on.
Its continuation
was in doubt.

Meanwhile,
Schulz married
Joyce, a divorced
young mother
of a little girl,
Meredith.

In the next few years,
they would have four more children:
Monte, Craig, Amy, and Jill.

Slowly, people began to notice
the small tribulations of Charlie Brown,
his friends, and his dog, Snoopy.
Peanuts was becoming an
international success.

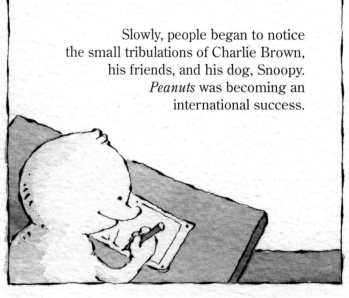

In 1955, Schulz won
a Reuben Award, the first
in a long series of
prestigious recognitions.

He kept drawing his strip every day of the week…

…always searching for the best pen line he could make.

In 1958, the Schulzes moved to California, into a large estate they bought in Sebastopol.

The first *Peanuts* figurines were produced, starting what would quickly become a merchandising empire.

By the late sixties, *Peanuts* was read by tens of millions of people all over the world.

At its peak, the strip was published daily in more than 2,500 papers.

Schulz always wrote and drew each panel himself, never wanting an assistant.

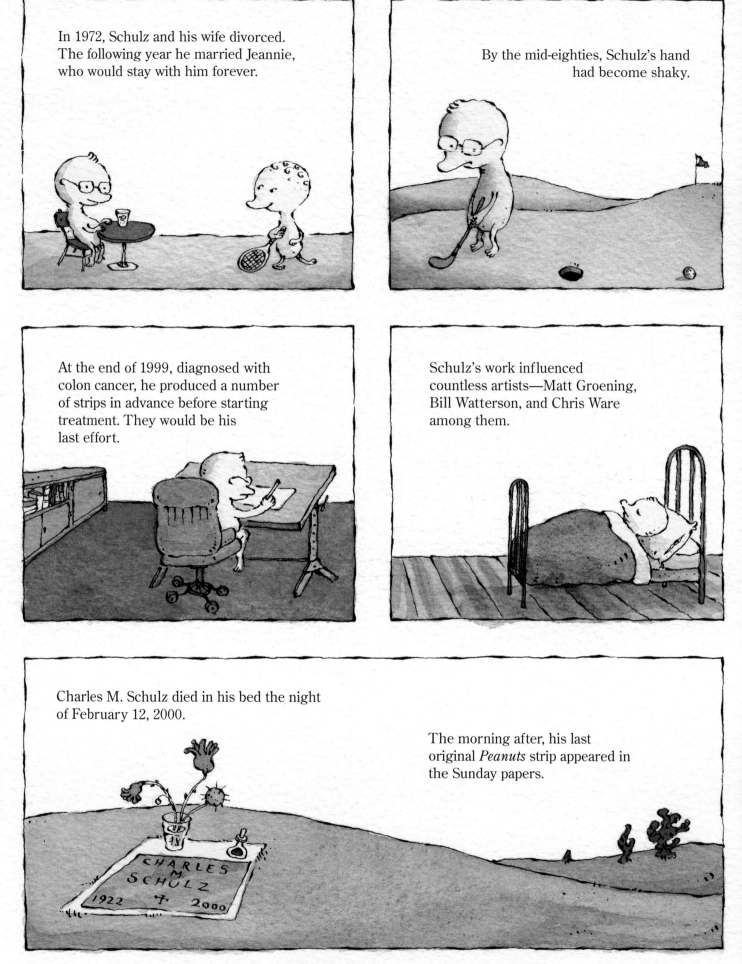

In 1972, Schulz and his wife divorced. The following year he married Jeannie, who would stay with him forever.

By the mid-eighties, Schulz's hand had become shaky.

At the end of 1999, diagnosed with colon cancer, he produced a number of strips in advance before starting treatment. They would be his last effort.

Schulz's work influenced countless artists—Matt Groening, Bill Watterson, and Chris Ware among them.

Charles M. Schulz died in his bed the night of February 12, 2000.

The morning after, his last original *Peanuts* strip appeared in the Sunday papers.

CHARLES M. SCHULZ
1922 † 2000

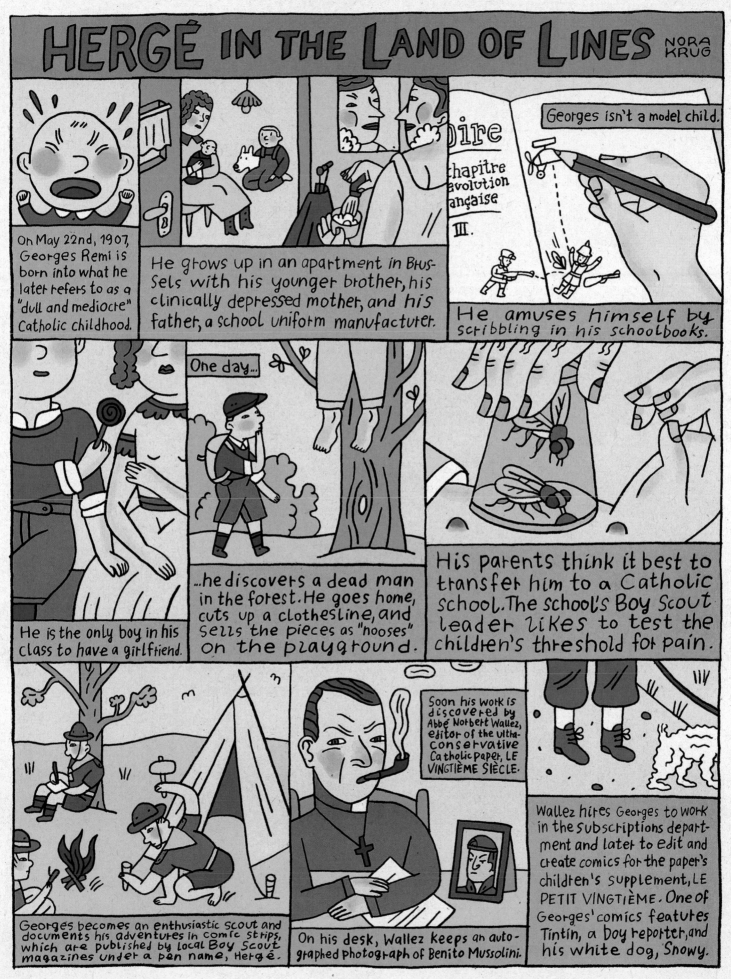

HERGÉ IN THE LAND OF LINES

NORA KRUG

On May 22nd, 1907, Georges Remi is born into what he later refers to as a "dull and mediocre" Catholic childhood.

He grows up in an apartment in Brussels with his younger brother, his clinically depressed mother, and his father, a school uniform manufacturer.

Georges isn't a model child.

He amuses himself by scribbling in his schoolbooks.

He is the only boy in his class to have a girlfriend.

One day... ...he discovers a dead man in the forest. He goes home, cuts up a clothesline, and sells the pieces as "nooses" on the playground.

His parents think it best to transfer him to a Catholic school. The school's Boy Scout leader likes to test the children's threshold for pain.

Georges becomes an enthusiastic scout and documents his adventures in comic strips, which are published by local Boy Scout magazines under a pen name, Hergé.

On his desk, Wallez keeps an autographed photograph of Benito Mussolini.

Soon his work is discovered by Abbé Norbert Wallez, editor of the ultra-conservative Catholic paper, LE VINGTIÈME SIÈCLE.

Wallez hires Georges to work in the subscriptions department and later to edit and create comics for the paper's children's supplement, LE PETIT VINGTIÈME. One of Georges' comics features Tintin, a boy reporter, and his white dog, Snowy.

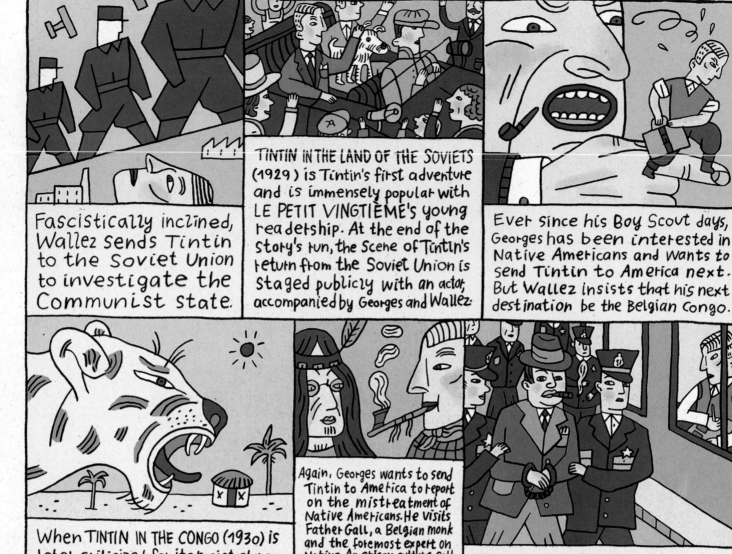

Fascistically inclined, Wallez sends Tintin to the Soviet Union to investigate the Communist state.

TINTIN IN THE LAND OF THE SOVIETS (1929) is Tintin's first adventure and is immensely popular with LE PETIT VINGTIÈME'S young readership. At the end of the story's run, the scene of Tintin's return from the Soviet Union is staged publicly with an actor, accompanied by Georges and Wallez.

Ever since his Boy Scout days, Georges has been interested in Native Americans and wants to send Tintin to America next. But Wallez insists that his next destination be the Belgian Congo.

When TINTIN IN THE CONGO (1930) is later criticized for its racist stereotypes and animal cruelty, Georges blames Belgian colonialist worldviews of the time, and revises the album.

Again, Georges wants to send Tintin to America to report on the mistreatment of Native Americans. He visits Father Gall, a Belgian monk and the foremost expert on Native American culture. Gall lives in a tipi in the Belgian countryside and corresponds with the Sioux tribe in America in their native language. They name him Lonely Sioux.

But Wallez decides that TINTIN IN AMERICA (1931) should focus on the world of crime in Chicago, instead.

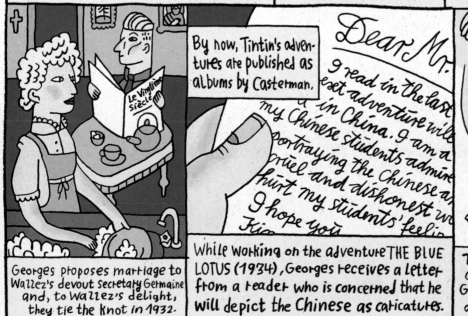

Georges proposes marriage to Wallez's devout secretary Germaine and, to Wallez's delight, they tie the knot in 1932.

While working on the adventure THE BLUE LOTUS (1934), Georges receives a letter from a reader who is concerned that he will depict the Chinese as caricatures.

The worried reader, a Belgian teacher of a group of Chinese students, introduces Georges to Zhang Chongren, an aspiring artist enrolled in the academy in Brussels.

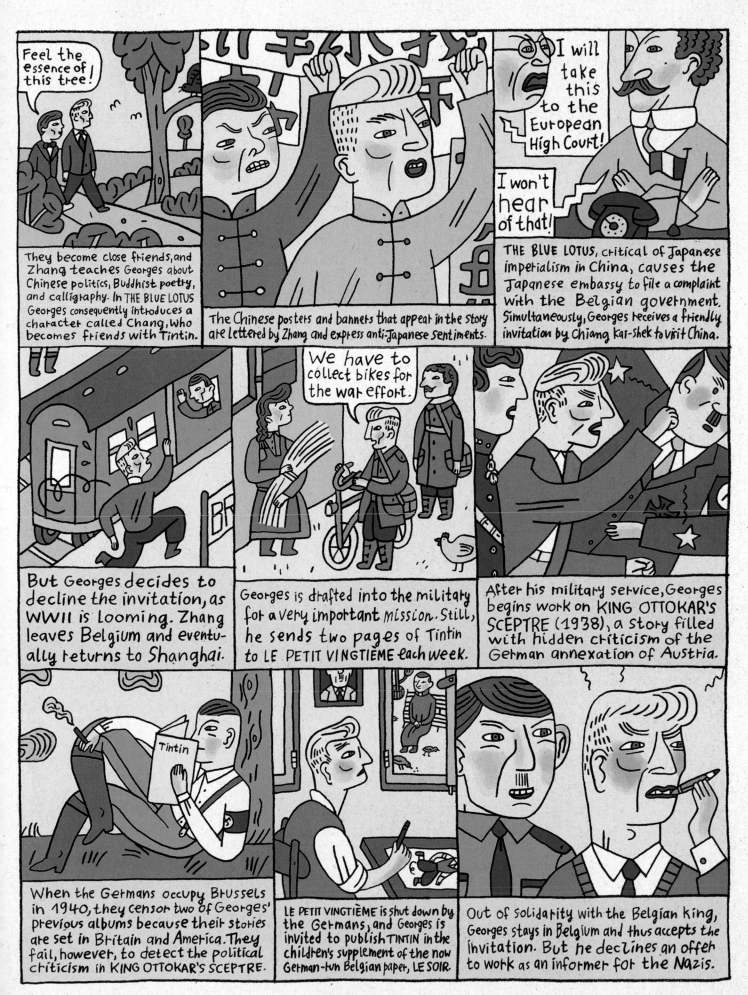

Feel the essence of this tree!

They become close friends, and Zhang teaches Georges about Chinese politics, Buddhist poetry, and calligraphy. In THE BLUE LOTUS Georges consequently introduces a character called Chang, who becomes friends with Tintin.

The Chinese posters and banners that appear in the story are lettered by Zhang and express anti-Japanese sentiments.

I will take this to the European High Court!

I won't hear of that!

THE BLUE LOTUS, critical of Japanese imperialism in China, causes the Japanese embassy to file a complaint with the Belgian government. Simultaneously, Georges receives a friendly invitation by Chiang Kai-shek to visit China.

But Georges decides to decline the invitation, as WWII is looming. Zhang leaves Belgium and eventually returns to Shanghai.

We have to collect bikes for the war effort.

Georges is drafted into the military for a very important mission. Still, he sends two pages of Tintin to LE PETIT VINGTIÈME each week.

After his military service, Georges begins work on KING OTTOKAR'S SCEPTRE (1938), a story filled with hidden criticism of the German annexation of Austria.

Tintin

When the Germans occupy Brussels in 1940, they censor two of Georges' previous albums because their stories are set in Britain and America. They fail, however, to detect the political criticism in KING OTTOKAR'S SCEPTRE.

LE PETIT VINGTIÈME is shut down by the Germans, and Georges is invited to publish TINTIN in the children's supplement of the now German-run Belgian paper, LE SOIR.

Out of solidarity with the Belgian king, Georges stays in Belgium and thus accepts the invitation. But he declines an offer to work as an informer for the Nazis.

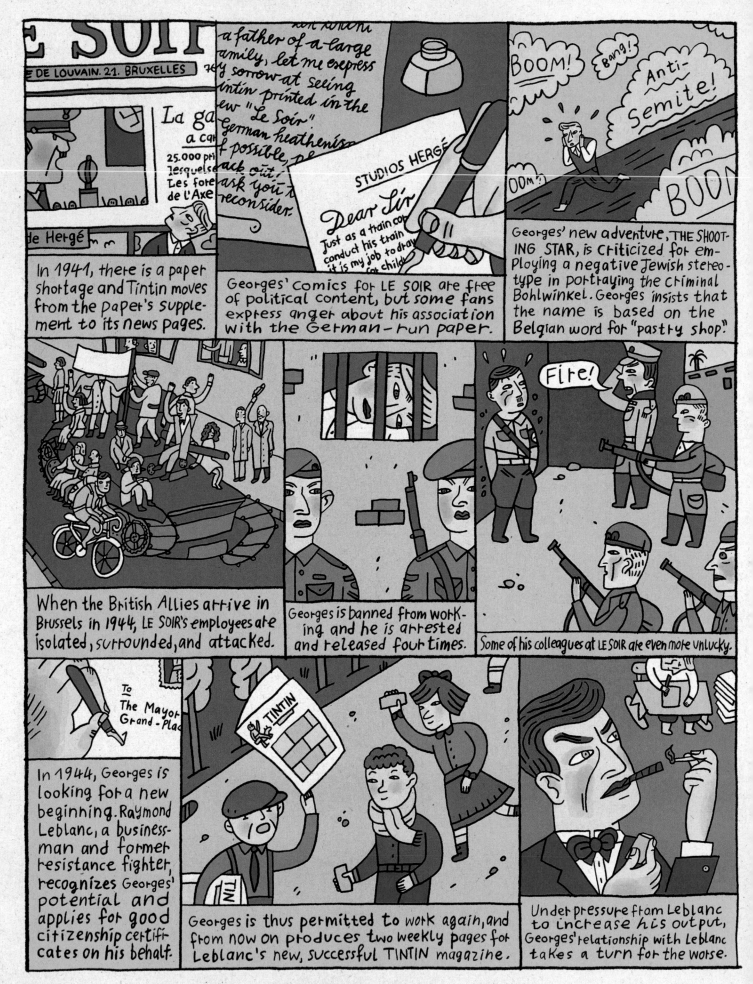

In 1941, there is a paper shortage and Tintin moves from the paper's supplement to its news pages.

Georges' comics for LE SOIR are free of political content, but some fans express anger about his association with the German-run paper.

Georges' new adventure, THE SHOOTING STAR, is criticized for employing a negative Jewish stereotype in portraying the criminal Bohlwinkel. Georges insists that the name is based on the Belgian word for "pastry shop."

When the British Allies arrive in Brussels in 1944, LE SOIR's employees are isolated, surrounded, and attacked.

Georges is banned from working and he is arrested and released four times.

Some of his colleagues at LE SOIR are even more unlucky.

In 1944, Georges is looking for a new beginning. Raymond Leblanc, a businessman and former resistance fighter, recognizes Georges' potential and applies for good citizenship certificates on his behalf.

Georges is thus permitted to work again, and from now on produces two weekly pages for Leblanc's new, successful TINTIN magazine.

Under pressure from Leblanc to increase his output, Georges' relationship with Leblanc takes a turn for the worse.

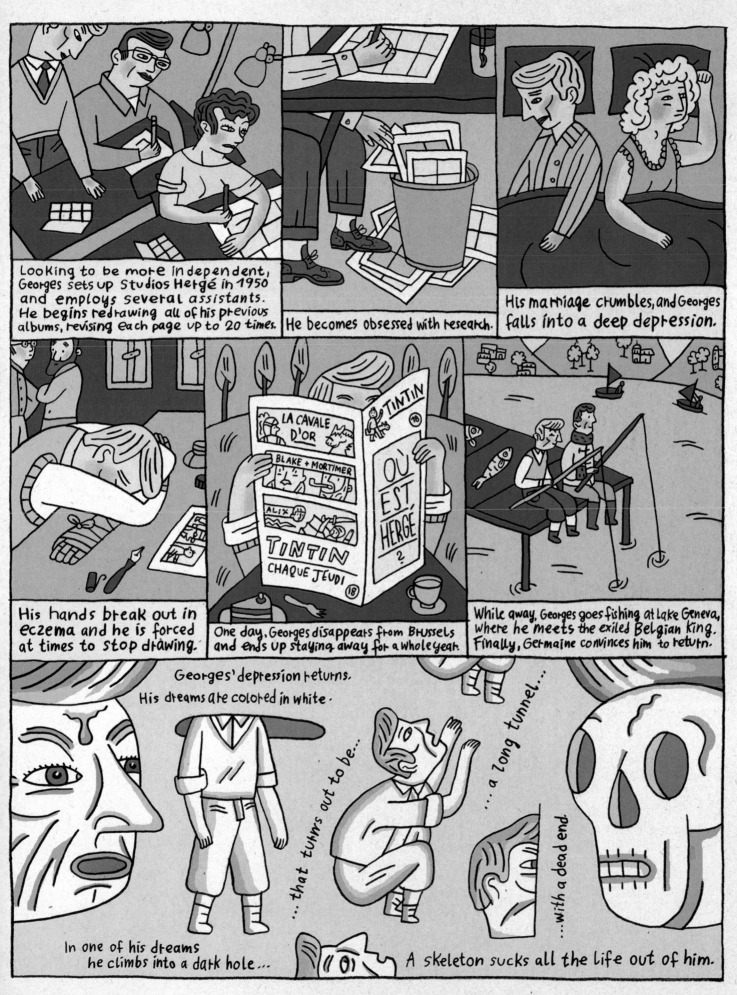

Looking to be more independent, Georges sets up Studios Hergé in 1950 and employs several assistants. He begins redrawing all of his previous albums, revising each page up to 20 times.

He becomes obsessed with research.

His marriage crumbles, and Georges falls into a deep depression.

His hands break out in eczema and he is forced at times to stop drawing.

One day, Georges disappears from Brussels and ends up staying away for a whole year.

While away, Georges goes fishing at Lake Geneva, where he meets the exiled Belgian king. Finally, Germaine convinces him to return.

Georges' depression returns. His dreams are colored in white.

In one of his dreams he climbs into a dark hole... ...that turns out to be... ...a long tunnel... ...with a dead end. A skeleton sucks all the life out of him.

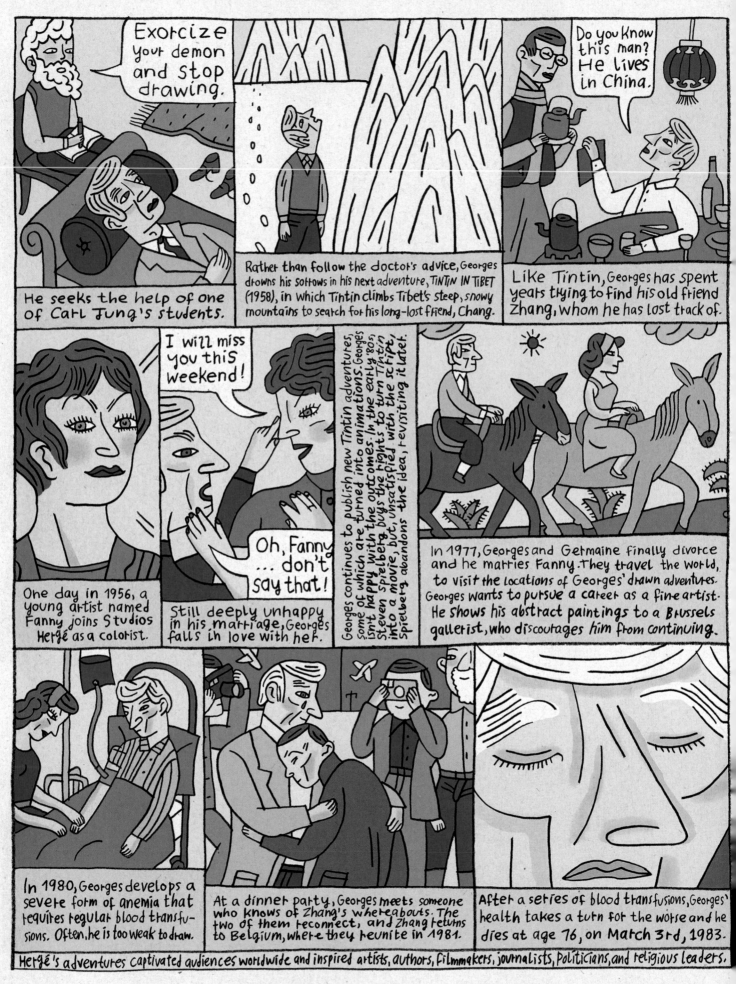

Exorcize your demon and stop drawing.

He seeks the help of one of Carl Jung's students.

Rather than follow the doctor's advice, Georges drowns his sorrows in his next adventure, TINTIN IN TIBET (1958), in which Tintin climbs Tibet's steep, snowy mountains to search for his long-lost friend, Chang.

Do you know this man? He lives in China.

Like Tintin, Georges has spent years trying to find his old friend Zhang, whom he has lost track of.

I will miss you this weekend!

Oh, Fanny... don't say that!

One day in 1956, a young artist named Fanny joins Studios Hergé as a colorist.

Still deeply unhappy in his marriage, Georges falls in love with her.

Georges continues to publish new Tintin adventures, some of which are turned into animations. Georges isn't happy with the outcomes. In the early '80s, Steven Spielberg buys the rights to turn TINTIN into a movie, but, unsatisfied with the script, Spielberg abandons the idea, revisiting it later.

In 1977, Georges and Germaine finally divorce and he marries Fanny. They travel the world, to visit the locations of Georges' drawn adventures. Georges wants to pursue a career as a fine artist. He shows his abstract paintings to a Brussels gallerist, who discourages him from continuing.

In 1980, Georges develops a severe form of anemia that requires regular blood transfusions. Often, he is too weak to draw.

At a dinner party, Georges meets someone who knows of Zhang's whereabouts. The two of them reconnect, and Zhang returns to Belgium, where they reunite in 1981.

After a series of blood transfusions, Georges' health takes a turn for the worse and he dies at age 76, on March 3rd, 1983.

Hergé's adventures captivated audiences worldwide and inspired artists, authors, filmmakers, journalists, politicians, and religious leaders.

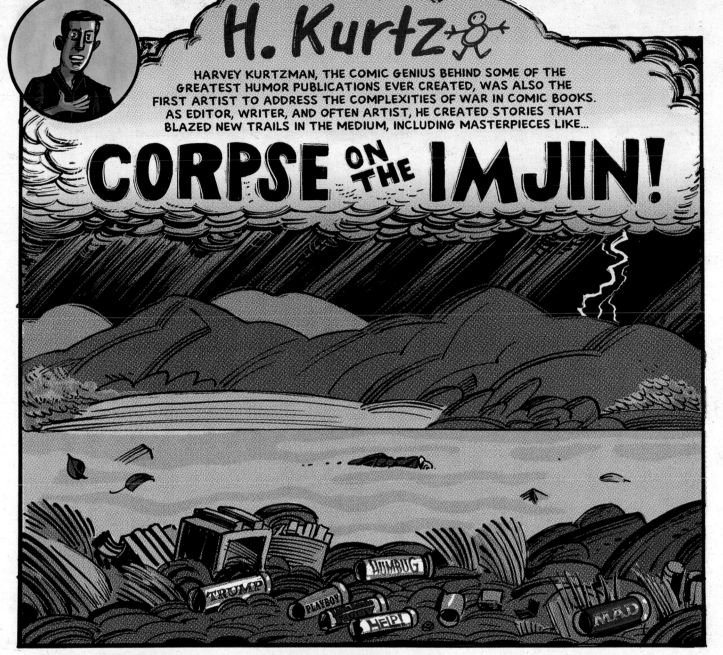

H. Kurtz

HARVEY KURTZMAN, THE COMIC GENIUS BEHIND SOME OF THE GREATEST HUMOR PUBLICATIONS EVER CREATED, WAS ALSO THE FIRST ARTIST TO ADDRESS THE COMPLEXITIES OF WAR IN COMIC BOOKS. AS EDITOR, WRITER, AND OFTEN ARTIST, HE CREATED STORIES THAT BLAZED NEW TRAILS IN THE MEDIUM, INCLUDING MASTERPIECES LIKE...

CORPSE ON THE IMJIN!

THOUGH HE PASSED AWAY IN 1993, KURTZMAN HAS LEFT A LEGACY THAT WILL LIVE ON IN THE LEGIONS HE INFLUENCED.

FROM THE UNDERGROUND COMIX MOVEMENT TO *THE DAILY SHOW*, KURTZMAN'S BRAND OF HUMOR HAS BEEN THE GUIDING LIGHT.

WITHOUT HARVEY KURTZMAN, WE WOULD NOT HAVE...

KUPER

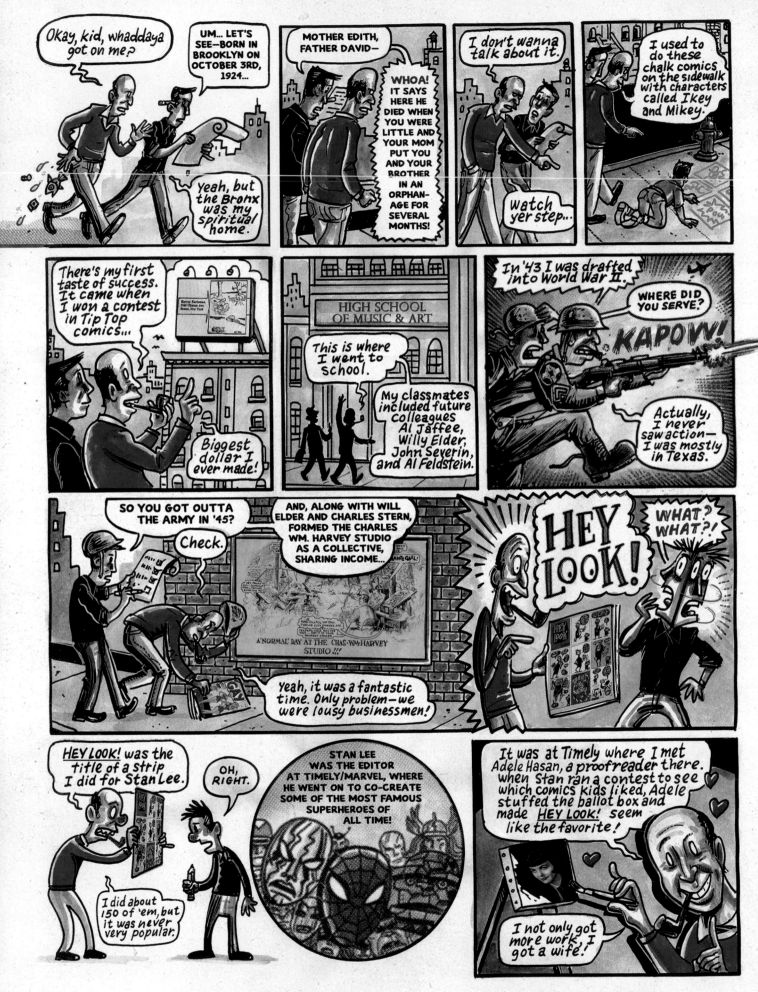

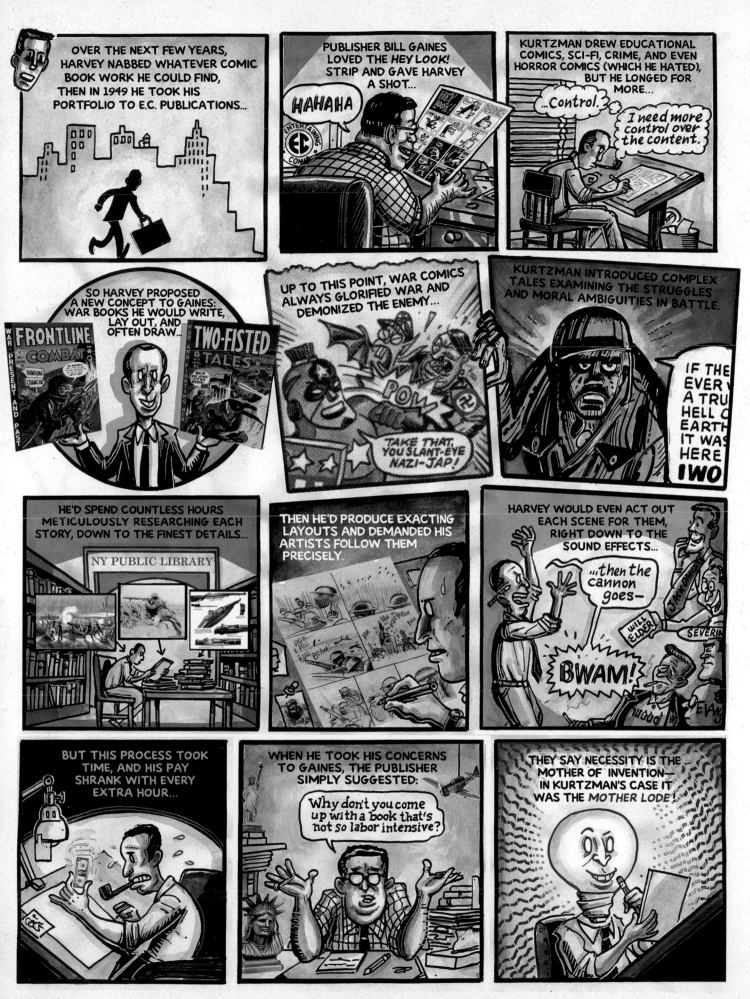

OVER THE NEXT FEW YEARS, HARVEY NABBED WHATEVER COMIC BOOK WORK HE COULD FIND, THEN IN 1949 HE TOOK HIS PORTFOLIO TO E.C. PUBLICATIONS...

PUBLISHER BILL GAINES LOVED THE *HEY LOOK!* STRIP AND GAVE HARVEY A SHOT...

HAHAHA

KURTZMAN DREW EDUCATIONAL COMICS, SCI-FI, CRIME, AND EVEN HORROR COMICS (WHICH HE HATED), BUT HE LONGED FOR MORE...

...Control.

I need more control over the content.

SO HARVEY PROPOSED A NEW CONCEPT TO GAINES: WAR BOOKS HE WOULD WRITE, LAY OUT, AND OFTEN DRAW...

FRONTLINE COMBAT

TWO-FISTED TALES

UP TO THIS POINT, WAR COMICS ALWAYS GLORIFIED WAR AND DEMONIZED THE ENEMY...

POW

TAKE THAT, YOU SLANT-EYE NAZI-JAP!

KURTZMAN INTRODUCED COMPLEX TALES EXAMINING THE STRUGGLES AND MORAL AMBIGUITIES IN BATTLE.

IF THE EVER A TRU HELL EARTH IT WAS HERE

IWO

HE'D SPEND COUNTLESS HOURS METICULOUSLY RESEARCHING EACH STORY, DOWN TO THE FINEST DETAILS...

NY PUBLIC LIBRARY

THEN HE'D PRODUCE EXACTING LAYOUTS AND DEMANDED HIS ARTISTS FOLLOW THEM PRECISELY.

HARVEY WOULD EVEN ACT OUT EACH SCENE FOR THEM, RIGHT DOWN TO THE SOUND EFFECTS...

...then the cannon goes—

BWAM!

WILL ELDER

JACK DAVIS

SEVERIN

WOOD

EVANS

BUT THIS PROCESS TOOK TIME, AND HIS PAY SHRANK WITH EVERY EXTRA HOUR...

WHEN HE TOOK HIS CONCERNS TO GAINES, THE PUBLISHER SIMPLY SUGGESTED:

Why don't you come up with a book that's not so labor intensive?

THEY SAY NECESSITY IS THE MOTHER OF INVENTION— IN KURTZMAN'S CASE IT WAS THE *MOTHER LODE!*

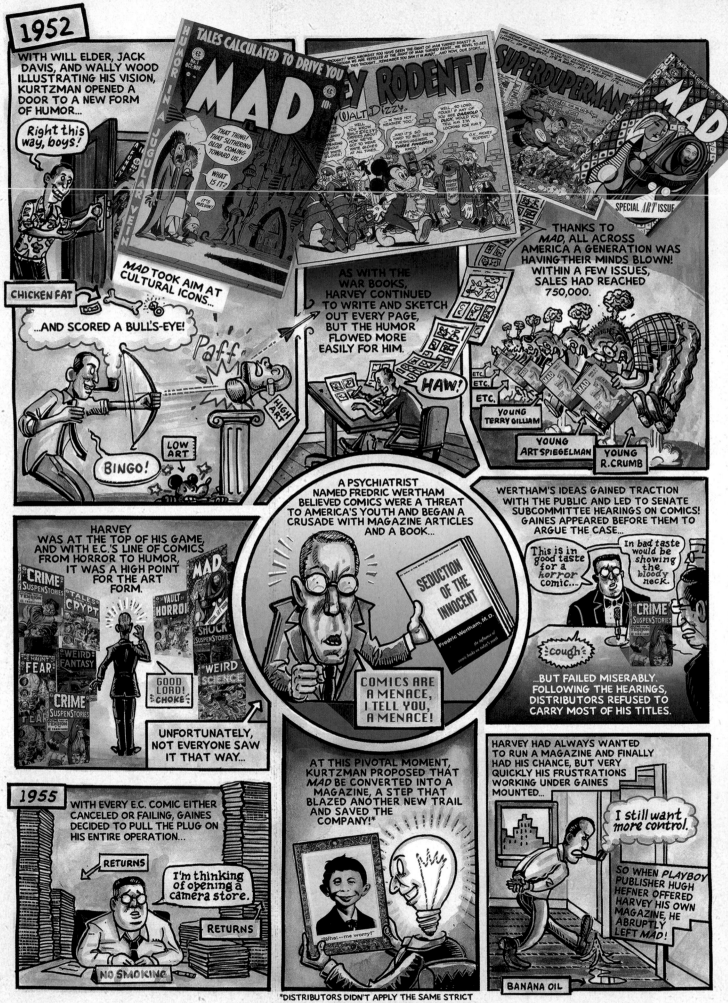

1952

WITH WILL ELDER, JACK DAVIS, AND WALLY WOOD ILLUSTRATING HIS VISION, KURTZMAN OPENED A DOOR TO A NEW FORM OF HUMOR...

Right this way, boys!

MAD TOOK AIM AT CULTURAL ICONS...

CHICKEN FAT

...AND SCORED A BULL'S-EYE!

BINGO!

HIGH ART

LOW ART

AS WITH THE WAR BOOKS, HARVEY CONTINUED TO WRITE AND SKETCH OUT EVERY PAGE, BUT THE HUMOR FLOWED MORE EASILY FOR HIM.

HAW!

THANKS TO MAD, ALL ACROSS AMERICA A GENERATION WAS HAVING THEIR MINDS BLOWN! WITHIN A FEW ISSUES, SALES HAD REACHED 750,000.

ETC.
ETC.
ETC.

YOUNG TERRY GILLIAM

YOUNG ART SPIEGELMAN

YOUNG R. CRUMB

HARVEY WAS AT THE TOP OF HIS GAME, AND WITH E.C.'S LINE OF COMICS FROM HORROR TO HUMOR, IT WAS A HIGH POINT FOR THE ART FORM.

GOOD LORD! CHOKE!

UNFORTUNATELY, NOT EVERYONE SAW IT THAT WAY...

A PSYCHIATRIST NAMED FREDRIC WERTHAM BELIEVED COMICS WERE A THREAT TO AMERICA'S YOUTH AND BEGAN A CRUSADE WITH MAGAZINE ARTICLES AND A BOOK...

SEDUCTION OF THE INNOCENT

Fredric Wertham, M.D.

COMICS ARE A MENACE, I TELL YOU, A MENACE!

WERTHAM'S IDEAS GAINED TRACTION WITH THE PUBLIC AND LED TO SENATE SUBCOMMITTEE HEARINGS ON COMICS! GAINES APPEARED BEFORE THEM TO ARGUE THE CASE...

This is in good taste for a horror comic...

In bad taste would be showing the bloody neck.

cough

...BUT FAILED MISERABLY. FOLLOWING THE HEARINGS, DISTRIBUTORS REFUSED TO CARRY MOST OF HIS TITLES.

1955

WITH EVERY E.C. COMIC EITHER CANCELED OR FAILING, GAINES DECIDED TO PULL THE PLUG ON HIS ENTIRE OPERATION...

RETURNS

I'm thinking of opening a camera store.

RETURNS

NO SMOKING

AT THIS PIVOTAL MOMENT, KURTZMAN PROPOSED THAT MAD BE CONVERTED INTO A MAGAZINE, A STEP THAT BLAZED ANOTHER NEW TRAIL AND SAVED THE COMPANY!*

HARVEY HAD ALWAYS WANTED TO RUN A MAGAZINE AND FINALLY HAD HIS CHANCE, BUT VERY QUICKLY HIS FRUSTRATIONS WORKING UNDER GAINES MOUNTED...

I still want more control.

SO WHEN PLAYBOY PUBLISHER HUGH HEFNER OFFERED HARVEY HIS OWN MAGAZINE, HE ABRUPTLY LEFT MAD!

BANANA OIL

*DISTRIBUTORS DIDN'T APPLY THE SAME STRICT RULES TO MAGAZINES AS THEY DID TO COMICS.

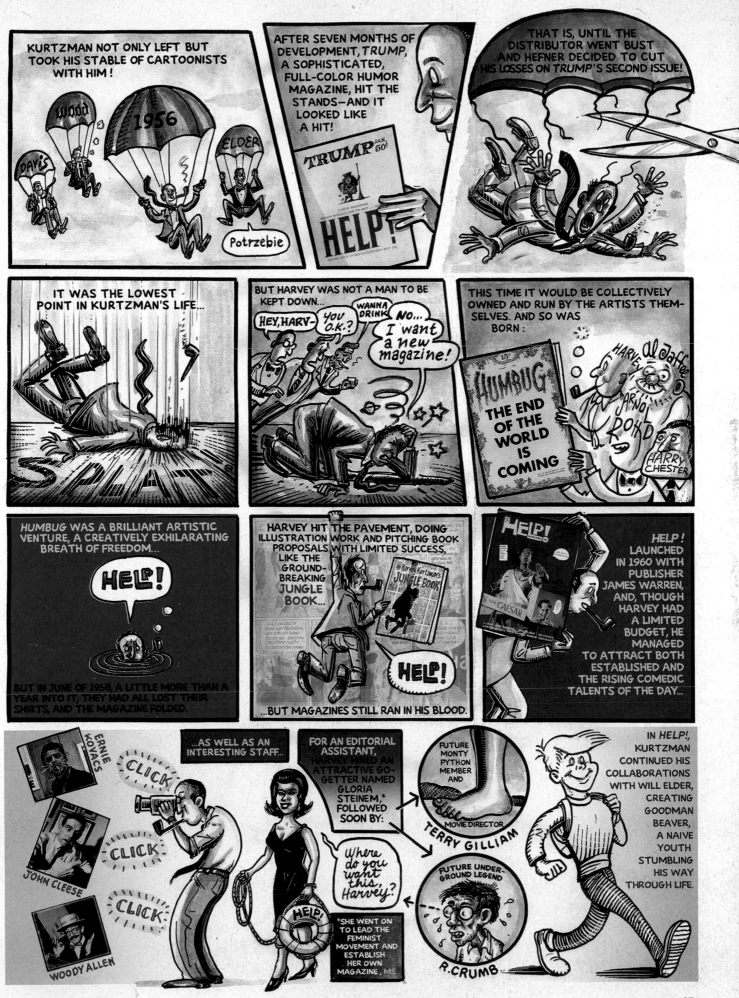

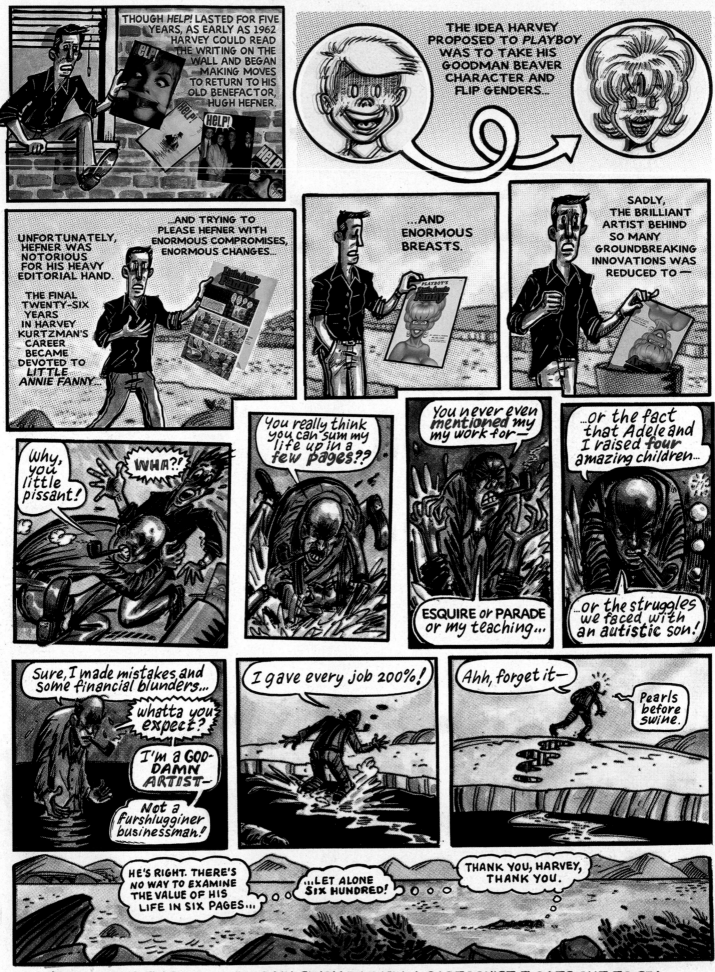

AS LIGHTNING FLASHES ON THE RAIN-SWOLLEN IMJIN, A CARTOONIST FLOATS OUT TO SEA.

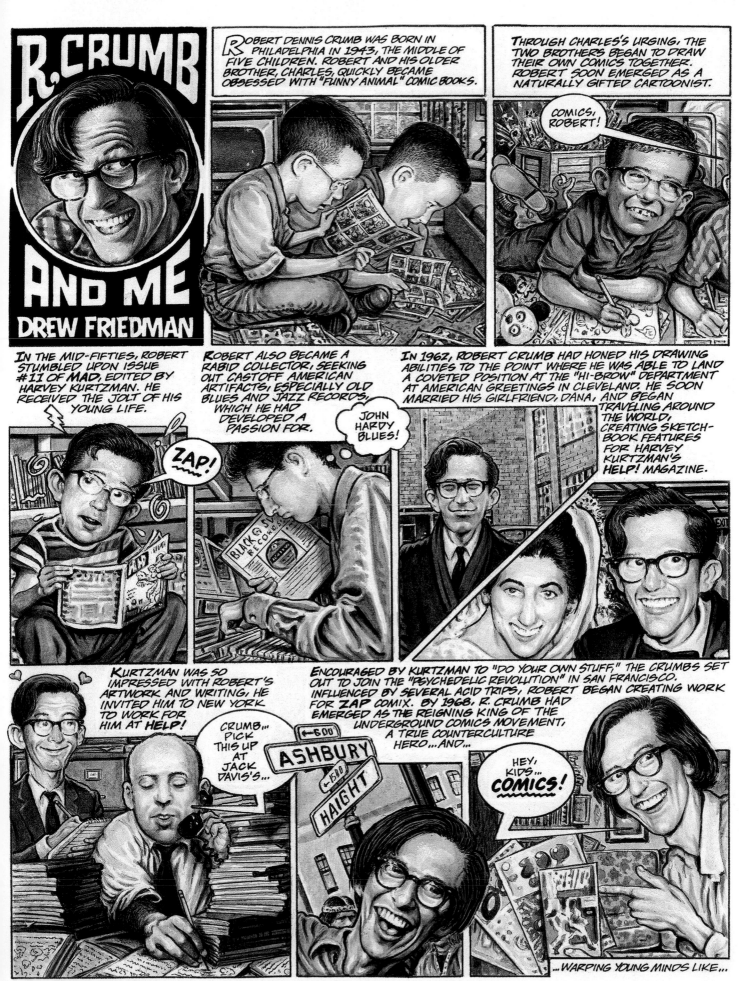

R. CRUMB AND ME

DREW FRIEDMAN

ROBERT DENNIS CRUMB WAS BORN IN PHILADELPHIA IN 1943, THE MIDDLE OF FIVE CHILDREN. ROBERT AND HIS OLDER BROTHER, CHARLES, QUICKLY BECAME OBSESSED WITH "FUNNY ANIMAL" COMIC BOOKS.

THROUGH CHARLES'S URGING, THE TWO BROTHERS BEGAN TO DRAW THEIR OWN COMICS TOGETHER. ROBERT SOON EMERGED AS A NATURALLY GIFTED CARTOONIST.

COMICS, ROBERT!

IN THE MID-FIFTIES, ROBERT STUMBLED UPON ISSUE #11 OF MAD, EDITED BY HARVEY KURTZMAN. HE RECEIVED THE JOLT OF HIS YOUNG LIFE.

ZAP!

ROBERT ALSO BECAME A RABID COLLECTOR, SEEKING OUT CASTOFF AMERICAN ARTIFACTS, ESPECIALLY OLD BLUES AND JAZZ RECORDS, WHICH HE HAD DEVELOPED A PASSION FOR.

JOHN HARDY BLUES!

IN 1962, ROBERT CRUMB HAD HONED HIS DRAWING ABILITIES TO THE POINT WHERE HE WAS ABLE TO LAND A COVETED POSITION AT THE "HI-BROW" DEPARTMENT AT AMERICAN GREETINGS IN CLEVELAND. HE SOON MARRIED HIS GIRLFRIEND, DANA, AND BEGAN TRAVELING AROUND THE WORLD, CREATING SKETCHBOOK FEATURES FOR HARVEY KURTZMAN'S HELP! MAGAZINE.

KURTZMAN WAS SO IMPRESSED WITH ROBERT'S ARTWORK AND WRITING, HE INVITED HIM TO NEW YORK TO WORK FOR HIM AT HELP!

CRUMB... PICK THIS UP AT JACK DAVIS'S...

ASHBURY ← 600
HAIGHT 600

ENCOURAGED BY KURTZMAN TO "DO YOUR OWN STUFF," THE CRUMBS SET OUT TO JOIN THE "PSYCHEDELIC REVOLUTION" IN SAN FRANCISCO. INFLUENCED BY SEVERAL ACID TRIPS, ROBERT BEGAN CREATING WORK FOR ZAP COMIX. BY 1968, R. CRUMB HAD EMERGED AS THE REIGNING KING OF THE UNDERGROUND COMICS MOVEMENT, A TRUE COUNTERCULTURE HERO...AND...

HEY, KIDS... COMICS!

...WARPING YOUNG MINDS LIKE...

LETTERING BY PHIL FELIX

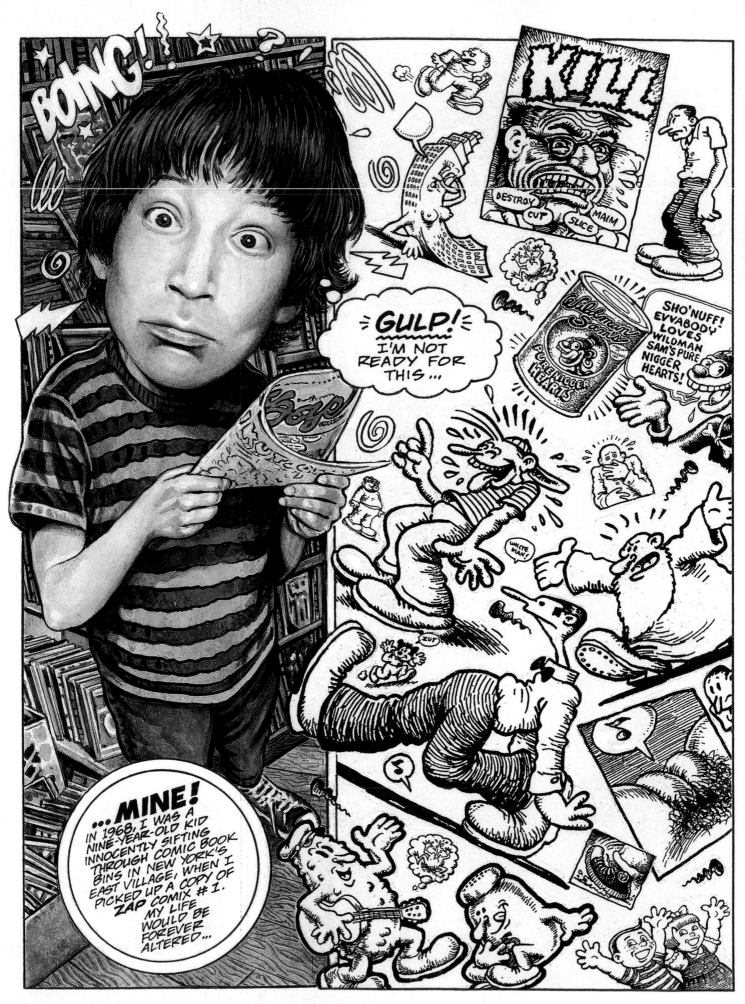

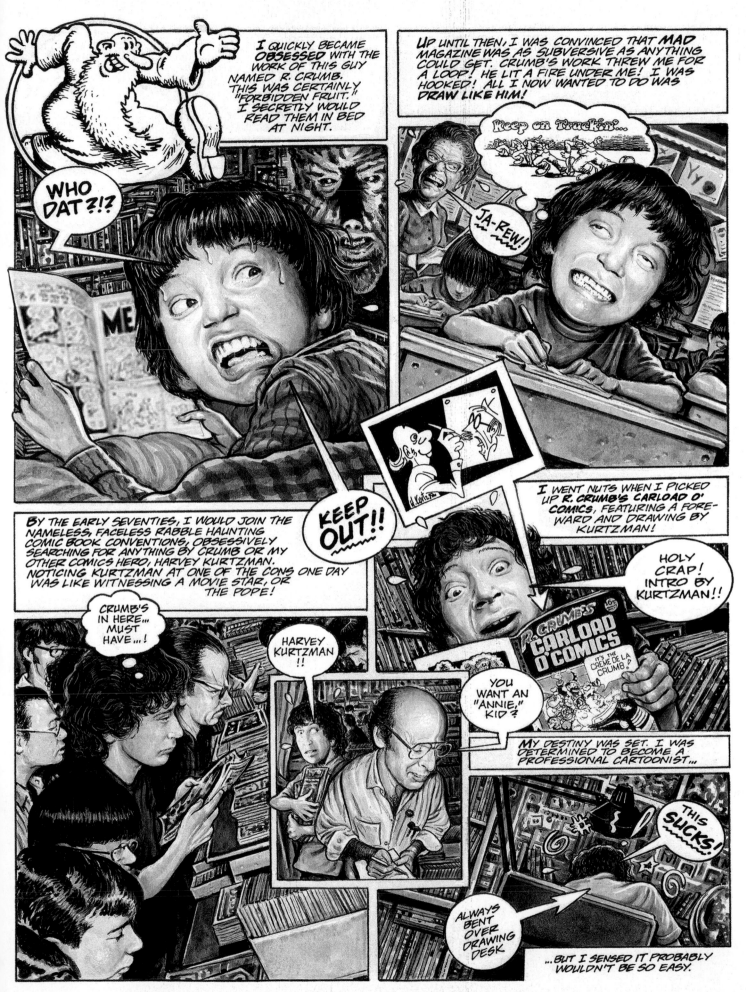

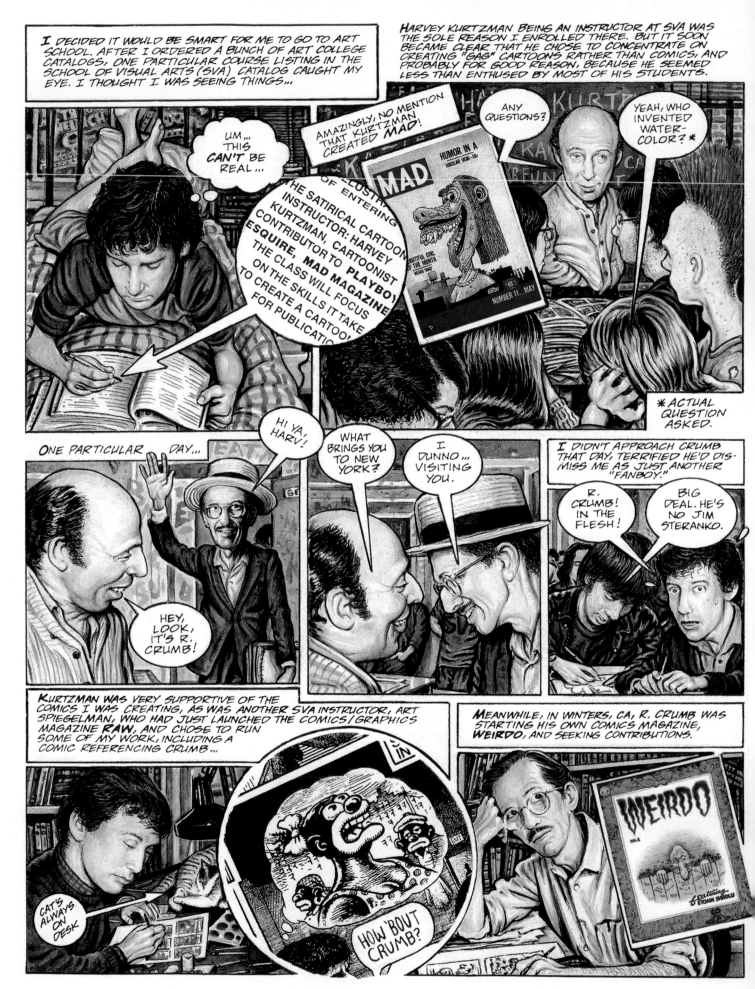

I DECIDED IT WOULD BE SMART FOR ME TO GO TO ART SCHOOL. AFTER I ORDERED A BUNCH OF ART COLLEGE CATALOGS, ONE PARTICULAR COURSE LISTING IN THE SCHOOL OF VISUAL ARTS (SVA) CATALOG CAUGHT MY EYE. I THOUGHT I WAS SEEING THINGS...

HARVEY KURTZMAN BEING AN INSTRUCTOR AT SVA WAS THE SOLE REASON I ENROLLED THERE. BUT IT SOON BECAME CLEAR THAT HE CHOSE TO CONCENTRATE ON CREATING "GAG" CARTOONS RATHER THAN COMICS, AND PROBABLY FOR GOOD REASON, BECAUSE HE SEEMED LESS THAN ENTHUSED BY MOST OF HIS STUDENTS.

UM... THIS *CAN'T* BE REAL...

AMAZINGLY, NO MENTION THAT KURTZMAN CREATED *MAD*!

...HE SATIRICAL CARTOON INSTRUCTOR: HARVEY KURTZMAN, CARTOONIST CONTRIBUTOR TO *PLAYBOY*, *ESQUIRE*, **MAD MAGAZINE**... THE CLASS WILL FOCUS ON THE SKILLS IT TAKE... TO CREATE A CARTOO... FOR PUBLICATIO...

HUMOR IN A JUGULAR VEIN—10¢
MAD
BEAUTIFUL GIRL OF THE MONTH HEADS MAD
NUMBER 11...MAY

ANY QUESTIONS?

YEAH, WHO INVENTED WATER-COLOR?*

* ACTUAL QUESTION ASKED.

ONE PARTICULAR DAY...

HI YA, HARV!

HEY, LOOK, IT'S R. CRUMB!

WHAT BRINGS YOU TO NEW YORK?

I DUNNO... VISITING YOU.

I DIDN'T APPROACH CRUMB THAT DAY, TERRIFIED HE'D DIS-MISS ME AS JUST ANOTHER "FANBOY."

R. CRUMB! IN THE FLESH!

BIG DEAL. HE'S NO JIM STERANKO.

KURTZMAN WAS VERY SUPPORTIVE OF THE COMICS I WAS CREATING, AS WAS ANOTHER SVA INSTRUCTOR, ART SPIEGELMAN, WHO HAD JUST LAUNCHED THE COMICS/GRAPHICS MAGAZINE **RAW**, AND CHOSE TO RUN SOME OF MY WORK, INCLUDING A COMIC REFERENCING CRUMB...

CAT'S ALWAYS ON DESK

HOW 'BOUT CRUMB?

MEANWHILE, IN WINTERS, CA, R. CRUMB WAS STARTING HIS OWN COMICS MAGAZINE, **WEIRDO**, AND SEEKING CONTRIBUTIONS.

WEIRDO
NO. 1

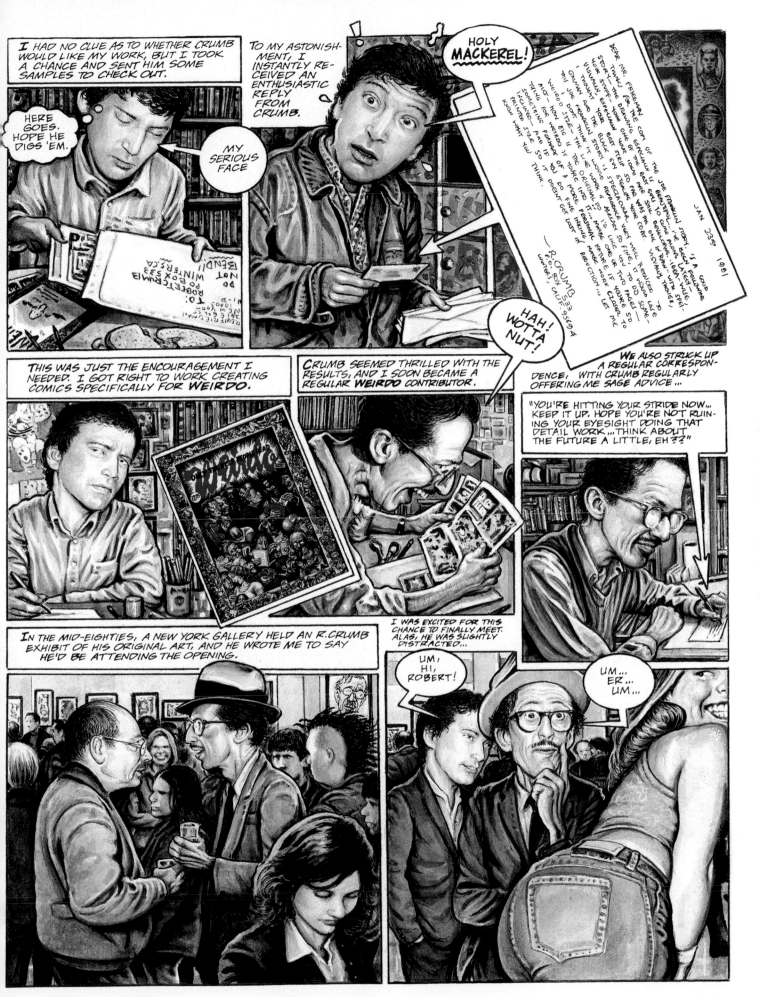

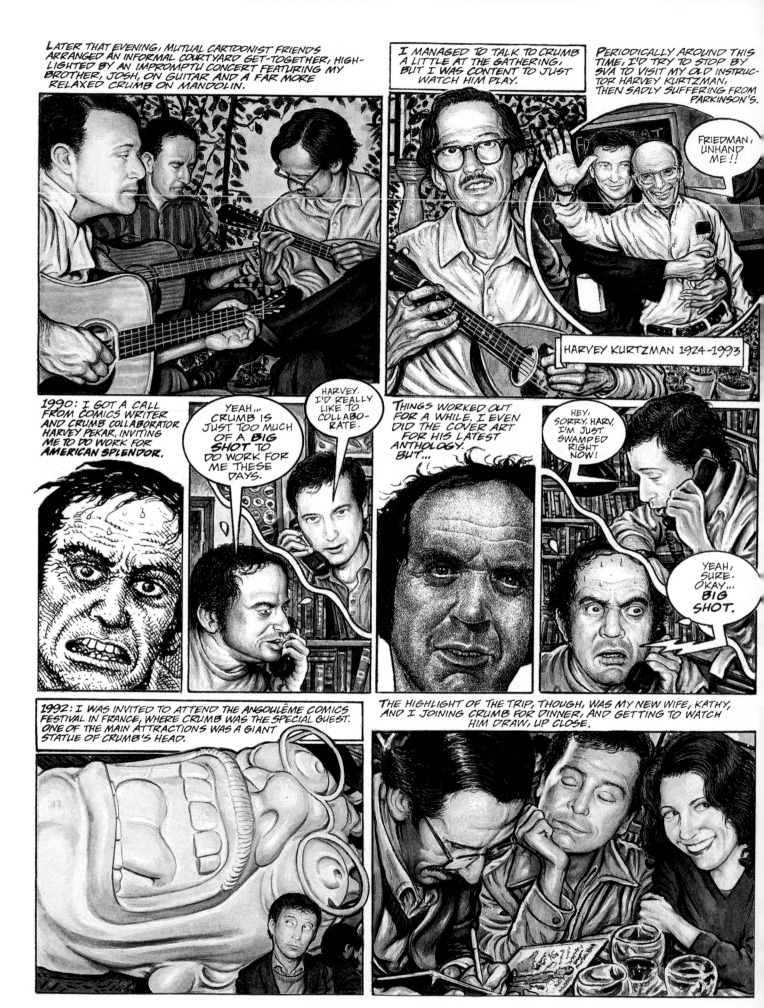

LATER THAT EVENING, MUTUAL CARTOONIST FRIENDS ARRANGED AN INFORMAL COURTYARD GET-TOGETHER, HIGHLIGHTED BY AN IMPROMPTU CONCERT FEATURING MY BROTHER, JOSH, ON GUITAR AND A FAR MORE RELAXED CRUMB ON MANDOLIN.

I MANAGED TO TALK TO CRUMB A LITTLE AT THE GATHERING, BUT I WAS CONTENT TO JUST WATCH HIM PLAY.

PERIODICALLY AROUND THIS TIME, I'D TRY TO STOP BY SVA TO VISIT MY OLD INSTRUCTOR HARVEY KURTZMAN, THEN SADLY SUFFERING FROM PARKINSON'S.

FRIEDMAN, UNHAND ME!!

HARVEY KURTZMAN 1924-1993

1990: I GOT A CALL FROM COMICS WRITER AND CRUMB COLLABORATOR HARVEY PEKAR, INVITING ME TO DO WORK FOR AMERICAN SPLENDOR.

YEAH... CRUMB IS JUST TOO MUCH OF A BIG SHOT TO DO WORK FOR ME THESE DAYS.

HARVEY, I'D REALLY LIKE TO COLLABORATE.

THINGS WORKED OUT FOR A WHILE. I EVEN DID THE COVER ART FOR HIS LATEST ANTHOLOGY. BUT...

HEY, SORRY, HARV, I'M JUST SWAMPED RIGHT NOW!

YEAH, SURE. OKAY... BIG SHOT.

1992: I WAS INVITED TO ATTEND THE ANGOULÊME COMICS FESTIVAL IN FRANCE, WHERE CRUMB WAS THE SPECIAL GUEST. ONE OF THE MAIN ATTRACTIONS WAS A GIANT STATUE OF CRUMB'S HEAD.

THE HIGHLIGHT OF THE TRIP, THOUGH, WAS MY NEW WIFE, KATHY, AND I JOINING CRUMB FOR DINNER, AND GETTING TO WATCH HIM DRAW, UP CLOSE.

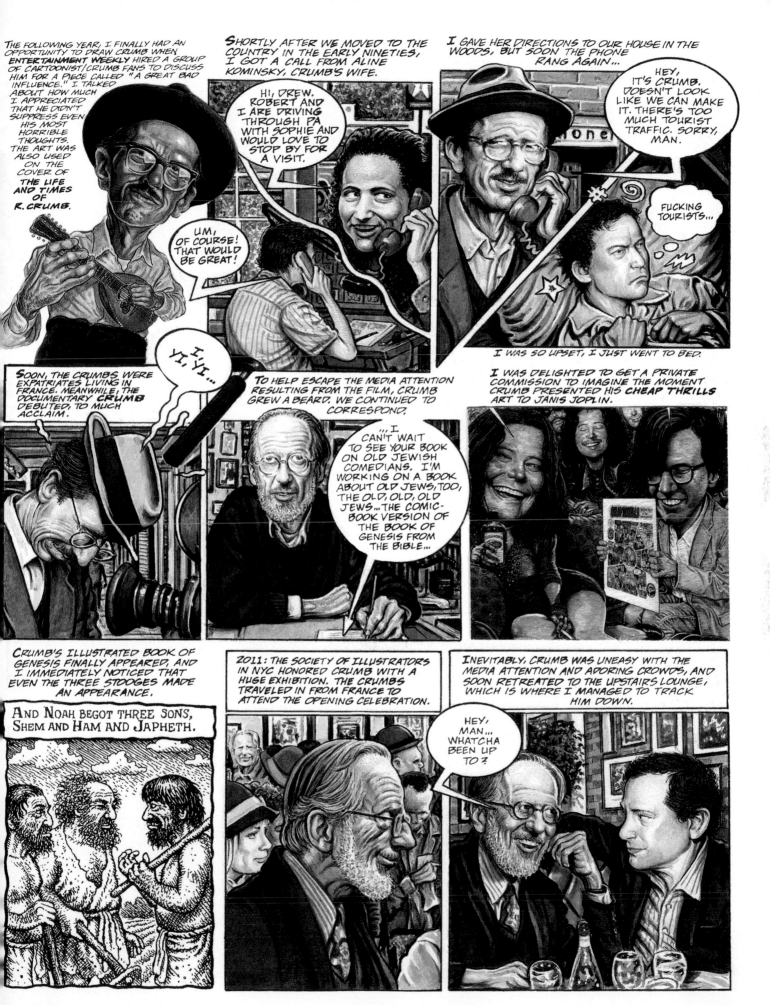

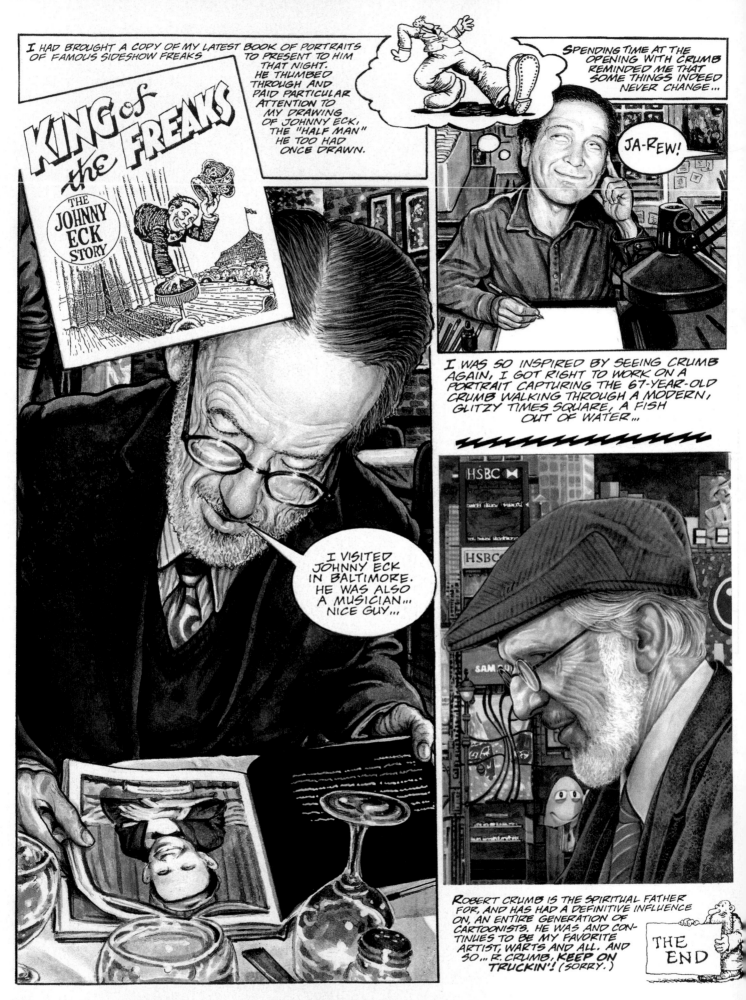

I HAD BROUGHT A COPY OF MY LATEST BOOK OF PORTRAITS OF FAMOUS SIDESHOW FREAKS TO PRESENT TO HIM THAT NIGHT. HE THUMBED THROUGH AND PAID PARTICULAR ATTENTION TO MY DRAWING OF JOHNNY ECK, THE "HALF MAN" HE TOO HAD ONCE DRAWN.

KING of the FREAKS

THE JOHNNY ECK STORY

I VISITED JOHNNY ECK IN BALTIMORE. HE WAS ALSO A MUSICIAN... NICE GUY...

SPENDING TIME AT THE OPENING WITH CRUMB REMINDED ME THAT SOME THINGS INDEED NEVER CHANGE...

JA-REW!

I WAS SO INSPIRED BY SEEING CRUMB AGAIN, I GOT RIGHT TO WORK ON A PORTRAIT CAPTURING THE 67-YEAR-OLD CRUMB WALKING THROUGH A MODERN, GLITZY TIMES SQUARE, A FISH OUT OF WATER...

HSBC

HSBC

ROBERT CRUMB IS THE SPIRITUAL FATHER FOR, AND HAS HAD A DEFINITIVE INFLUENCE ON, AN ENTIRE GENERATION OF CARTOONISTS. HE WAS AND CONTINUES TO BE MY FAVORITE ARTIST, WARTS AND ALL. AND SO... R. CRUMB, *KEEP ON TRUCKIN'!* (SORRY.)

THE END

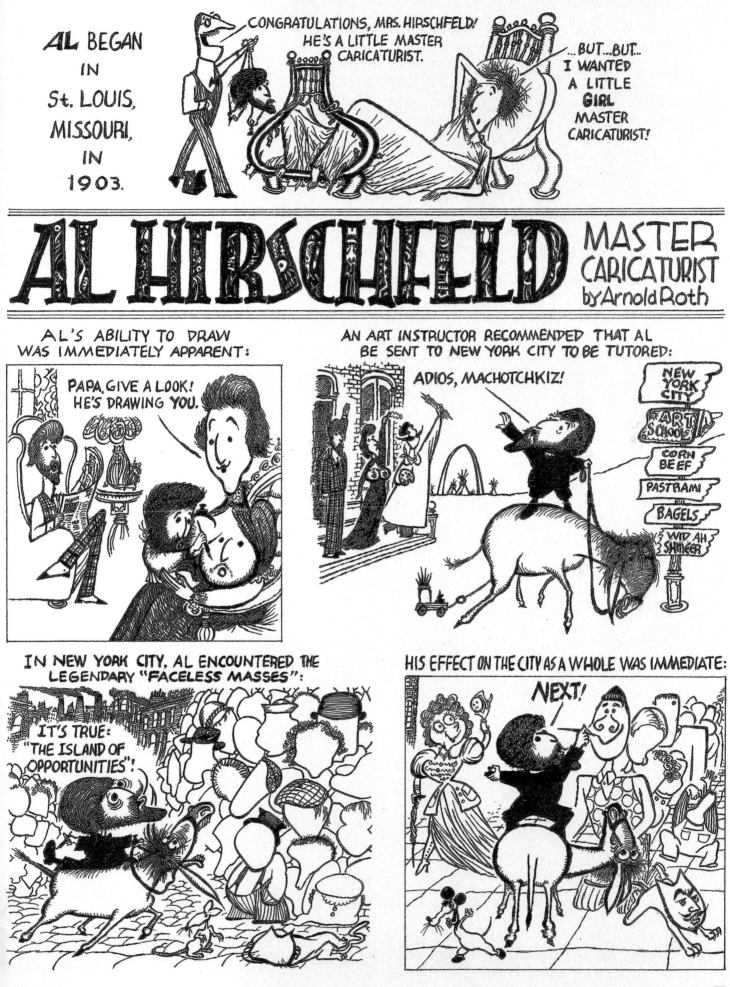

STILL IN HIS TEENS, **AL** BECAME ART DIRECTOR FOR SELZNICK SILENT MOTION PICTURES:

PUBLICATIONS COMMISSIONED HIS WORK.....
....EVEN THE AUGUSTINIAN <u>NEW YORK TIMES</u>:

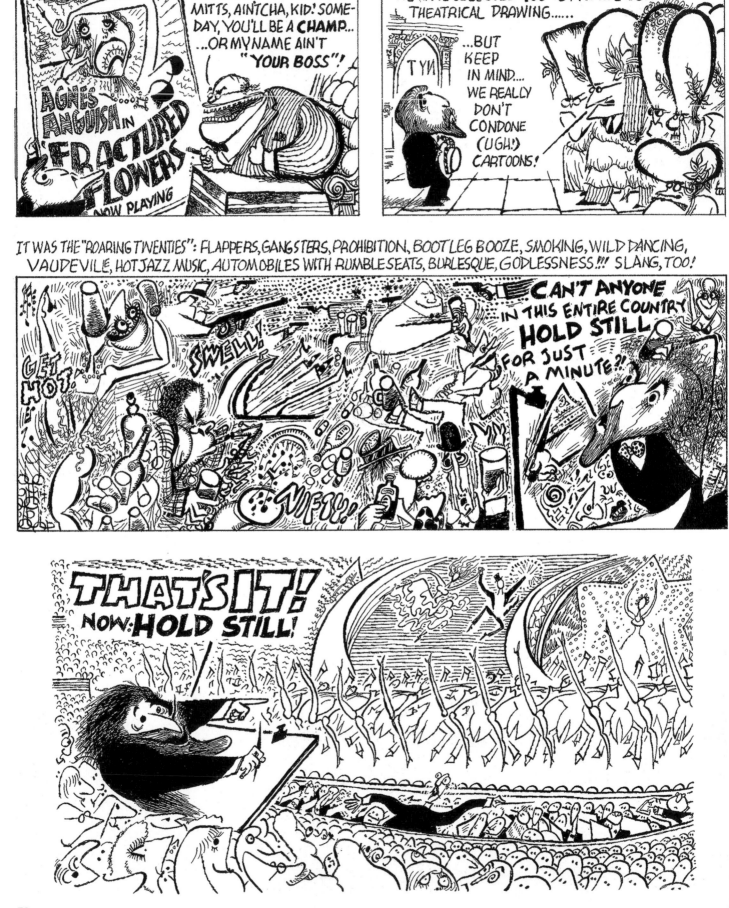

PRETTY HANDY WIT' YER MITTS, AIN'TCHA, KID! SOMEDAY, YOU'LL BE A **CHAMP**... ...OR MY NAME AIN'T "YOUR BOSS"!

AGNES ANGUISH IN "FRACTURED FLOWERS" NOW PLAYING

WE HAVE SELECTED **YOU** TO PROVIDE OUR THEATRICAL DRAWING......

...BUT KEEP IN MIND.... WE REALLY DON'T CONDONE (UGH!) CARTOONS!

IT WAS THE "ROARING TWENTIES": FLAPPERS, GANGSTERS, PROHIBITION, BOOTLEG BOOZE, SMOKING, WILD DANCING, VAUDEVILLE, HOT JAZZ MUSIC, AUTOMOBILES WITH RUMBLE SEATS, BURLESQUE, GODLESSNESS!!! SLANG, TOO!

GET HOT! SWELL! NIFTY!

CAN'T ANYONE IN THIS ENTIRE COUNTRY **HOLD STILL** FOR JUST A MINUTE?!

THAT'S IT! NOW: **HOLD STILL!**

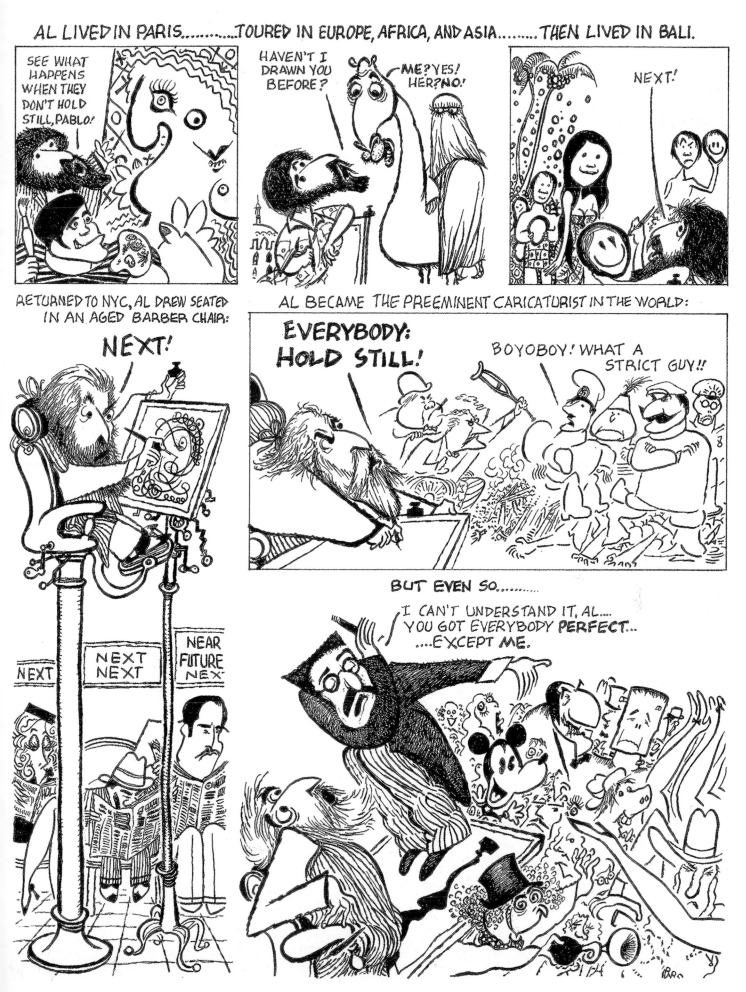

A PLAYFUL AND DEVOTED DAD,
AL HID HIS DAUGHTER'S NAME, NINA, IN MANY OF HIS DRAWINGS:

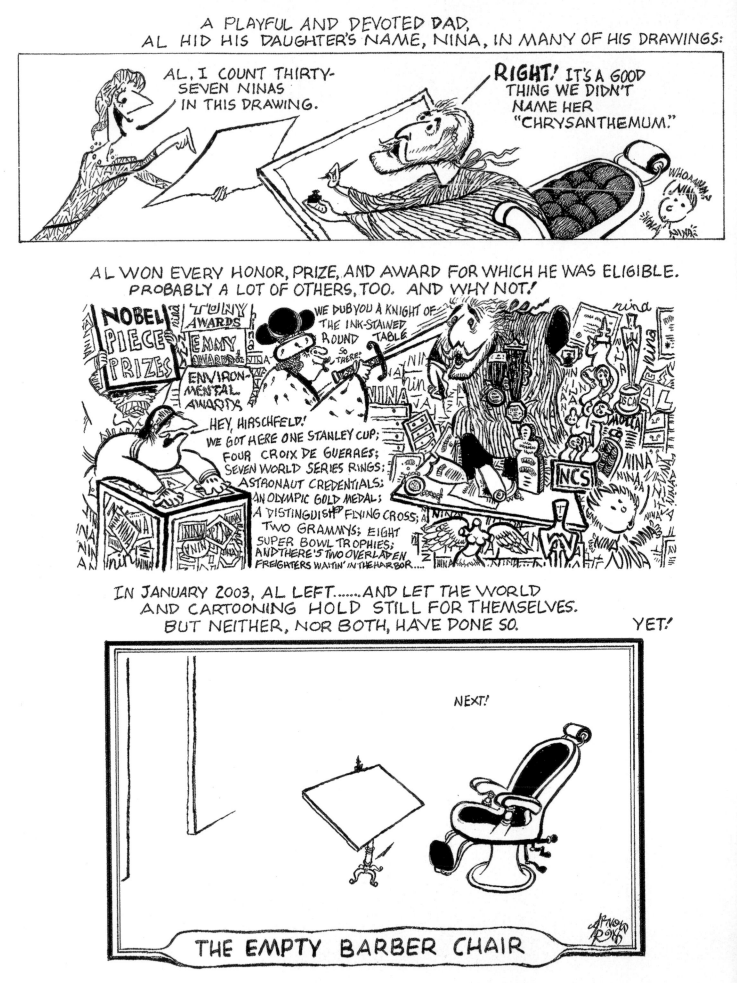

AL, I COUNT THIRTY-SEVEN NINAS IN THIS DRAWING.

RIGHT! IT'S A GOOD THING WE DIDN'T NAME HER "CHRYSANTHEMUM."

AL WON EVERY HONOR, PRIZE, AND AWARD FOR WHICH HE WAS ELIGIBLE.
PROBABLY A LOT OF OTHERS, TOO. AND WHY NOT!

NOBEL PIECES PRIZES

TONY AWARDS

EMMY AWARDS

ENVIRONMENTAL AWARDS

WE DUB YOU A KNIGHT OF THE INK-STAINED ROUND TABLE SO THERE!

HEY, HIRSCHFELD!
WE GOT HERE ONE STANLEY CUP;
FOUR CROIX DE GUERRES;
SEVEN WORLD SERIES RINGS;
ASTRONAUT CREDENTIALS;
AN OLYMPIC GOLD MEDAL;
A DISTINGUISH'D FLYING CROSS;
TWO GRAMMYS; EIGHT
SUPER BOWL TROPHIES;
AND THERE'S TWO OVERLADEN
FREIGHTERS WAITIN' IN THE HARBOR....

NCS

IN JANUARY 2003, AL LEFT.......AND LET THE WORLD
AND CARTOONING HOLD STILL FOR THEMSELVES.
BUT NEITHER, NOR BOTH, HAVE DONE SO. YET!

NEXT!

THE EMPTY BARBER CHAIR

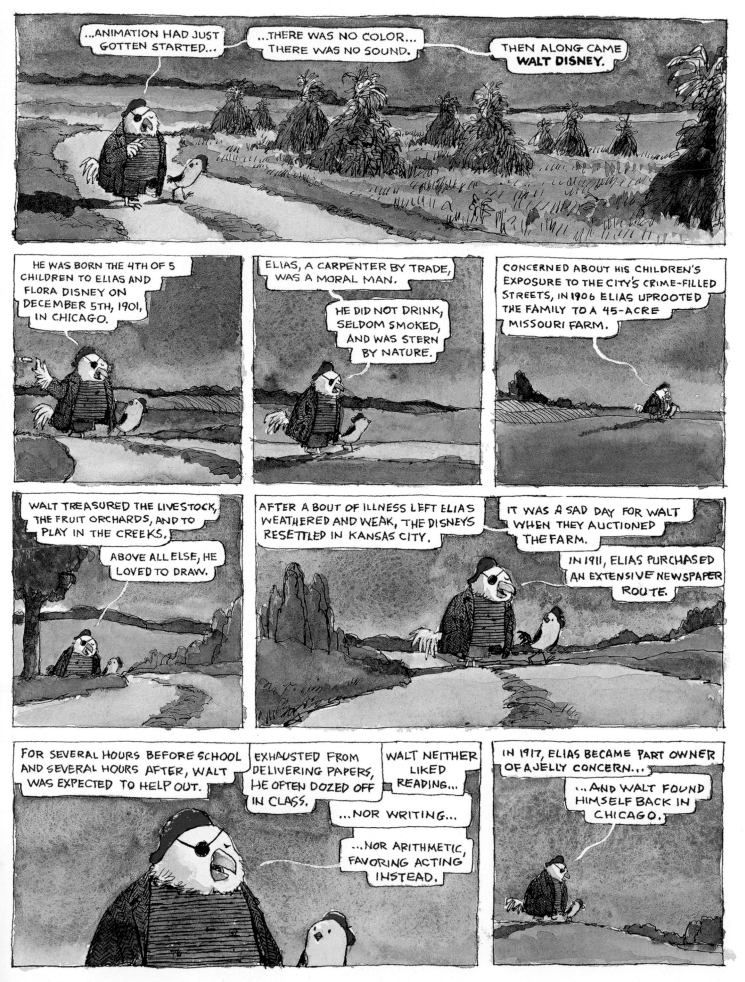

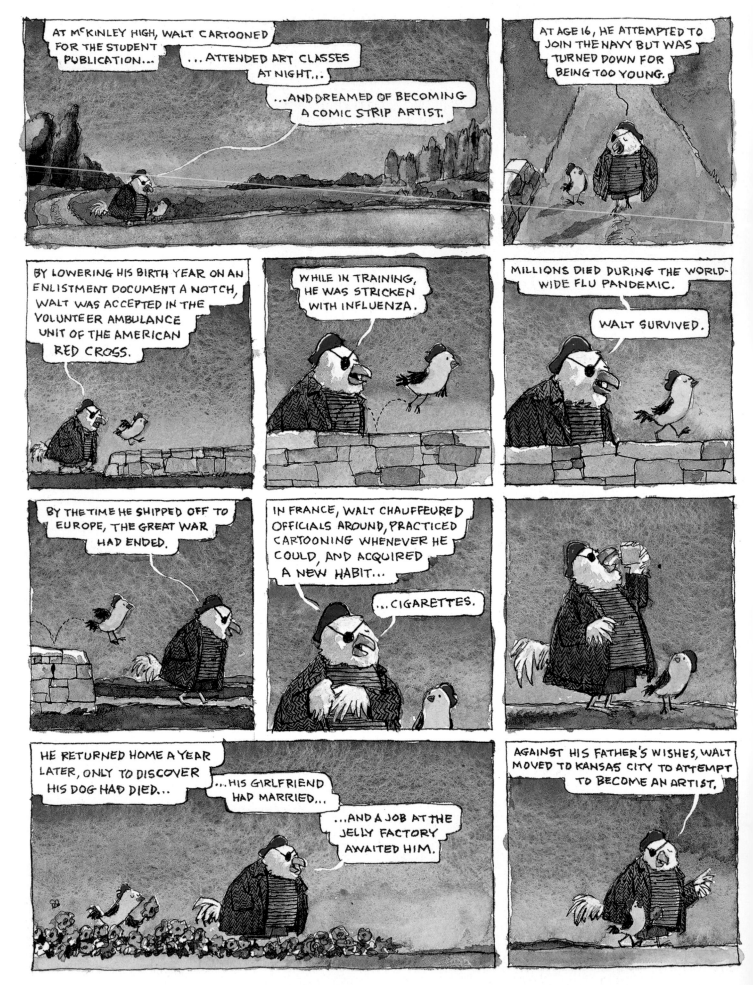

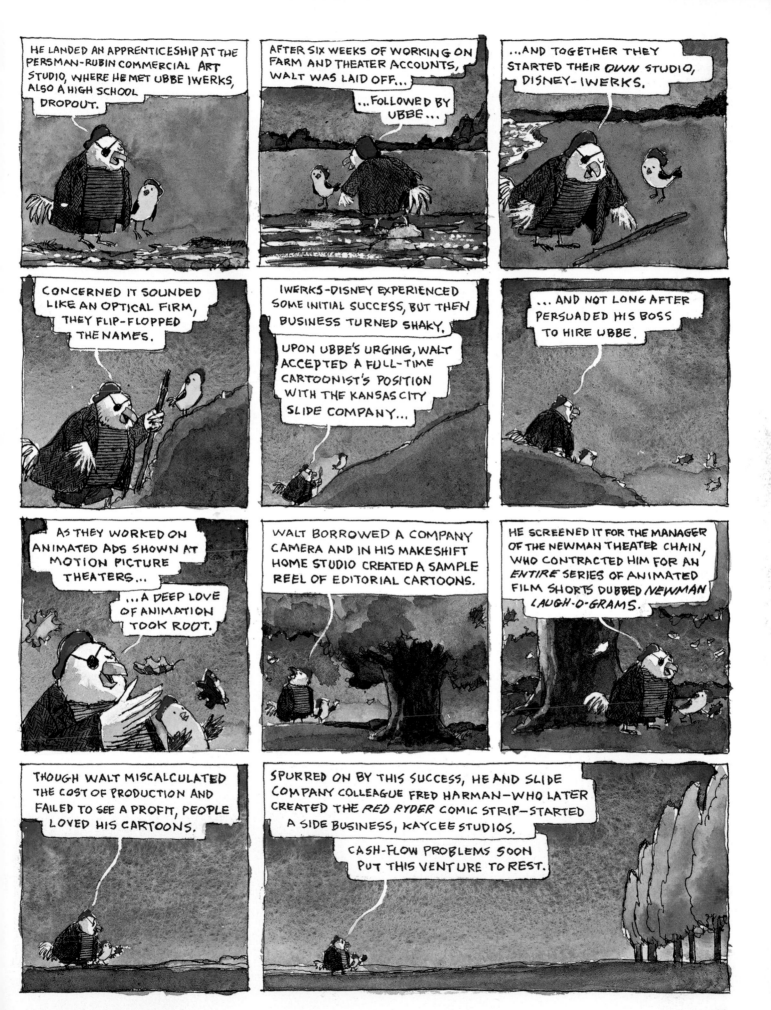

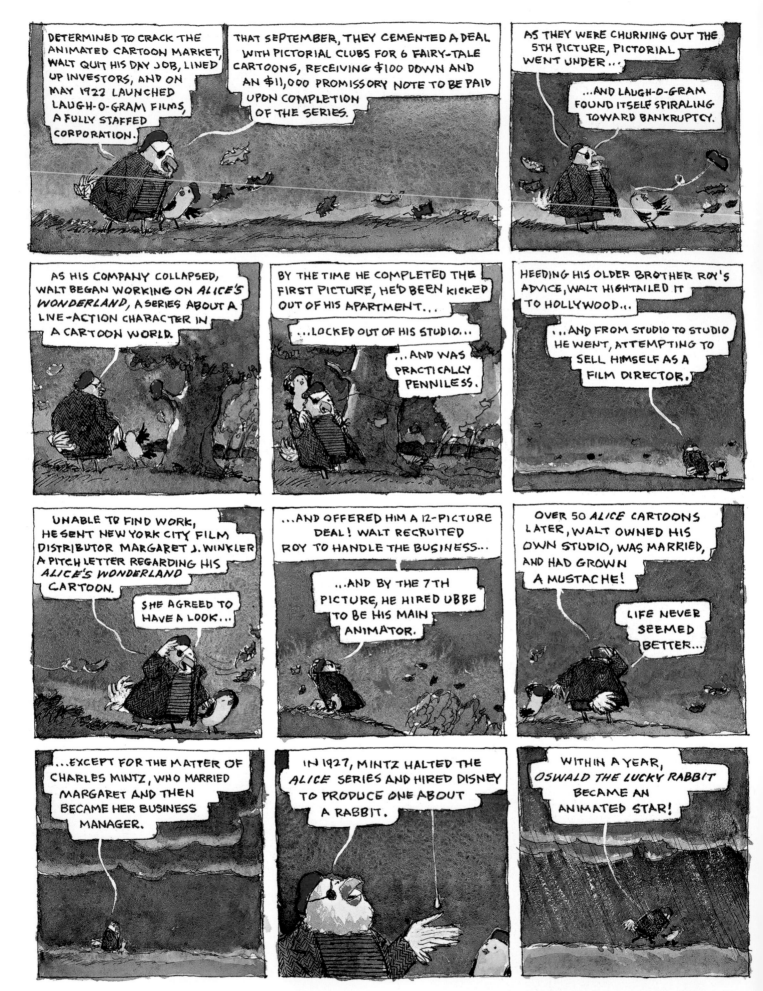

DETERMINED TO CRACK THE ANIMATED CARTOON MARKET, WALT QUIT HIS DAY JOB, LINED UP INVESTORS, AND ON MAY 1922 LAUNCHED LAUGH-O-GRAM FILMS, A FULLY STAFFED CORPORATION.

THAT SEPTEMBER, THEY CEMENTED A DEAL WITH PICTORIAL CLUBS FOR 6 FAIRY-TALE CARTOONS, RECEIVING $100 DOWN AND AN $11,000 PROMISSORY NOTE TO BE PAID UPON COMPLETION OF THE SERIES.

AS THEY WERE CHURNING OUT THE 5TH PICTURE, PICTORIAL WENT UNDER...

...AND LAUGH-O-GRAM FOUND ITSELF SPIRALING TOWARD BANKRUPTCY.

AS HIS COMPANY COLLAPSED, WALT BEGAN WORKING ON *ALICE'S WONDERLAND*, A SERIES ABOUT A LIVE-ACTION CHARACTER IN A CARTOON WORLD.

BY THE TIME HE COMPLETED THE FIRST PICTURE, HE'D BEEN KICKED OUT OF HIS APARTMENT...

...LOCKED OUT OF HIS STUDIO...

...AND WAS PRACTICALLY PENNILESS.

HEEDING HIS OLDER BROTHER ROY'S ADVICE, WALT HIGHTAILED IT TO HOLLYWOOD...

...AND FROM STUDIO TO STUDIO HE WENT, ATTEMPTING TO SELL HIMSELF AS A FILM DIRECTOR.

UNABLE TO FIND WORK, HE SENT NEW YORK CITY FILM DISTRIBUTOR MARGARET J. WINKLER A PITCH LETTER REGARDING HIS *ALICE'S WONDERLAND* CARTOON.

SHE AGREED TO HAVE A LOOK...

...AND OFFERED HIM A 12-PICTURE DEAL! WALT RECRUITED ROY TO HANDLE THE BUSINESS...

...AND BY THE 7TH PICTURE, HE HIRED UBBE TO BE HIS MAIN ANIMATOR.

OVER 50 *ALICE* CARTOONS LATER, WALT OWNED HIS OWN STUDIO, WAS MARRIED, AND HAD GROWN A MUSTACHE!

LIFE NEVER SEEMED BETTER...

...EXCEPT FOR THE MATTER OF CHARLES MINTZ, WHO MARRIED MARGARET AND THEN BECAME HER BUSINESS MANAGER.

IN 1927, MINTZ HALTED THE *ALICE* SERIES AND HIRED DISNEY TO PRODUCE ONE ABOUT A RABBIT.

WITHIN A YEAR, *OSWALD THE LUCKY RABBIT* BECAME AN ANIMATED STAR!

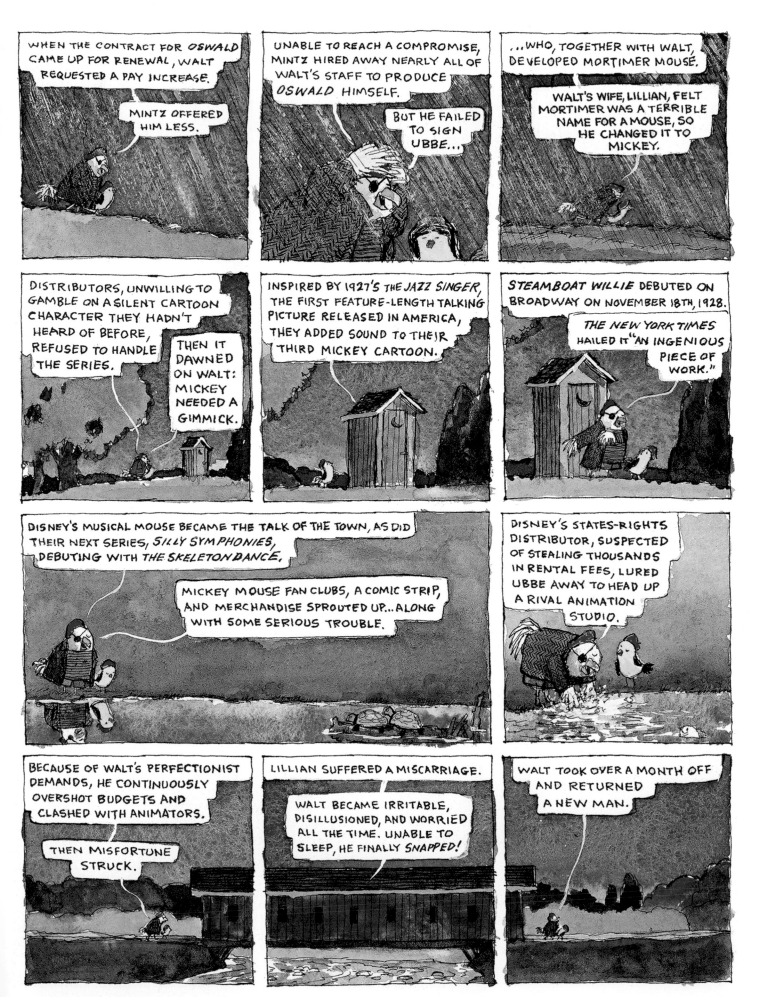

WHEN THE CONTRACT FOR *OSWALD* CAME UP FOR RENEWAL, WALT REQUESTED A PAY INCREASE.

MINTZ OFFERED HIM LESS.

UNABLE TO REACH A COMPROMISE, MINTZ HIRED AWAY NEARLY ALL OF WALT'S STAFF TO PRODUCE *OSWALD* HIMSELF.

BUT HE FAILED TO SIGN UBBE...

...WHO, TOGETHER WITH WALT, DEVELOPED MORTIMER MOUSE.

WALT'S WIFE, LILLIAN, FELT MORTIMER WAS A TERRIBLE NAME FOR A MOUSE, SO HE CHANGED IT TO MICKEY.

DISTRIBUTORS, UNWILLING TO GAMBLE ON A SILENT CARTOON CHARACTER THEY HADN'T HEARD OF BEFORE, REFUSED TO HANDLE THE SERIES.

THEN IT DAWNED ON WALT: MICKEY NEEDED A GIMMICK.

INSPIRED BY 1927'S *THE JAZZ SINGER*, THE FIRST FEATURE-LENGTH TALKING PICTURE RELEASED IN AMERICA, THEY ADDED SOUND TO THEIR THIRD MICKEY CARTOON.

STEAMBOAT WILLIE DEBUTED ON BROADWAY ON NOVEMBER 18TH, 1928.

THE *NEW YORK TIMES* HAILED IT "AN INGENIOUS PIECE OF WORK."

DISNEY'S MUSICAL MOUSE BECAME THE TALK OF THE TOWN, AS DID THEIR NEXT SERIES, *SILLY SYMPHONIES*, DEBUTING WITH *THE SKELETON DANCE*.

MICKEY MOUSE FAN CLUBS, A COMIC STRIP, AND MERCHANDISE SPROUTED UP...ALONG WITH SOME SERIOUS TROUBLE.

DISNEY'S STATES-RIGHTS DISTRIBUTOR, SUSPECTED OF STEALING THOUSANDS IN RENTAL FEES, LURED UBBE AWAY TO HEAD UP A RIVAL ANIMATION STUDIO.

BECAUSE OF WALT'S PERFECTIONIST DEMANDS, HE CONTINUOUSLY OVERSHOT BUDGETS AND CLASHED WITH ANIMATORS.

THEN MISFORTUNE STRUCK.

LILLIAN SUFFERED A MISCARRIAGE.

WALT BECAME IRRITABLE, DISILLUSIONED, AND WORRIED ALL THE TIME. UNABLE TO SLEEP, HE FINALLY *SNAPPED!*

WALT TOOK OVER A MONTH OFF AND RETURNED A NEW MAN.

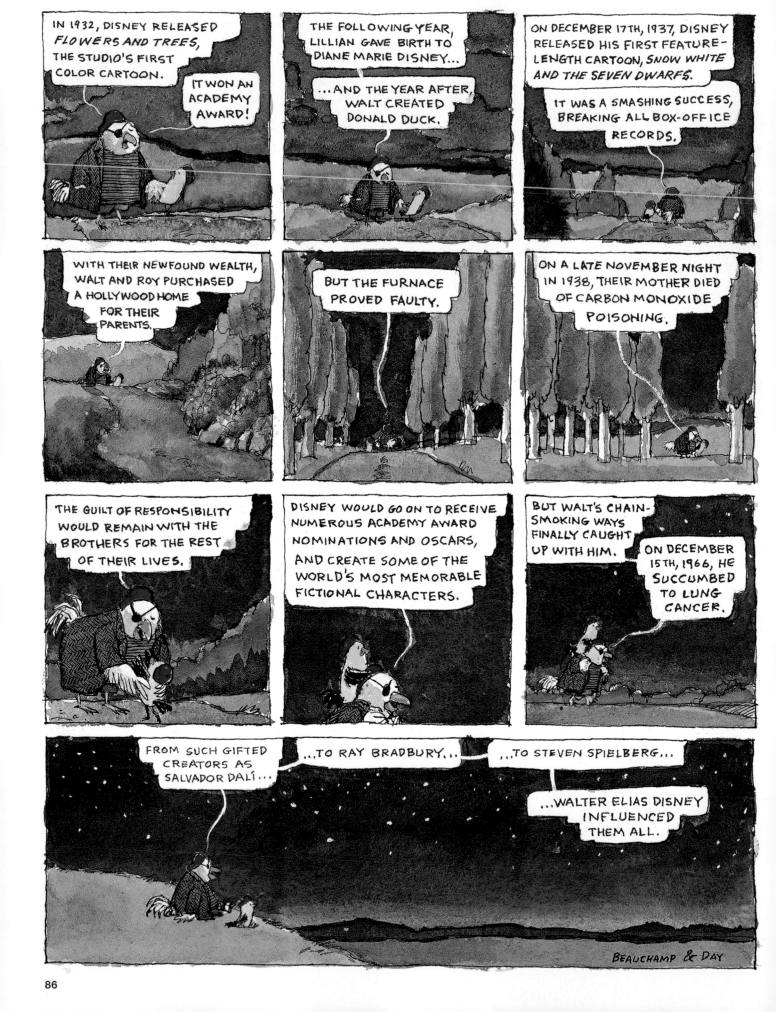

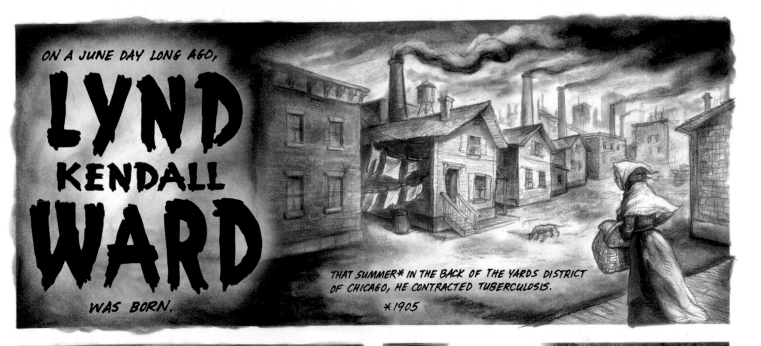

ON A JUNE DAY LONG AGO,

LYND KENDALL WARD

WAS BORN.

THAT SUMMER* IN THE BACK OF THE YARDS DISTRICT OF CHICAGO, HE CONTRACTED TUBERCULOSIS.

*1905

WHEN HE FAILED TO RECOVER UNDER A DOCTOR'S CARE, HIS PARENTS BROUGHT HIM TO THE CANADIAN WILDERNESS FOR REST AND FRESH AIR.* SEVERAL MONTHS LATER, THE DISEASE ABATED.

*TO THE FAMILY'S SUMMER CABIN AT LONELY LAKE, ONTARIO, CANADA

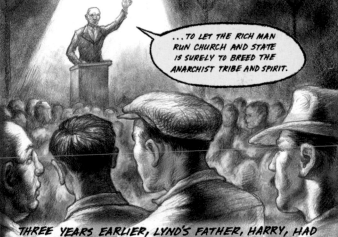

...TO LET THE RICH MAN RUN CHURCH AND STATE IS SURELY TO BREED THE ANARCHIST TRIBE AND SPIRIT.

THREE YEARS EARLIER, LYND'S FATHER, HARRY, HAD BEEN ORDAINED AN ELDER IN THE METHODIST CHURCH. FROM THE PULPIT, HE HIT HIS STRIDE.

DECEMBER 3, 1907

1907 PROVED A HARD YEAR FOR LYND'S MOTHER, DAISY. HARRY WAS LARGELY ABSENT, OUT ADVOCATING FOR SOCIAL REFORM; SHE GAVE BIRTH TO A THIRD CHILD, MURIEL; AND LYND'S MASTOID INFECTION RETURNED.

HARRY, WITH LIKE-MINDED METHODIST LEADERS, STAGED A NATIONAL CONVENTION IN WASHINGTON, D.C., FROM WHICH THE METHODIST FEDERATION FOR SOCIAL SERVICE* AROSE.

*MFSS

IS THERE ANYTHING UN-CHRISTIAN IN SOCIALISM'S ECONOMICS?

... WE MUST IMPROVE THE LIVES OF THE UNDERPRIVILEGED.

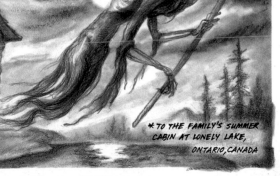

Owen Smith

STORY BY MONTE BEAUCHAMP

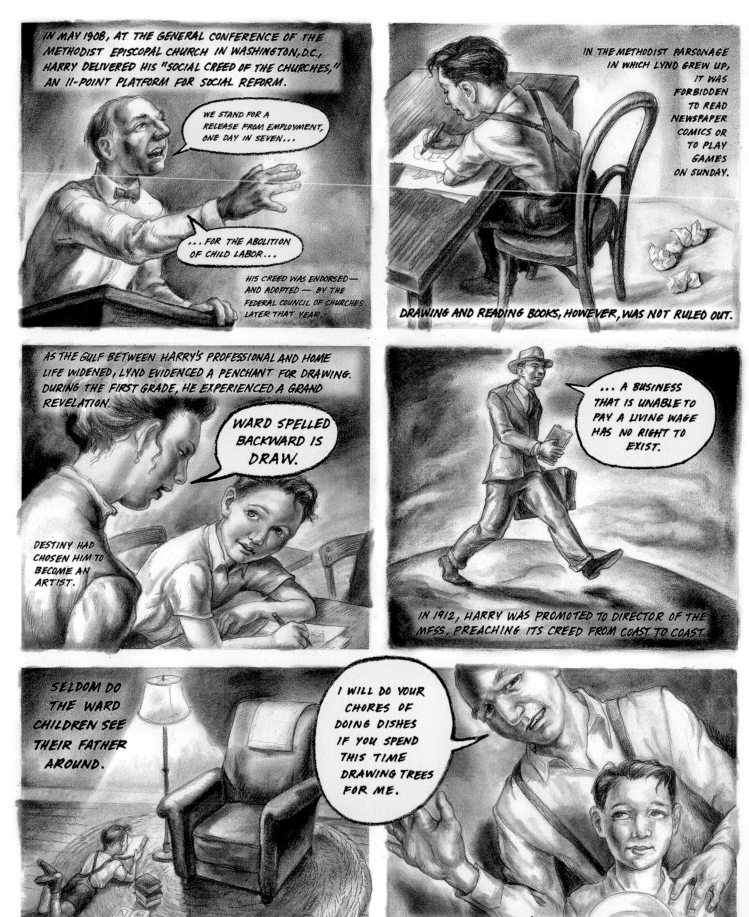

IN THIRD GRADE, AFTER THE FAMILY MOVED TO BOSTON, LYND ATTEMPTED TO MARKET HIS ART... BUT HE HAD NO BUYERS.

LYND WARD
ARTIST
PICTURES
PAINTED
WHILE YOU WAIT

AT AGE TEN, LYND DEVELOPED A FASCINATION WITH PICTURE BOOKS, IMMERSING HIMSELF IN THE GRAND ILLUSTRATIONS.

THANKS TO DAISY, LYND WAS EXPOSED TO GREAT MUSEUM ART AT AN EARLY AGE. AFTER ATTENDING AN EXHIBITION OF ZULOAGA ZABALETA, SHE HAD ONLY ONE COMMENT TO MAKE.

WELL, LYND, I JUST HOPE THAT WHEN YOU GROW UP, YOU WON'T WANT TO PAINT NAKED LADIES.

LYND ALSO EXHIBITED A KNACK FOR MUSIC, TEACHING HIMSELF FOLK SONGS AND METHODIST HYMNS BY EAR.

IN 1918, HARRY ACCEPTED A JOB AT NEW YORK'S UNION THEOLOGICAL SEMINARY AND RELOCATED HIS FAMILY TO NEW JERSEY.

DURING LYND'S SOPHOMORE YEAR AT ENGLEWOOD HIGH—WHERE HE CONTRIBUTED DRAWINGS TO THE SCHOOL PAPER AND YEARBOOK—HARRY HELPED FOUND THE ACLU, WHOSE BOARD HE WOULD CHAIR.

AT TEACHERS COLLEGE, COLUMBIA UNIVERSITY, LYND STUDIED FINE ART, DREW FOR AND EDITED THE COLUMBIA JESTER, AND MET JOURNALISM MAJOR MAY YONGE McNEER. THE WEEK THEY BOTH GRADUATED, THEY WED AND SET SAIL FOR EUROPE.

IN LEIPZIG, GERMANY, LYND ATTENDED A YEARLONG PROGRAM AT THE NATIONAL ACADEMY FOR GRAPHIC ARTS TO STUDY* ETCHING, LITHOGRAPHY, AND WOOD ENGRAVING.

*UNDER PROFESSORS HANS ALEXANDER MUELLER, ALOIS KOLB, AND GEORG MATHÉY.

WHILE BROWSING WITH MAY THROUGH A LEIPZIG BOOKSHOP, LYND MADE A STARTLING DISCOVERY... A WOODCUT NOVEL WITHOUT ANY WORDS, BY BELGIAN ENGRAVER FRANS MASEREEL.

MAY LATER RECALLED:

DIE SONNE EXCITED HIM ENORMOUSLY— AS DID SCHICKSAL BY GERMAN ENGRAVER OTTO NÜCKEL. THEY FIRED LYND UP WITH AN INTENSE DESIRE TO PRODUCE A WOODCUT NOVEL HIMSELF.

UPON THE COUPLE'S RETURN TO THE STATES, LYND SOUGHT WORK AS AN ILLUSTRATOR, AS MAY PURSUED A WRITING CAREER. HARRISON SMITH AT HARCOURT BRACE WAS AMONG THE FIRST BOOK EDITORS TO GIVE HIM AN ASSIGNMENT.

IN BETWEEN COMMISSIONS, AND POWERED BY THE CONVICTION THAT PICTURES CAN COMMUNICATE MORE EFFECTIVELY THAN WORDS, LYND STARTED A WORDLESS WOODCUT NOVEL.

UPON LEARNING THAT HARRISON HAD FORMED A PUBLISHING FIRM WITH JONATHAN CAPE, LYND PAID HIM A VISIT.

IF YOU CAN DELIVER THE REMAINDER OF THE BLOCKS BY AUGUST, I WILL PUBLISH IT IN OCTOBER.

WARD PRODUCED OVER ONE HUNDRED WOOD ENGRAVINGS, DELIVERING THEM ON TIME — A SEEMINGLY IMPOSSIBLE TASK.

GODS' MAN: A NOVEL IN WOODCUTS WAS ISSUED THE WEEK THAT THE STOCK MARKET CRASHED. WITHIN THREE MONTHS, IT ENTERED A THIRD PRINTING. LYND LAUNCHED INTO ANOTHER WOODCUT NOVEL REFLECTIVE OF THE HUMAN CONDITION.

AFTER COMPLETING <u>MADMAN'S DRUM</u>, TRAGEDY STRUCK. THE WARDS' FIRST CHILD DIED JUST DAYS AFTER BEING BORN PREMATURELY. THE COUPLE RETREATED TO PARIS.

LYND FOUND SOLACE IN TEACHING HIMSELF THE ACCORDIAN.

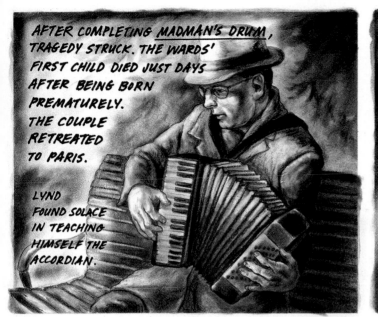

LYND VIEWED BOOKS AS OBJECTS OF ART AND PARLAYED HIS PASSION INTO THE FORMATION OF THE EQUINOX COOPERATIVE PRESS, SPECIALIZING IN ILLUSTRATED, HAND-ASSEMBLED LIMITED EDITIONS. COMPRISED OF A SMALL BAND OF LIKE-MINDED INDIVIDUALS, EQUINOX SET FORTH TO PUBLISH WORKS CONVENTIONAL PUBLISHERS WOULDN'T DARE TOUCH. MAKING MONEY WAS NOT A FACTOR.

1932 PROVED A PIVOTAL YEAR FOR WARD. EQUINOX RELEASED ITS FIRST BOOK; HIS THIRD WOODCUT NOVEL, <u>WILD PILGRIMAGE</u>, APPEARED; AND DAUGHTER NANDA WEEDON WARD WAS BORN HEALTHY.

THANKS TO A CHANCE ENCOUNTER WITH <u>DIE SONNE</u>, WARD HAD ESTABLISHED HIMSELF AS AMERICA'S PREMIERE WOODCUT NOVELIST/ILLUSTRATOR, ILLUMINATING EDITIONS OF <u>FAUST</u>, AND <u>FRANKENSTEIN</u>, AND WORKS OF FAULKNER, AMONG OTHERS.

THE MUCH-IN-DEMAND ILLUSTRATOR ALSO PRODUCED COMMISSIONS IN GOUACHE, WATERCOLOR, LITHOGRAPHY, PENCIL, AND INK.

IN 1937, WARD WAS APPOINTED SUPERVISOR OF THE GRAPHIC ARTS DIVISION OF THE NEW YORK CHAPTER OF THE FEDERAL ART PROJECT,* AND A SECOND DAUGHTER WAS BORN.

*A DIVISION OF THE WPA— WORKS PROGRESS ADMINISTRATION.

HE ALSO RELEASED <u>VERTIGO</u>, HIS SIXTH AND FINAL WOODCUT NOVEL.

DUE TO PROFESSIONAL AND FAMILY DEMANDS, WARD RELINQUISHED HIS PRESIDENCY OF EQUINOX PRESS.

IN REGARD TO HIS PERSONAL WORK, WHENEVER ANYONE INQUIRED, "WHAT DID YOU MEAN BY THIS?" LYND TYPICALLY RESPONDED:

IT ISN'T WHAT I INTENDED THAT MATTERS, IT IS WHAT YOU SEE IN IT THAT COUNTS.

THROUGHOUT HIS LIFE, WARD COMMITTED HIMSELF TO THE PLIGHT OF THE UNDERPRIVILEGED. DETERMINED TO KEEP HIS WORK AFFORDABLE, RARELY DID HE NUMBER HIS PRINTS.

HE NEVER APPROACHED A JOB WITH AN ESTIMATE OF THE TIME IT WOULD TAKE, ONLY WITH THE DESIRE TO DO IT WELL. UNHAPPY WITH HIS FIRST TEN DRAWINGS FOR THE BIGGEST BEAR, LYND TOSSED THEM OUT AND STARTED OVER.

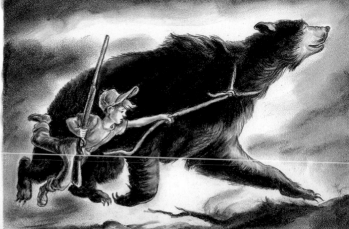

IN 1953, THE BOOK EARNED HIM A CALDECOTT—THE HIGHEST HONOR AWARDED A CHILDREN'S PICTURE BOOK. NUMEROUS OTHER AWARDS AND HONORS FOLLOWED.

IN 1974, HAVING ILLUSTRATED WELL OVER ONE HUNDRED BOOKS, MANY IN COLLABORATION WITH HIS WIFE, MAY, ABRAMS RELEASED STORYTELLER WITHOUT WORDS, A COFFEE-TABLE COMPILATION OF WARD'S WOODCUT NOVELS.

1977:
WHILE ON VACATION AT LONELY LAKE, LYND WAS HOSPITALIZED FOR A BLEEDING ULCER. FATIGUE, DEPRESSION, AND MEMORY LOSS PLAGUED HIM IN THE WEEKS AHEAD.

IN 1978, A CONTRACT WITH GOD APPEARED, USHERING IN A VITAL NEW PUBLISHING GENRE— THE GRAPHIC NOVEL. IN THE INTRO TO HIS BOOK, WILL EISNER WROTE: "I CONSIDER MY EFFORTS IN THIS AREA ATTEMPTS AT EXPANSION OF WARD'S ORIGINAL PREMISE." THAT SAME YEAR, WARD WAS DIAGNOSED WITH ALZHEIMER'S. IN 1979, THE PROLIFIC ARTIST, WRITER, AND BOOK ILLUSTRATOR RETIRED TO RESTON, VIRGINIA, SO HE AND MAY COULD BE CLOSER TO THEIR DAUGHTERS AND GRANDCHILDREN.

ON A JUNE DAY IN 1985, LYND KENDALL WARD GAVE UP THE GHOST. NINE YEARS LATER, MAY WOULD JOIN HIM. THEIR ASHES WERE MERGED AND THEN SCATTERED...

...ONTO THE SERENE SUMMER WATERS OF LONELY LAKE.

THE END

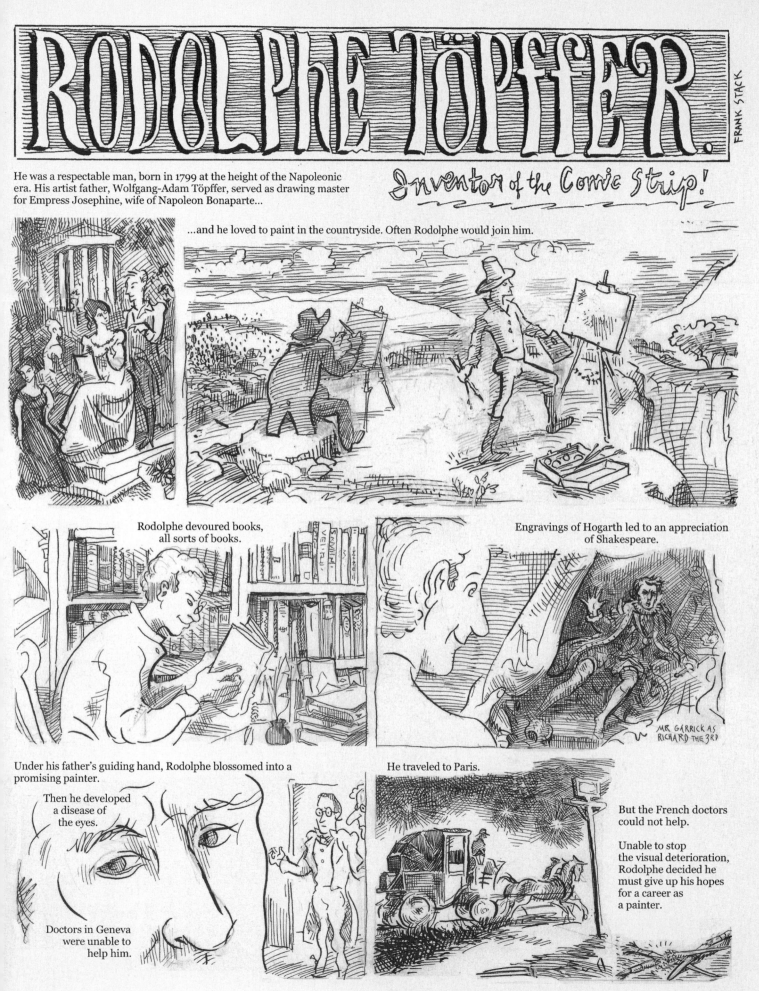

RODOLPHE TÖPFFER.

Inventor of the Comic Strip!

FRANK STACK

He was a respectable man, born in 1799 at the height of the Napoleonic era. His artist father, Wolfgang-Adam Töpffer, served as drawing master for Empress Josephine, wife of Napoleon Bonaparte...

...and he loved to paint in the countryside. Often Rodolphe would join him.

Rodolphe devoured books, all sorts of books.

Engravings of Hogarth led to an appreciation of Shakespeare.

MR. GARRICK AS RICHARD THE 3RD

Under his father's guiding hand, Rodolphe blossomed into a promising painter.

Then he developed a disease of the eyes.

Doctors in Geneva were unable to help him.

He traveled to Paris.

But the French doctors could not help.

Unable to stop the visual deterioration, Rodolphe decided he must give up his hopes for a career as a painter.

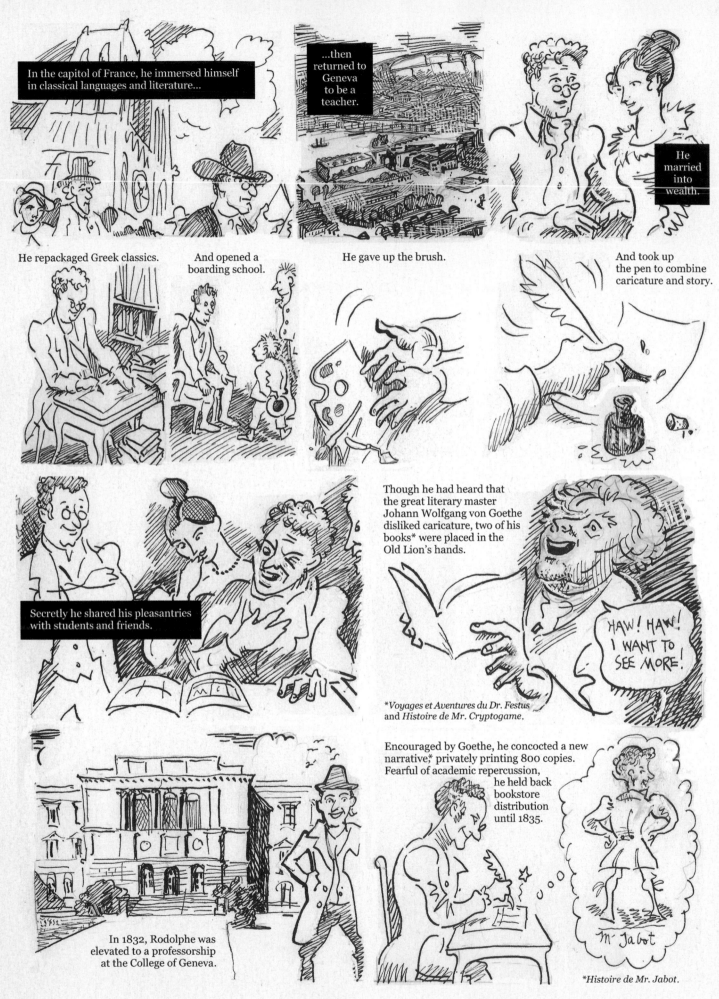

In the capitol of France, he immersed himself in classical languages and literature...

...then returned to Geneva to be a teacher.

He married into wealth.

He repackaged Greek classics.

And opened a boarding school.

He gave up the brush.

And took up the pen to combine caricature and story.

Secretly he shared his pleasantries with students and friends.

Though he had heard that the great literary master Johann Wolfgang von Goethe disliked caricature, two of his books* were placed in the Old Lion's hands.

HAW! HAW! I WANT TO SEE MORE!

*Voyages et Aventures du Dr. Festus and Histoire de Mr. Cryptogame.

In 1832, Rodolphe was elevated to a professorship at the College of Geneva.

Encouraged by Goethe, he concocted a new narrative,* privately printing 800 copies. Fearful of academic repercussion, he held back bookstore distribution until 1835.

Mr Jabot

*Histoire de Mr. Jabot.

In 1837, Töpffer issued a second picture story, *Histoire de Mr. Crépin* (500 copies).

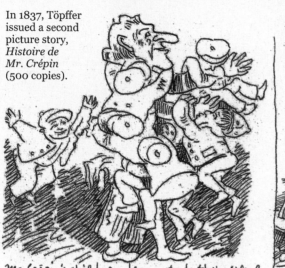

Mr. Crépin's children demonstrate their filial love for their father.

Followed by a third, *Les Amours de Mr. Vieux Bois* (500 copies).

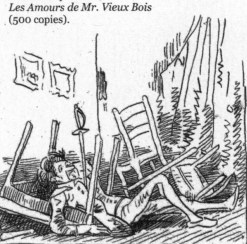

Monsieur Vieux Bois believed he was dead for 48 hours.

Some proclaimed Töpffer had created something new.

THERE'S NEVER... ...LIKE THIS. ...BEEN ANYTHING... IT'S THE START OF SOMETHING NEW.

Throughout Europe, demand arose for his comic albums. In 1839, three bootlegs appeared. That same year his first novel, *Le Presbytère*, was published.

Essayist Xavier de Maistre hailed him...

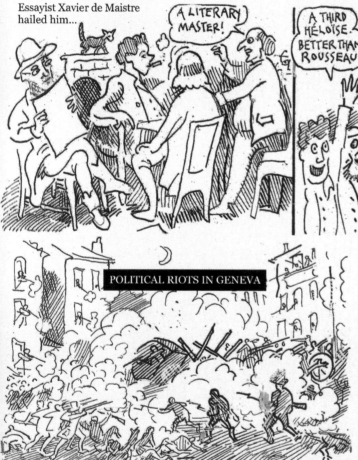

A LITERARY MASTER!

A THIRD HÉLOÏSE. BETTER THAN ROUSSEAU!

Thanks to high praise from the French critic Charles-Augustin Sainte-Beuve, Töpffer became a celebrated writer in the Parisian literary world.

In an essay Sainte-Beuve penned on Töpffer for the journal *Revue des deux mondes*, he lauded him for his French prose but dismissed his comic albums.

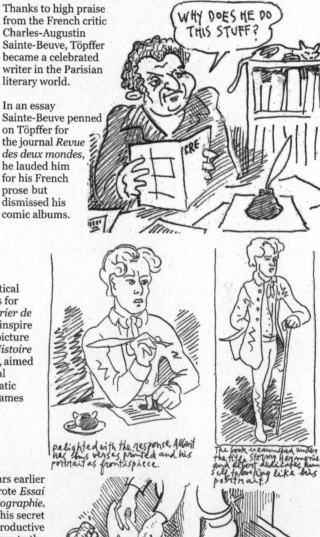

WHY DOES HE DO THIS STUFF?

POLITICAL RIOTS IN GENEVA

His political columns for *Le Courrier de Genève* inspire a sixth picture novel, *Histoire d'Albert*, aimed at radical Democratic leader James Fazy.

Delighted with the response, Albert has this verses printed and his portrait as frontispiece.

The book is launched under the title *Stormy Harmonies* and Albert dedicates himself to looking like his portrait.

In 1843, Rodolphe's health falters drastically. He is sent to Lavey for rest.

And the next year he takes a turn for the worse.

His physicians inform him that he will not recover.

Two years earlier he wrote *Essai d'autographie*, revealing his secret reproductive procedure to the world—transfer lithography, which allowed him to draw his stories directly on paper and transfer them to a printing stone.

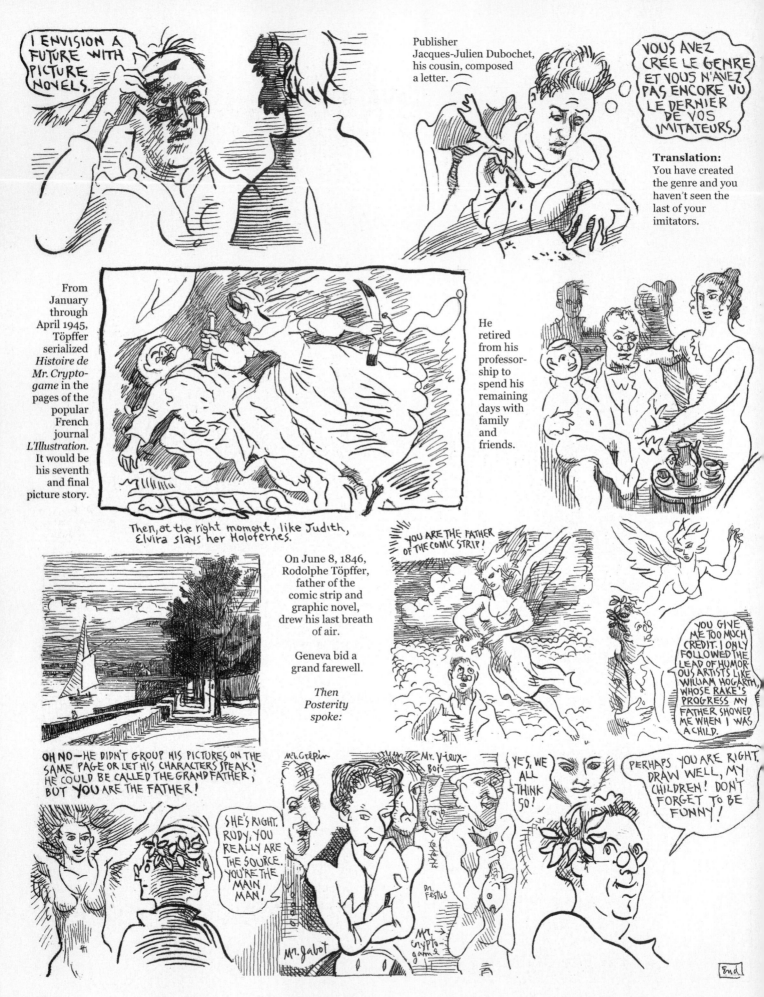

EDWARD GOREY

by

Greg Clarke

Chicago, February 22, 1925

Edward St. John Gorey entered the world like the rest of his species—beardless and dyspeptic. The only child of Helen and Edward Gorey, he was extremely precocious, drawing at 18 months and reading by age 3.

Ted, as he was called by family and friends, excelled academically, skipping two grades at the esteemed Francis W. Parker School in Chicago. Years later, when asked what he was like as a boy, he replied, "Small."

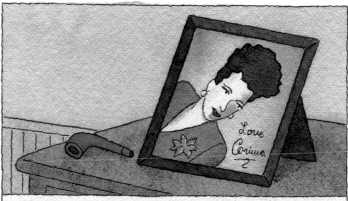

After finishing 8th grade, his father broke up the family, leaving his wife and son for the nightclub singer Corinna Mura (later known for belting out "La Marseillaise" in the movie *Casablanca*). His parents would remarry 16 years later.

Following high school, he spent one semester at the Art Institute of Chicago—the extent of his formal art training—before being drafted into the army in 1943. He sat out World War II, serving as a company clerk stationed at Dugway Proving Ground in Utah.

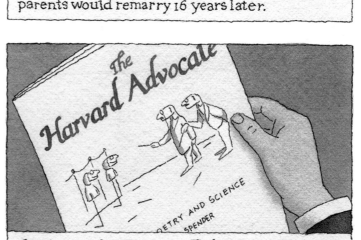

Discharged 3 years later, Ted entered Harvard, where he studied French literature. Rooming with poet Frank O'Hara, he drew for the *Harvard Advocate* and illustrated several books of verse for poets Merrill Moore and John Ciardi.

Graduating in 1950, he took some time finding his life's direction. He kicked around Boston reading, writing, and working in a bookstore. He moved to New York in 1953, albeit reluctantly, when friends secured him a job doing paste-up at Doubleday & Co.

The publisher soon opened a paperback division called Anchor Press, and he was made Art Editor. He was now responsible for cover design, commissioning art from various artists, including Milton Glaser, Leonard Baskin, and Andy Warhol.

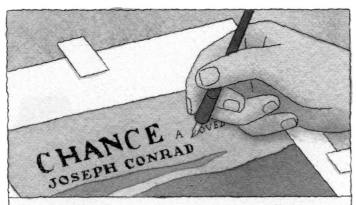

His innovative designs were hailed as "modern" and "arty." In all, he designed 200 covers (illustrating a quarter of them himself). Of his celebrated hand-lettering, he said, "It was simply easier than spec'ing type."

From his small apartment on 38th Street and Madison Avenue (where he would live on and off for the next 30 years), he found time, in between his day job, to write and illustrate his own books. He always regarded himself as a writer first and a visual artist second.

The first publisher to take a keen interest in his work was Duell, Sloan and Pearce, releasing his first two titles in 1953 and '54. They sold miserably. He recalled, to his dismay, finding them remaindered on 42nd Street for 19 cents each. Undaunted, he continued to write.

Thus began a familiar pattern of publishers taking him on, then abandoning him, in spite of his growing list of prominent fans. Nobel Prize-winner Hermann Hesse, writing to his publisher in 1960, said, "I recently saw a fantastic picture book, *The Doubtful Guest* by Edward Gorey...I recommend it highly."

During the '60s, he refined his style, often writing under a variety of pen names (anagrams of his own name). He began self-publishing small editions of his more toxic book proposals under his own imprint, the Fantod Press. Asked why he hated children, he responded, "I don't know any."

He typically set his tales in a quasi-Edwardian milieu—the ideal backdrop for his archly sinister and often calamitous plotlines. What obsessed him more than anything in this world was why some things happened and other things didn't.

He was loath to explain his work but once said, "Life is intrinsically, well, boring and dangerous at the same time. At any given moment the floor may open up. Of course, it almost never does—that's what makes it so boring."

Virtually all his drawings were done to the size of reproduction using India ink and Hunt #104 or Gillott Tit Quill pen nibs on Strathmore two-ply matte finish. He was haunted by the prospect of his favorite pen nibs someday being discontinued.

His sexual orientation was the subject of some speculation. He admitted to some "emotional entanglements" but was never married nor seen with a partner. When asked by a reporter if he was gay, he glibly replied, "I don't even know."

Notoriously diffident, he seldom responded to letters or knocks at the door, and refused to answer the phone after 6pm. Generally preferring feline company to that of his fellow humans, he was often joined by his cats on his frequent forays between New York and Cape Cod.

BALLET

Initially wary of Gotham, he soon embraced the city's cultural offerings. He was a legendary balletomane who worshipped at the altar of George Balanchine. He famously attended every show by the New York City Ballet for 23 seasons.

He prowled the streets adorned in his singular brand of sartorial splendor—a fur coat, sneakers, necklaces, and fingers swathed in rings. He later renounced fur, devoting himself to animal welfare.

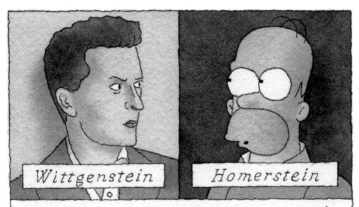

Wittgenstein *Homerstein*

His tastes ran the gamut from high to low—from Anthony Trollope, Ludwig Wittgenstein, and silent filmmaker Louis Feuillade to soap operas, Homer Simpson, and *Buffy the Vampire Slayer*. He was a gourmet cook who loved TV dinners.

Movies were an abiding passion, and for a period, he claimed to have seen a thousand films a year. He revered obscure silent films and often attributed the decline of cinema to special effects.

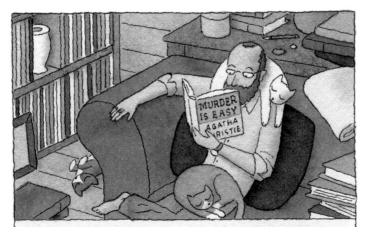

An inveterate reader, he counted Agatha Christie, Jane Austen, W. H. Auden, Ronald Firbank, and Lady Murasaki among his favorite authors. He accumulated some 30,000 books over his lifetime.

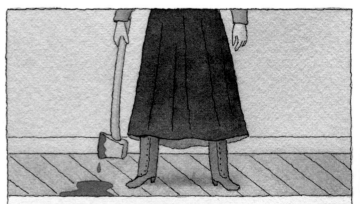

He was a great aficionado of true crime and could recite the plot details from such famous cases as Lizzie Borden, the Black Dahlia, the Boston Strangler, the Tichborne Affair, the Profumo case, and the Yorkshire Ripper.

Goya, Balthus, Charles Burchfield, and Aubrey Beardsley were among his favorite artists. He owned drawings by Vuillard and Bonnard, etchings by Berthe Morisot and Paul Klee, and a lithograph by Edvard Munch.

He collected all manner of things: Mozart and Bach CDs, videocassettes, finials, ancient coins, furry animal dolls, puppets, seashells, cheese graters, old wooden potato mashers, and telephone pole insulators (to name just a few!).

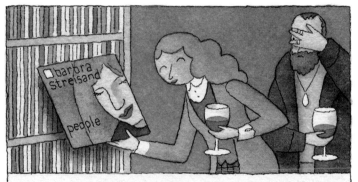

His list of dislikes was long: Henry James, Judith Krantz, Marquis de Sade, minimal art, Picasso, Andrew Wyeth, Andrew Lloyd Webber, Barbra Streisand, Al Pacino, television evangelists, fools, travel, CD cellophane, discussions about his own work, and brussels sprouts.

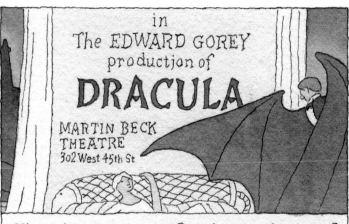

His designs for the 1977 Broadway production of *Dracula* spread his fame far and wide. A Tony Award and the resultant windfall enabled him to buy a house on the Cape in Yarmouth Port.

The neglected house, built in the early 19th century, was so run-down it would require numerous renovations and another 6 years before he slept there. He christened it Elephant House, a special name he shared with only a few people.

In 1980, PBS commissioned him to create what would become one of his signature pieces: the animated opening title sequence for its popular series *Mystery!*

With the death of George Balanchine in 1983, Gorey and his six cats soon abandoned New York to live on the Cape year-round. Elephant House became his focus as he filled every room with his multifarious collections of inanimate objects.

In addition to working on his own books and various other projects, he continued to illustrate for a wide array of magazines such as *Sports Illustrated*, *Vogue*, *TV Guide*, and *The New Yorker* (including several covers that never ran).

In his final days, afflicted with prostate cancer, diabetes, and an abnormal heart condition, he looked frail and ashen. Friends urged him to check into a hospital for observation, but he refused, at the same time expressing misgivings about the new millennium.

On April 13, 2000, he suffered a massive heart attack at home and was dead two days later at the age of 75. His ashes were scattered over Barnstable Harbor.

Since his untimely demise, Gorey's stature and influence continue to swell. His impishly perverse sensibility has permeated the culture, surfacing in the work of Tim Burton, Neil Gaiman, Lemony Snicket, the Kronos Quartet, and on the tattooed arm of an *American Idol* contestant.

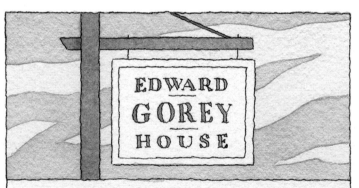

Under the terms of his will, Elephant House (aka The Edward Gorey House) was purchased by the Highland Street Foundation. A museum would be created celebrating the artist's life and work. It opened to the public in the summer of 2002 and presently receives 7,000 visitors per year.

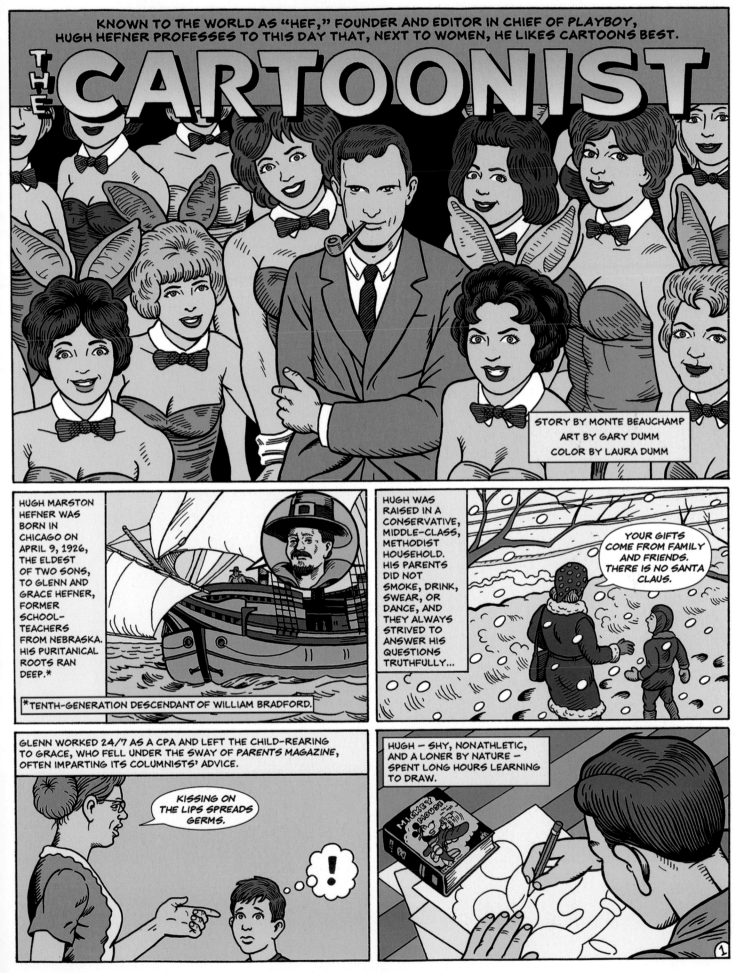

KNOWN TO THE WORLD AS "HEF," FOUNDER AND EDITOR IN CHIEF OF PLAYBOY, HUGH HEFNER PROFESSES TO THIS DAY THAT, NEXT TO WOMEN, HE LIKES CARTOONS BEST.

THE CARTOONIST

STORY BY MONTE BEAUCHAMP
ART BY GARY DUMM
COLOR BY LAURA DUMM

HUGH MARSTON HEFNER WAS BORN IN CHICAGO ON APRIL 9, 1926, THE ELDEST OF TWO SONS, TO GLENN AND GRACE HEFNER, FORMER SCHOOLTEACHERS FROM NEBRASKA. HIS PURITANICAL ROOTS RAN DEEP.*

*TENTH-GENERATION DESCENDANT OF WILLIAM BRADFORD.

HUGH WAS RAISED IN A CONSERVATIVE, MIDDLE-CLASS, METHODIST HOUSEHOLD. HIS PARENTS DID NOT SMOKE, DRINK, SWEAR, OR DANCE, AND THEY ALWAYS STRIVED TO ANSWER HIS QUESTIONS TRUTHFULLY...

YOUR GIFTS COME FROM FAMILY AND FRIENDS. THERE IS NO SANTA CLAUS.

GLENN WORKED 24/7 AS A CPA AND LEFT THE CHILD-REARING TO GRACE, WHO FELL UNDER THE SWAY OF PARENTS MAGAZINE, OFTEN IMPARTING ITS COLUMNISTS' ADVICE.

KISSING ON THE LIPS SPREADS GERMS.

!

HUGH — SHY, NONATHLETIC, AND A LONER BY NATURE — SPENT LONG HOURS LEARNING TO DRAW.

MICKEY MOUSE

1

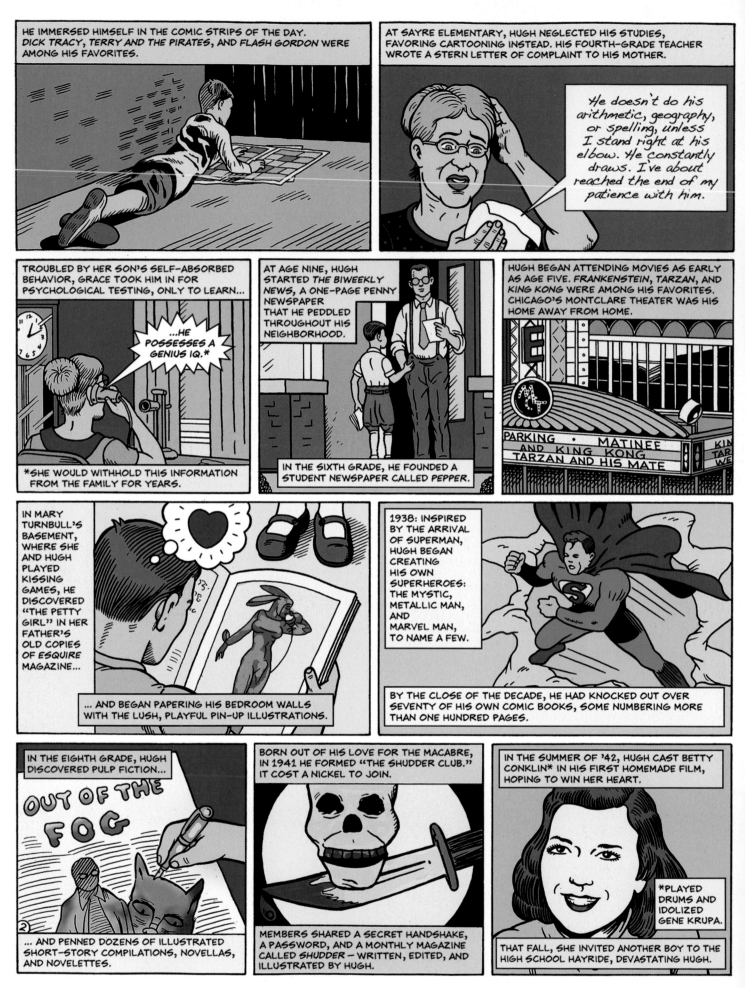

HE IMMERSED HIMSELF IN THE COMIC STRIPS OF THE DAY. DICK TRACY, TERRY AND THE PIRATES, AND FLASH GORDON WERE AMONG HIS FAVORITES.

AT SAYRE ELEMENTARY, HUGH NEGLECTED HIS STUDIES, FAVORING CARTOONING INSTEAD. HIS FOURTH-GRADE TEACHER WROTE A STERN LETTER OF COMPLAINT TO HIS MOTHER.

He doesn't do his arithmetic, geography, or spelling, unless I stand right at his elbow. He constantly draws. I've about reached the end of my patience with him.

TROUBLED BY HER SON'S SELF-ABSORBED BEHAVIOR, GRACE TOOK HIM IN FOR PSYCHOLOGICAL TESTING, ONLY TO LEARN...

...HE POSSESSES A GENIUS IQ.*

*SHE WOULD WITHHOLD THIS INFORMATION FROM THE FAMILY FOR YEARS.

AT AGE NINE, HUGH STARTED THE BIWEEKLY NEWS, A ONE-PAGE PENNY NEWSPAPER THAT HE PEDDLED THROUGHOUT HIS NEIGHBORHOOD.

IN THE SIXTH GRADE, HE FOUNDED A STUDENT NEWSPAPER CALLED PEPPER.

HUGH BEGAN ATTENDING MOVIES AS EARLY AS AGE FIVE. FRANKENSTEIN, TARZAN, AND KING KONG WERE AMONG HIS FAVORITES. CHICAGO'S MONTCLARE THEATER WAS HIS HOME AWAY FROM HOME.

PARKING • MATINEE
AND KING KONG
TARZAN AND HIS MATE

IN MARY TURNBULL'S BASEMENT, WHERE SHE AND HUGH PLAYED KISSING GAMES, HE DISCOVERED "THE PETTY GIRL" IN HER FATHER'S OLD COPIES OF ESQUIRE MAGAZINE...

... AND BEGAN PAPERING HIS BEDROOM WALLS WITH THE LUSH, PLAYFUL PIN-UP ILLUSTRATIONS.

1938: INSPIRED BY THE ARRIVAL OF SUPERMAN, HUGH BEGAN CREATING HIS OWN SUPERHEROES: THE MYSTIC, METALLIC MAN, AND MARVEL MAN, TO NAME A FEW.

BY THE CLOSE OF THE DECADE, HE HAD KNOCKED OUT OVER SEVENTY OF HIS OWN COMIC BOOKS, SOME NUMBERING MORE THAN ONE HUNDRED PAGES.

IN THE EIGHTH GRADE, HUGH DISCOVERED PULP FICTION...

OUT OF THE FOG

... AND PENNED DOZENS OF ILLUSTRATED SHORT-STORY COMPILATIONS, NOVELLAS, AND NOVELETTES.

BORN OUT OF HIS LOVE FOR THE MACABRE, IN 1941 HE FORMED "THE SHUDDER CLUB." IT COST A NICKEL TO JOIN.

MEMBERS SHARED A SECRET HANDSHAKE, A PASSWORD, AND A MONTHLY MAGAZINE CALLED SHUDDER – WRITTEN, EDITED, AND ILLUSTRATED BY HUGH.

IN THE SUMMER OF '42, HUGH CAST BETTY CONKLIN* IN HIS FIRST HOMEMADE FILM, HOPING TO WIN HER HEART.

*PLAYED DRUMS AND IDOLIZED GENE KRUPA.

THAT FALL, SHE INVITED ANOTHER BOY TO THE HIGH SCHOOL HAYRIDE, DEVASTATING HUGH.

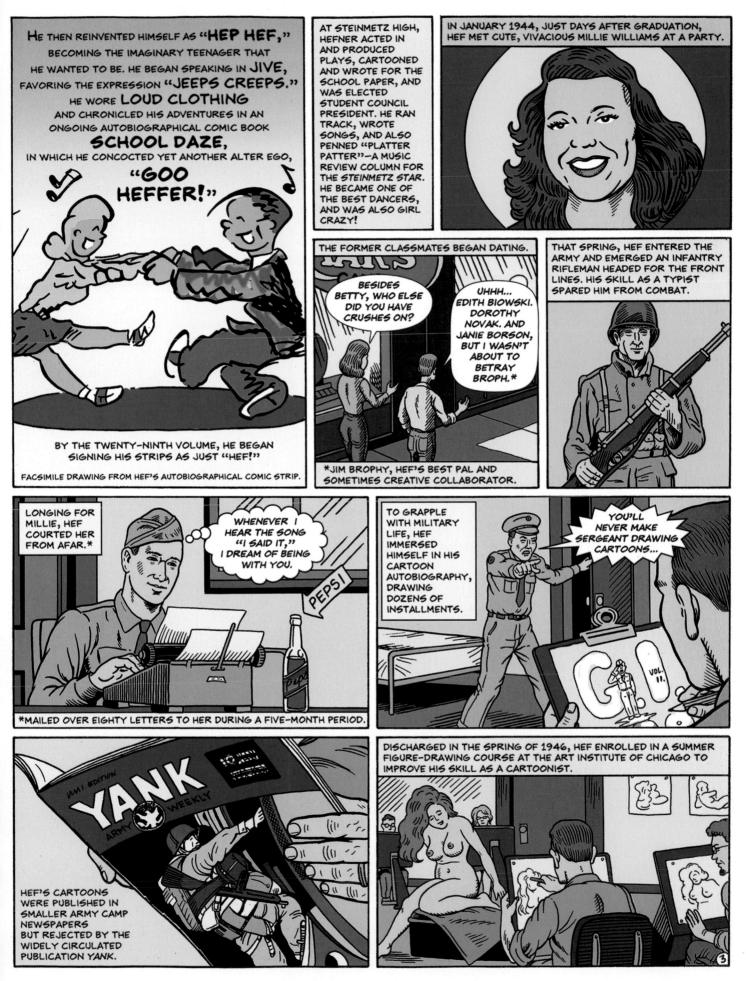

HE THEN REINVENTED HIMSELF AS "HEP HEF," BECOMING THE IMAGINARY TEENAGER THAT HE WANTED TO BE. HE BEGAN SPEAKING IN JIVE, FAVORING THE EXPRESSION "JEEPS CREEPS." HE WORE LOUD CLOTHING AND CHRONICLED HIS ADVENTURES IN AN ONGOING AUTOBIOGRAPHICAL COMIC BOOK SCHOOL DAZE, IN WHICH HE CONCOCTED YET ANOTHER ALTER EGO, "GOO HEFFER!"

BY THE TWENTY-NINTH VOLUME, HE BEGAN SIGNING HIS STRIPS AS JUST "HEF!"

FACSIMILE DRAWING FROM HEF'S AUTOBIOGRAPHICAL COMIC STRIP.

AT STEINMETZ HIGH, HEFNER ACTED IN AND PRODUCED PLAYS, CARTOONED AND WROTE FOR THE SCHOOL PAPER, AND WAS ELECTED STUDENT COUNCIL PRESIDENT. HE RAN TRACK, WROTE SONGS, AND ALSO PENNED "PLATTER PATTER"—A MUSIC REVIEW COLUMN FOR THE STEINMETZ STAR. HE BECAME ONE OF THE BEST DANCERS, AND WAS ALSO GIRL CRAZY!

IN JANUARY 1944, JUST DAYS AFTER GRADUATION, HEF MET CUTE, VIVACIOUS MILLIE WILLIAMS AT A PARTY.

THE FORMER CLASSMATES BEGAN DATING.

BESIDES BETTY, WHO ELSE DID YOU HAVE CRUSHES ON?

UHHH... EDITH BIOWSKI. DOROTHY NOVAK. AND JANIE BORSON, BUT I WASN'T ABOUT TO BETRAY BROPH.*

*JIM BROPHY, HEF'S BEST PAL AND SOMETIMES CREATIVE COLLABORATOR.

THAT SPRING, HEF ENTERED THE ARMY AND EMERGED AN INFANTRY RIFLEMAN HEADED FOR THE FRONT LINES. HIS SKILL AS A TYPIST SPARED HIM FROM COMBAT.

LONGING FOR MILLIE, HEF COURTED HER FROM AFAR.*

WHENEVER I HEAR THE SONG "I SAID IT," I DREAM OF BEING WITH YOU.

PEPSI

*MAILED OVER EIGHTY LETTERS TO HER DURING A FIVE-MONTH PERIOD.

TO GRAPPLE WITH MILITARY LIFE, HEF IMMERSED HIMSELF IN HIS CARTOON AUTOBIOGRAPHY, DRAWING DOZENS OF INSTALLMENTS.

YOU'LL NEVER MAKE SERGEANT DRAWING CARTOONS...

VOL. II.

HEF'S CARTOONS WERE PUBLISHED IN SMALLER ARMY CAMP NEWSPAPERS BUT REJECTED BY THE WIDELY CIRCULATED PUBLICATION YANK.

YANK ARMY WEEKLY

DISCHARGED IN THE SPRING OF 1946, HEF ENROLLED IN A SUMMER FIGURE-DRAWING COURSE AT THE ART INSTITUTE OF CHICAGO TO IMPROVE HIS SKILL AS A CARTOONIST.

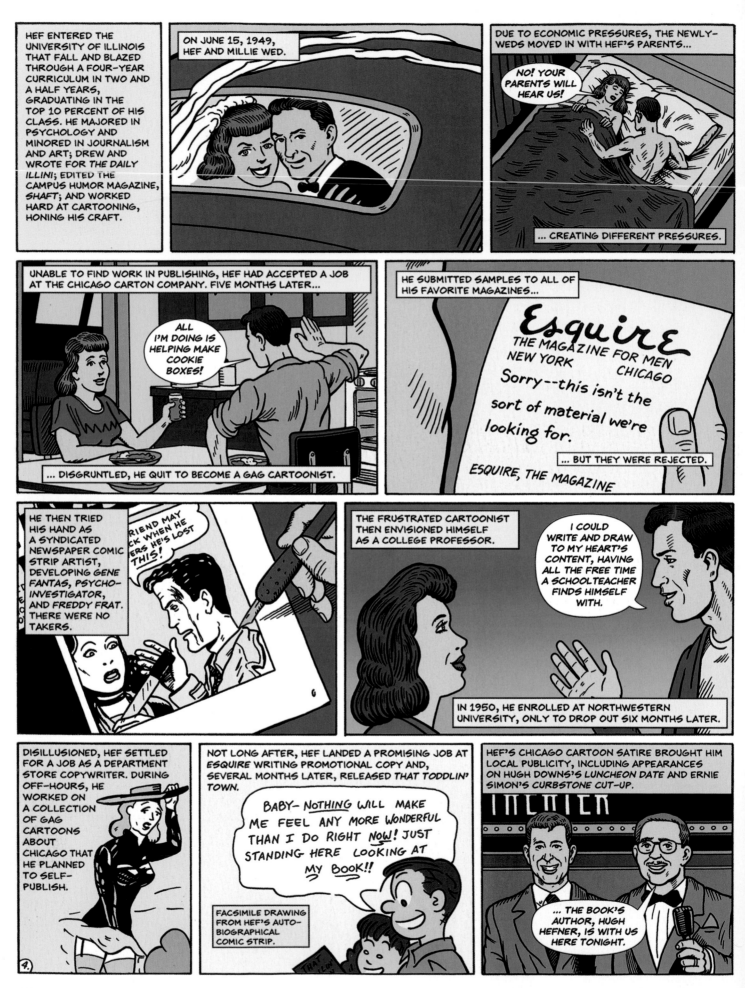

HEF ENTERED THE UNIVERSITY OF ILLINOIS THAT FALL AND BLAZED THROUGH A FOUR-YEAR CURRICULUM IN TWO AND A HALF YEARS, GRADUATING IN THE TOP 10 PERCENT OF HIS CLASS. HE MAJORED IN PSYCHOLOGY AND MINORED IN JOURNALISM AND ART; DREW AND WROTE FOR *THE DAILY ILLINI*; EDITED THE CAMPUS HUMOR MAGAZINE, *SHAFT*; AND WORKED HARD AT CARTOONING, HONING HIS CRAFT.

ON JUNE 15, 1949, HEF AND MILLIE WED.

DUE TO ECONOMIC PRESSURES, THE NEWLY-WEDS MOVED IN WITH HEF'S PARENTS...

NO! YOUR PARENTS WILL HEAR US!

... CREATING DIFFERENT PRESSURES.

UNABLE TO FIND WORK IN PUBLISHING, HEF HAD ACCEPTED A JOB AT THE CHICAGO CARTON COMPANY. FIVE MONTHS LATER...

ALL I'M DOING IS HELPING MAKE COOKIE BOXES!

... DISGRUNTLED, HE QUIT TO BECOME A GAG CARTOONIST.

HE SUBMITTED SAMPLES TO ALL OF HIS FAVORITE MAGAZINES...

Esquire
THE MAGAZINE FOR MEN
NEW YORK CHICAGO
Sorry--this isn't the sort of material we're looking for.
ESQUIRE, THE MAGAZINE

... BUT THEY WERE REJECTED.

HE THEN TRIED HIS HAND AS A SYNDICATED NEWSPAPER COMIC STRIP ARTIST, DEVELOPING *GENE FANTAS, PSYCHO-INVESTIGATOR,* AND *FREDDY FRAT.* THERE WERE NO TAKERS.

RIEND MAY CK WHEN HE ERS HE'S LOST THIS!

THE FRUSTRATED CARTOONIST THEN ENVISIONED HIMSELF AS A COLLEGE PROFESSOR.

I COULD WRITE AND DRAW TO MY HEART'S CONTENT, HAVING ALL THE FREE TIME A SCHOOLTEACHER FINDS HIMSELF WITH.

IN 1950, HE ENROLLED AT NORTHWESTERN UNIVERSITY, ONLY TO DROP OUT SIX MONTHS LATER.

DISILLUSIONED, HEF SETTLED FOR A JOB AS A DEPARTMENT STORE COPYWRITER. DURING OFF-HOURS, HE WORKED ON A COLLECTION OF GAG CARTOONS ABOUT CHICAGO THAT HE PLANNED TO SELF-PUBLISH.

NOT LONG AFTER, HEF LANDED A PROMISING JOB AT ESQUIRE WRITING PROMOTIONAL COPY AND, SEVERAL MONTHS LATER, RELEASED *THAT TODDLIN' TOWN.*

BABY- *NOTHING* WILL MAKE ME FEEL ANY MORE WONDERFUL THAN I DO RIGHT *NOW!* JUST STANDING HERE LOOKING AT MY BOOK!!

FACSIMILE DRAWING FROM HEF'S AUTO-BIOGRAPHICAL COMIC STRIP.

HEF'S CHICAGO CARTOON SATIRE BROUGHT HIM LOCAL PUBLICITY, INCLUDING APPEARANCES ON HUGH DOWNS'S *LUNCHEON DATE* AND ERNIE SIMON'S *CURBSTONE CUT-UP.*

... THE BOOK'S AUTHOR, HUGH HEFNER, IS WITH US HERE TONIGHT.

106

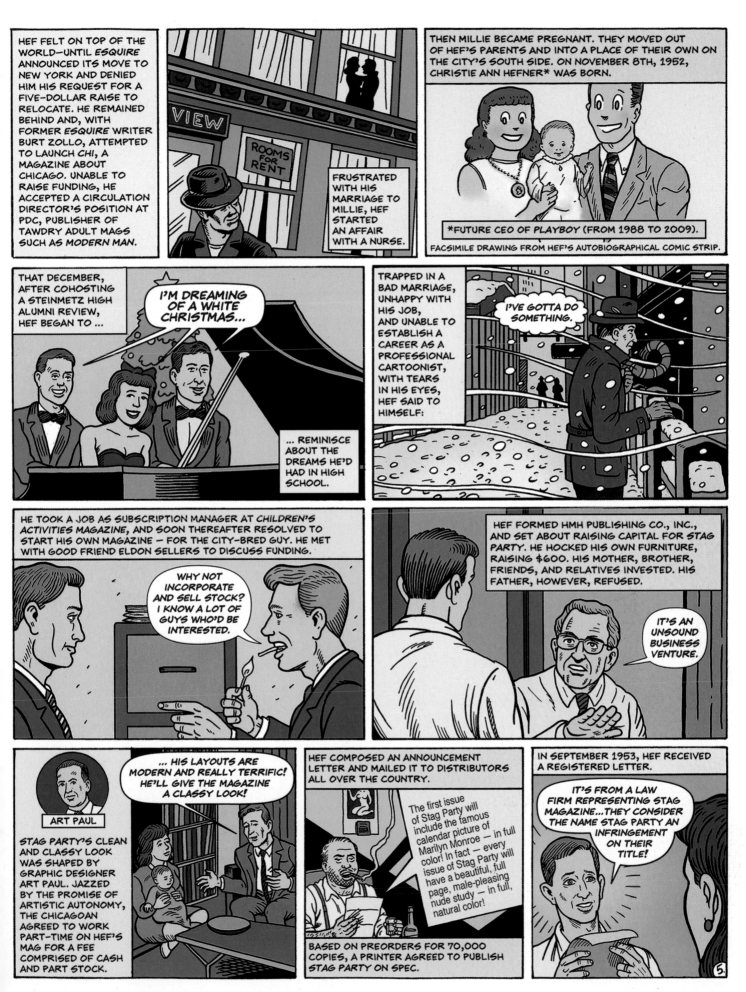

HEF FELT ON TOP OF THE WORLD—UNTIL *ESQUIRE* ANNOUNCED ITS MOVE TO NEW YORK AND DENIED HIM HIS REQUEST FOR A FIVE-DOLLAR RAISE TO RELOCATE. HE REMAINED BEHIND AND, WITH FORMER *ESQUIRE* WRITER BURT ZOLLO, ATTEMPTED TO LAUNCH *CHI*, A MAGAZINE ABOUT CHICAGO. UNABLE TO RAISE FUNDING, HE ACCEPTED A CIRCULATION DIRECTOR'S POSITION AT PDC, PUBLISHER OF TAWDRY ADULT MAGS SUCH AS *MODERN MAN*.

FRUSTRATED WITH HIS MARRIAGE TO MILLIE, HEF STARTED AN AFFAIR WITH A NURSE.

THEN MILLIE BECAME PREGNANT. THEY MOVED OUT OF HEF'S PARENTS AND INTO A PLACE OF THEIR OWN ON THE CITY'S SOUTH SIDE. ON NOVEMBER 8TH, 1952, CHRISTIE ANN HEFNER* WAS BORN.

*FUTURE CEO OF PLAYBOY (FROM 1988 TO 2009).
FACSIMILE DRAWING FROM HEF'S AUTOBIOGRAPHICAL COMIC STRIP.

THAT DECEMBER, AFTER COHOSTING A STEINMETZ HIGH ALUMNI REVIEW, HEF BEGAN TO ...

I'M DREAMING OF A WHITE CHRISTMAS...

... REMINISCE ABOUT THE DREAMS HE'D HAD IN HIGH SCHOOL.

TRAPPED IN A BAD MARRIAGE, UNHAPPY WITH HIS JOB, AND UNABLE TO ESTABLISH A CAREER AS A PROFESSIONAL CARTOONIST, WITH TEARS IN HIS EYES, HEF SAID TO HIMSELF:

I'VE GOTTA DO SOMETHING.

HE TOOK A JOB AS SUBSCRIPTION MANAGER AT *CHILDREN'S ACTIVITIES* MAGAZINE, AND SOON THEREAFTER RESOLVED TO START HIS OWN MAGAZINE — FOR THE CITY-BRED GUY. HE MET WITH GOOD FRIEND ELDON SELLERS TO DISCUSS FUNDING.

WHY NOT INCORPORATE AND SELL STOCK? I KNOW A LOT OF GUYS WHO'D BE INTERESTED.

HEF FORMED HMH PUBLISHING CO., INC., AND SET ABOUT RAISING CAPITAL FOR *STAG PARTY*. HE HOCKED HIS OWN FURNITURE, RAISING $600. HIS MOTHER, BROTHER, FRIENDS, AND RELATIVES INVESTED. HIS FATHER, HOWEVER, REFUSED.

IT'S AN UNSOUND BUSINESS VENTURE.

ART PAUL

STAG PARTY'S CLEAN AND CLASSY LOOK WAS SHAPED BY GRAPHIC DESIGNER ART PAUL. JAZZED BY THE PROMISE OF ARTISTIC AUTONOMY, THE CHICAGOAN AGREED TO WORK PART-TIME ON HEF'S MAG FOR A FEE COMPRISED OF CASH AND PART STOCK.

... HIS LAYOUTS ARE MODERN AND REALLY TERRIFIC! HE'LL GIVE THE MAGAZINE A CLASSY LOOK!

HEF COMPOSED AN ANNOUNCEMENT LETTER AND MAILED IT TO DISTRIBUTORS ALL OVER THE COUNTRY.

The first issue of Stag Party will include the famous calendar picture of Marilyn Monroe — in full color! In fact — every issue of Stag Party will have a beautiful, full page, male-pleasing nude study — in full, natural color!

BASED ON PREORDERS FOR 70,000 COPIES, A PRINTER AGREED TO PUBLISH STAG PARTY ON SPEC.

IN SEPTEMBER 1953, HEF RECEIVED A REGISTERED LETTER.

IT'S FROM A LAW FIRM REPRESENTING STAG MAGAZINE...THEY CONSIDER THE NAME STAG PARTY AN INFRINGEMENT ON THEIR TITLE!

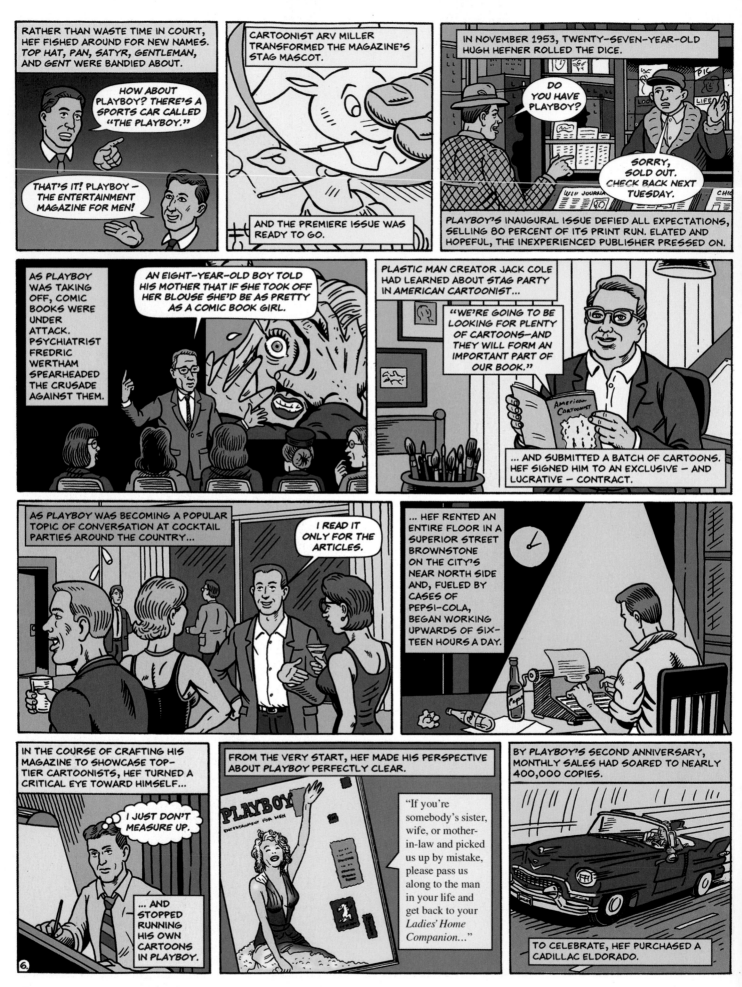

RATHER THAN WASTE TIME IN COURT, HEF FISHED AROUND FOR NEW NAMES. TOP HAT, PAN, SATYR, GENTLEMAN, AND GENT WERE BANDIED ABOUT.

HOW ABOUT PLAYBOY? THERE'S A SPORTS CAR CALLED "THE PLAYBOY."

THAT'S IT! PLAYBOY — THE ENTERTAINMENT MAGAZINE FOR MEN!

CARTOONIST ARV MILLER TRANSFORMED THE MAGAZINE'S STAG MASCOT.

AND THE PREMIERE ISSUE WAS READY TO GO.

IN NOVEMBER 1953, TWENTY-SEVEN-YEAR-OLD HUGH HEFNER ROLLED THE DICE.

DO YOU HAVE PLAYBOY?

SORRY, SOLD OUT. CHECK BACK NEXT TUESDAY.

PLAYBOY'S INAUGURAL ISSUE DEFIED ALL EXPECTATIONS, SELLING 80 PERCENT OF ITS PRINT RUN. ELATED AND HOPEFUL, THE INEXPERIENCED PUBLISHER PRESSED ON.

AS PLAYBOY WAS TAKING OFF, COMIC BOOKS WERE UNDER ATTACK. PSYCHIATRIST FREDRIC WERTHAM SPEARHEADED THE CRUSADE AGAINST THEM.

AN EIGHT-YEAR-OLD BOY TOLD HIS MOTHER THAT IF SHE TOOK OFF HER BLOUSE SHE'D BE AS PRETTY AS A COMIC BOOK GIRL.

PLASTIC MAN CREATOR JACK COLE HAD LEARNED ABOUT STAG PARTY IN AMERICAN CARTOONIST...

"WE'RE GOING TO BE LOOKING FOR PLENTY OF CARTOONS—AND THEY WILL FORM AN IMPORTANT PART OF OUR BOOK."

... AND SUBMITTED A BATCH OF CARTOONS. HEF SIGNED HIM TO AN EXCLUSIVE — AND LUCRATIVE — CONTRACT.

AS PLAYBOY WAS BECOMING A POPULAR TOPIC OF CONVERSATION AT COCKTAIL PARTIES AROUND THE COUNTRY...

I READ IT ONLY FOR THE ARTICLES.

... HEF RENTED AN ENTIRE FLOOR IN A SUPERIOR STREET BROWNSTONE ON THE CITY'S NEAR NORTH SIDE AND, FUELED BY CASES OF PEPSI-COLA, BEGAN WORKING UPWARDS OF SIX-TEEN HOURS A DAY.

IN THE COURSE OF CRAFTING HIS MAGAZINE TO SHOWCASE TOP-TIER CARTOONISTS, HEF TURNED A CRITICAL EYE TOWARD HIMSELF...

I JUST DON'T MEASURE UP.

... AND STOPPED RUNNING HIS OWN CARTOONS IN PLAYBOY.

FROM THE VERY START, HEF MADE HIS PERSPECTIVE ABOUT PLAYBOY PERFECTLY CLEAR.

"If you're somebody's sister, wife, or mother-in-law and picked us up by mistake, please pass us along to the man in your life and get back to your *Ladies' Home Companion...*"

BY PLAYBOY'S SECOND ANNIVERSARY, MONTHLY SALES HAD SOARED TO NEARLY 400,000 COPIES.

TO CELEBRATE, HEF PURCHASED A CADILLAC ELDORADO.

6.

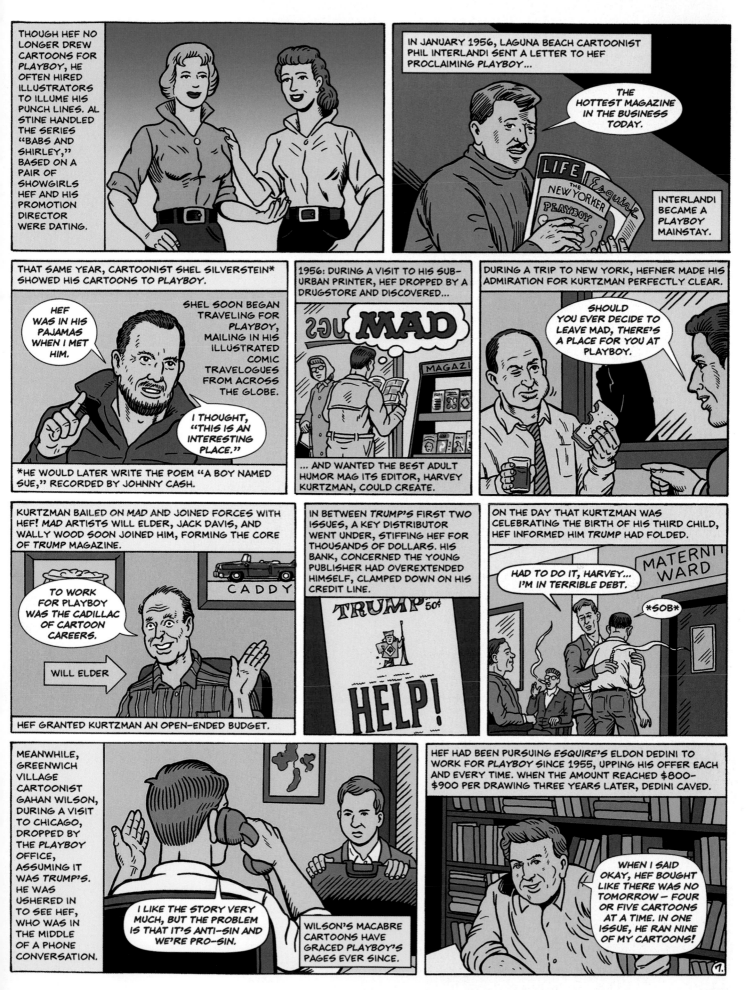

THOUGH HEF NO LONGER DREW CARTOONS FOR PLAYBOY, HE OFTEN HIRED ILLUSTRATORS TO ILLUME HIS PUNCH LINES. AL STINE HANDLED THE SERIES "BABS AND SHIRLEY," BASED ON A PAIR OF SHOWGIRLS HEF AND HIS PROMOTION DIRECTOR WERE DATING.

IN JANUARY 1956, LAGUNA BEACH CARTOONIST PHIL INTERLANDI SENT A LETTER TO HEF PROCLAIMING PLAYBOY...

THE HOTTEST MAGAZINE IN THE BUSINESS TODAY.

INTERLANDI BECAME A PLAYBOY MAINSTAY.

THAT SAME YEAR, CARTOONIST SHEL SILVERSTEIN* SHOWED HIS CARTOONS TO PLAYBOY.

HEF WAS IN HIS PAJAMAS WHEN I MET HIM.

SHEL SOON BEGAN TRAVELING FOR PLAYBOY, MAILING IN HIS ILLUSTRATED COMIC TRAVELOGUES FROM ACROSS THE GLOBE.

I THOUGHT, "THIS IS AN INTERESTING PLACE."

*HE WOULD LATER WRITE THE POEM "A BOY NAMED SUE," RECORDED BY JOHNNY CASH.

1956: DURING A VISIT TO HIS SUB-URBAN PRINTER, HEF DROPPED BY A DRUGSTORE AND DISCOVERED...

MAD

... AND WANTED THE BEST ADULT HUMOR MAG ITS EDITOR, HARVEY KURTZMAN, COULD CREATE.

DURING A TRIP TO NEW YORK, HEFNER MADE HIS ADMIRATION FOR KURTZMAN PERFECTLY CLEAR.

SHOULD YOU EVER DECIDE TO LEAVE MAD, THERE'S A PLACE FOR YOU AT PLAYBOY.

KURTZMAN BAILED ON MAD AND JOINED FORCES WITH HEF! MAD ARTISTS WILL ELDER, JACK DAVIS, AND WALLY WOOD SOON JOINED HIM, FORMING THE CORE OF TRUMP MAGAZINE.

CADDY

TO WORK FOR PLAYBOY WAS THE CADILLAC OF CARTOON CAREERS.

WILL ELDER

HEF GRANTED KURTZMAN AN OPEN-ENDED BUDGET.

IN BETWEEN TRUMP'S FIRST TWO ISSUES, A KEY DISTRIBUTOR WENT UNDER, STIFFING HEF FOR THOUSANDS OF DOLLARS. HIS BANK, CONCERNED THE YOUNG PUBLISHER HAD OVEREXTENDED HIMSELF, CLAMPED DOWN ON HIS CREDIT LINE.

TRUMP 50¢

HELP!

ON THE DAY THAT KURTZMAN WAS CELEBRATING THE BIRTH OF HIS THIRD CHILD, HEF INFORMED HIM TRUMP HAD FOLDED.

MATERNITY WARD

HAD TO DO IT, HARVEY... I'M IN TERRIBLE DEBT.

SOB

MEANWHILE, GREENWICH VILLAGE CARTOONIST GAHAN WILSON, DURING A VISIT TO CHICAGO, DROPPED BY THE PLAYBOY OFFICE, ASSUMING IT WAS TRUMP'S. HE WAS USHERED IN TO SEE HEF, WHO WAS IN THE MIDDLE OF A PHONE CONVERSATION.

I LIKE THE STORY VERY MUCH, BUT THE PROBLEM IS THAT IT'S ANTI-SIN AND WE'RE PRO-SIN.

WILSON'S MACABRE CARTOONS HAVE GRACED PLAYBOY'S PAGES EVER SINCE.

HEF HAD BEEN PURSUING ESQUIRE'S ELDON DEDINI TO WORK FOR PLAYBOY SINCE 1955, UPPING HIS OFFER EACH AND EVERY TIME. WHEN THE AMOUNT REACHED $800–$900 PER DRAWING THREE YEARS LATER, DEDINI CAVED.

WHEN I SAID OKAY, HEF BOUGHT LIKE THERE WAS NO TOMORROW — FOUR OR FIVE CARTOONS AT A TIME. IN ONE ISSUE, HE RAN NINE OF MY CARTOONS!

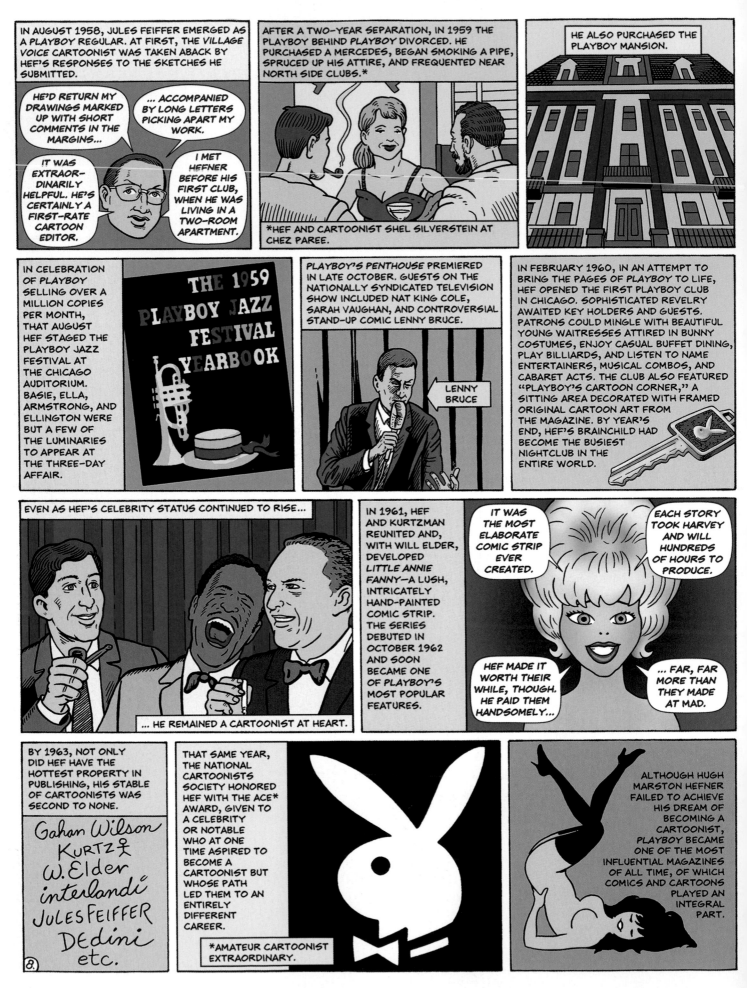

IN AUGUST 1958, JULES FEIFFER EMERGED AS A *PLAYBOY* REGULAR. AT FIRST, THE *VILLAGE VOICE* CARTOONIST WAS TAKEN ABACK BY HEF'S RESPONSES TO THE SKETCHES HE SUBMITTED.

HE'D RETURN MY DRAWINGS MARKED UP WITH SHORT COMMENTS IN THE MARGINS...

...ACCOMPANIED BY LONG LETTERS PICKING APART MY WORK.

IT WAS EXTRAORDINARILY HELPFUL. HE'S CERTAINLY A FIRST-RATE CARTOON EDITOR.

I MET HEFNER BEFORE HIS FIRST CLUB, WHEN HE WAS LIVING IN A TWO-ROOM APARTMENT.

AFTER A TWO-YEAR SEPARATION, IN 1959 THE PLAYBOY BEHIND *PLAYBOY* DIVORCED. HE PURCHASED A MERCEDES, BEGAN SMOKING A PIPE, SPRUCED UP HIS ATTIRE, AND FREQUENTED NEAR NORTH SIDE CLUBS.*

*HEF AND CARTOONIST SHEL SILVERSTEIN AT CHEZ PAREE.

HE ALSO PURCHASED THE PLAYBOY MANSION.

IN CELEBRATION OF *PLAYBOY* SELLING OVER A MILLION COPIES PER MONTH, THAT AUGUST HEF STAGED THE PLAYBOY JAZZ FESTIVAL AT THE CHICAGO AUDITORIUM. BASIE, ELLA, ARMSTRONG, AND ELLINGTON WERE BUT A FEW OF THE LUMINARIES TO APPEAR AT THE THREE-DAY AFFAIR.

THE 1959 PLAYBOY JAZZ FESTIVAL YEARBOOK

PLAYBOY'S PENTHOUSE PREMIERED IN LATE OCTOBER. GUESTS ON THE NATIONALLY SYNDICATED TELEVISION SHOW INCLUDED NAT KING COLE, SARAH VAUGHAN, AND CONTROVERSIAL STAND-UP COMIC LENNY BRUCE.

LENNY BRUCE

IN FEBRUARY 1960, IN AN ATTEMPT TO BRING THE PAGES OF *PLAYBOY* TO LIFE, HEF OPENED THE FIRST PLAYBOY CLUB IN CHICAGO. SOPHISTICATED REVELRY AWAITED KEY HOLDERS AND GUESTS. PATRONS COULD MINGLE WITH BEAUTIFUL YOUNG WAITRESSES ATTIRED IN BUNNY COSTUMES, ENJOY CASUAL BUFFET DINING, PLAY BILLIARDS, AND LISTEN TO NAME ENTERTAINERS, MUSICAL COMBOS, AND CABARET ACTS. THE CLUB ALSO FEATURED "PLAYBOY'S CARTOON CORNER," A SITTING AREA DECORATED WITH FRAMED ORIGINAL CARTOON ART FROM THE MAGAZINE. BY YEAR'S END, HEF'S BRAINCHILD HAD BECOME THE BUSIEST NIGHTCLUB IN THE ENTIRE WORLD.

EVEN AS HEF'S CELEBRITY STATUS CONTINUED TO RISE...

...HE REMAINED A CARTOONIST AT HEART.

IN 1961, HEF AND KURTZMAN REUNITED AND, WITH WILL ELDER, DEVELOPED *LITTLE ANNIE FANNY*—A LUSH, INTRICATELY HAND-PAINTED COMIC STRIP. THE SERIES DEBUTED IN OCTOBER 1962 AND SOON BECAME ONE OF *PLAYBOY'S* MOST POPULAR FEATURES.

IT WAS THE MOST ELABORATE COMIC STRIP EVER CREATED.

EACH STORY TOOK HARVEY AND WILL HUNDREDS OF HOURS TO PRODUCE.

HEF MADE IT WORTH THEIR WHILE, THOUGH. HE PAID THEM HANDSOMELY...

...FAR, FAR MORE THAN THEY MADE AT *MAD*.

BY 1963, NOT ONLY DID HEF HAVE THE HOTTEST PROPERTY IN PUBLISHING, HIS STABLE OF CARTOONISTS WAS SECOND TO NONE.

Gahan Wilson
KURTZ ☂
W. Elder
interlandi
Jules Feiffer
Dedini
etc.

⑧.

THAT SAME YEAR, THE NATIONAL CARTOONISTS SOCIETY HONORED HEF WITH THE ACE* AWARD, GIVEN TO A CELEBRITY OR NOTABLE WHO AT ONE TIME ASPIRED TO BECOME A CARTOONIST BUT WHOSE PATH LED THEM TO AN ENTIRELY DIFFERENT CAREER.

*AMATEUR CARTOONIST EXTRAORDINARY.

ALTHOUGH HUGH MARSTON HEFNER FAILED TO ACHIEVE HIS DREAM OF BECOMING A CARTOONIST, *PLAYBOY* BECAME ONE OF THE MOST INFLUENTIAL MAGAZINES OF ALL TIME, OF WHICH COMICS AND CARTOONS PLAYED AN INTEGRAL PART.

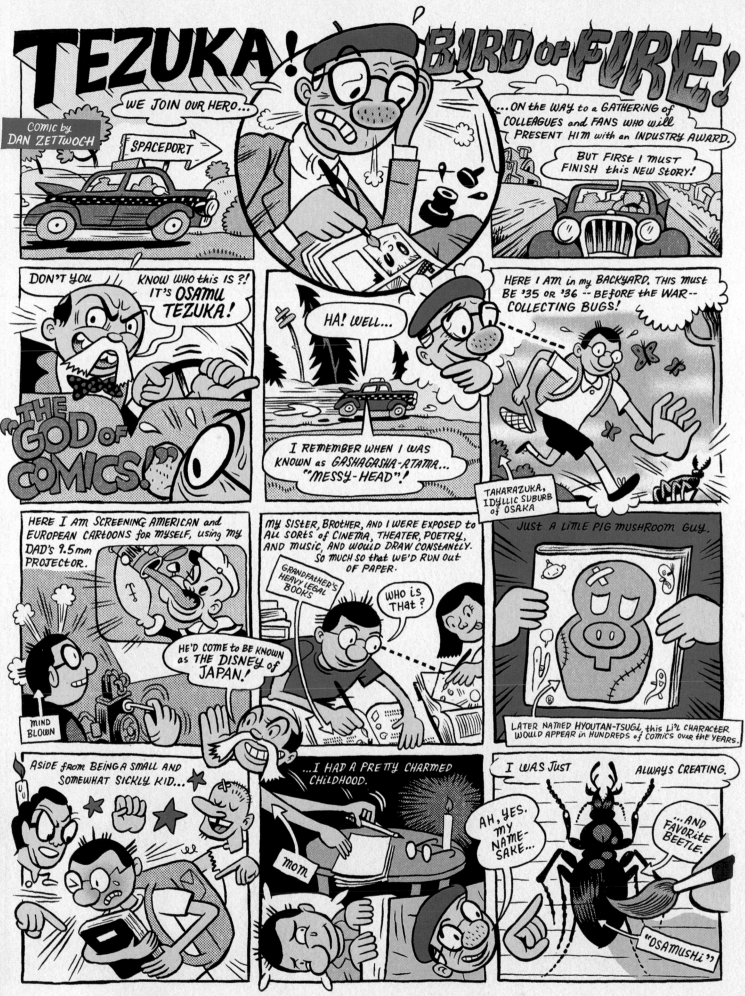

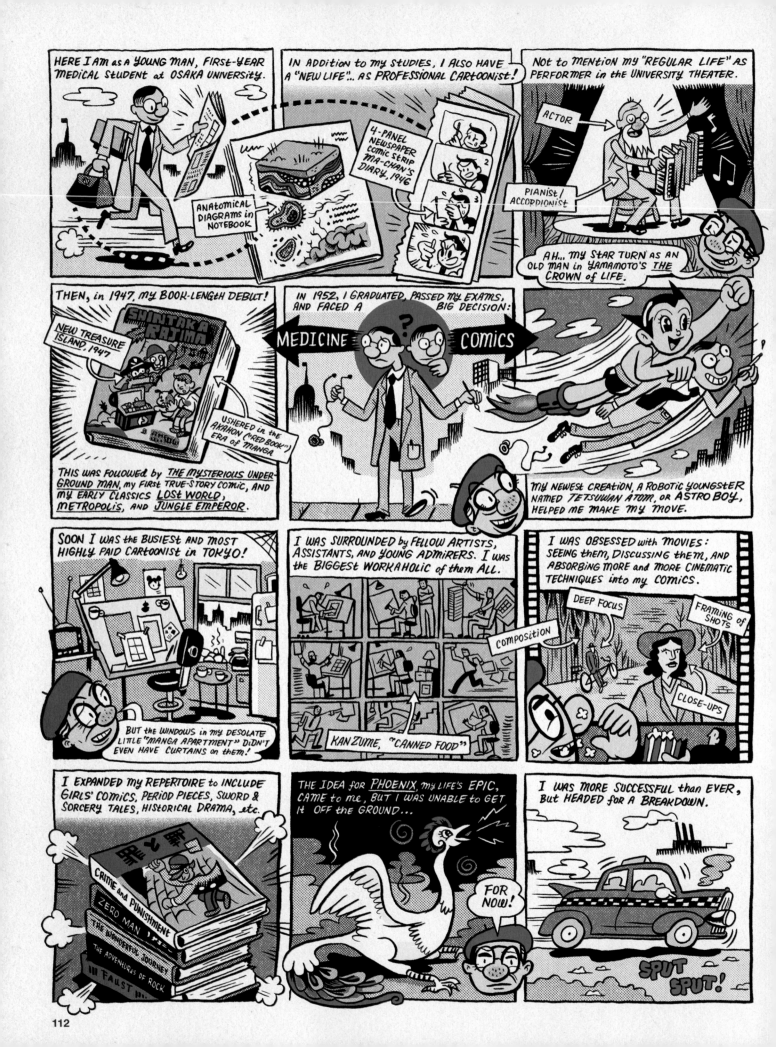

HERE I AM as a YOUNG MAN, FIRST-YEAR MEDICAL STUDENT at OSAKA UNIVERSITY.

ANATOMICAL DIAGRAMS in NOTEBOOK

IN ADDITION TO MY STUDIES, I ALSO HAVE A "NEW LIFE"... AS PROFESSIONAL CARTOONIST!

4-PANEL NEWSPAPER COMIC STRIP MA-CHAN'S DIARY, 1946

NOT TO MENTION MY "REGULAR LIFE" AS PERFORMER IN THE UNIVERSITY THEATER.

ACTOR

PIANIST/ ACCORDIONIST

AH... MY STAR TURN AS AN OLD MAN IN YAMAMOTO'S THE CROWN of LIFE.

THEN, in 1947, MY BOOK-LENGTH DEBUT!

SHINTAKA RAJIMA

NEW TREASURE ISLAND, 1947

USHERED IN THE AKAMON ("RED BOOK") ERA OF MANGA

THIS WAS FOLLOWED by THE MYSTERIOUS UNDERGROUND MAN, my FIRST TRUE-STORY COMIC, AND MY EARLY CLASSICS LOST WORLD, METROPOLIS, AND JUNGLE EMPEROR.

IN 1952, I GRADUATED, PASSED MY EXAMS, AND FACED A BIG DECISION:

MEDICINE ← → COMICS

MY NEWEST CREATION, A ROBOTIC YOUNGSTER NAMED TETSUWAN ATOM, OR ASTRO BOY, HELPED ME MAKE MY MOVE.

SOON I WAS THE BUSIEST AND MOST HIGHLY PAID CARTOONIST in TOKYO!

BUT THE WINDOWS in MY DESOLATE LITTLE "MANGA APARTMENT" DIDN'T EVEN HAVE CURTAINS ON THEM!

I WAS SURROUNDED by FELLOW ARTISTS, ASSISTANTS, AND YOUNG ADMIRERS. I WAS the BIGGEST WORKAHOLIC of them ALL.

KANZUME, "CANNED FOOD"

I WAS OBSESSED with MOVIES: SEEING them, DISCUSSING them, AND ABSORBING MORE and MORE CINEMATIC TECHNIQUES into my COMICS.

DEEP FOCUS

COMPOSITION

FRAMING OF SHOTS

CLOSE-UPS

I EXPANDED MY REPERTOIRE TO INCLUDE GIRLS' COMICS, PERIOD PIECES, SWORD & SORCERY TALES, HISTORICAL DRAMA, etc.

CRIME and PUNISHMENT
ZERO MAN
THE WONDERFUL JOURNEY
THE ADVENTURES OF ROCK
FAUST

THE IDEA FOR PHOENIX, my LIFE'S EPIC, CAME TO ME, BUT I WAS UNABLE TO GET IT OFF THE GROUND...

FOR NOW!

I WAS MORE SUCCESSFUL than EVER, BUT HEADED for A BREAKDOWN.

SPUT SPUT!

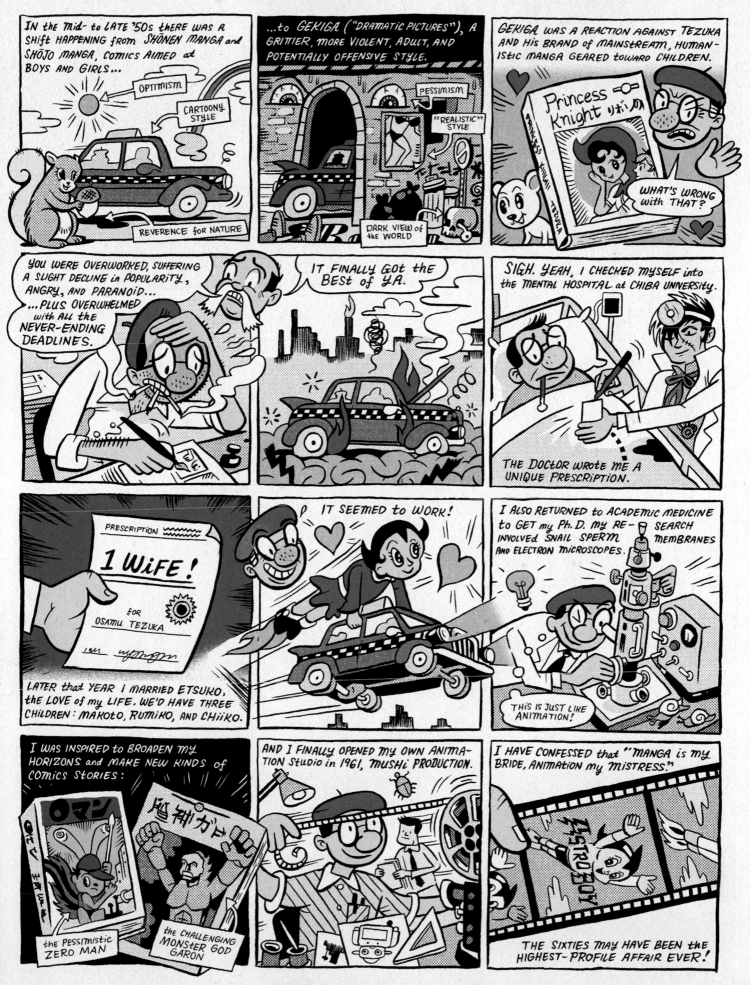

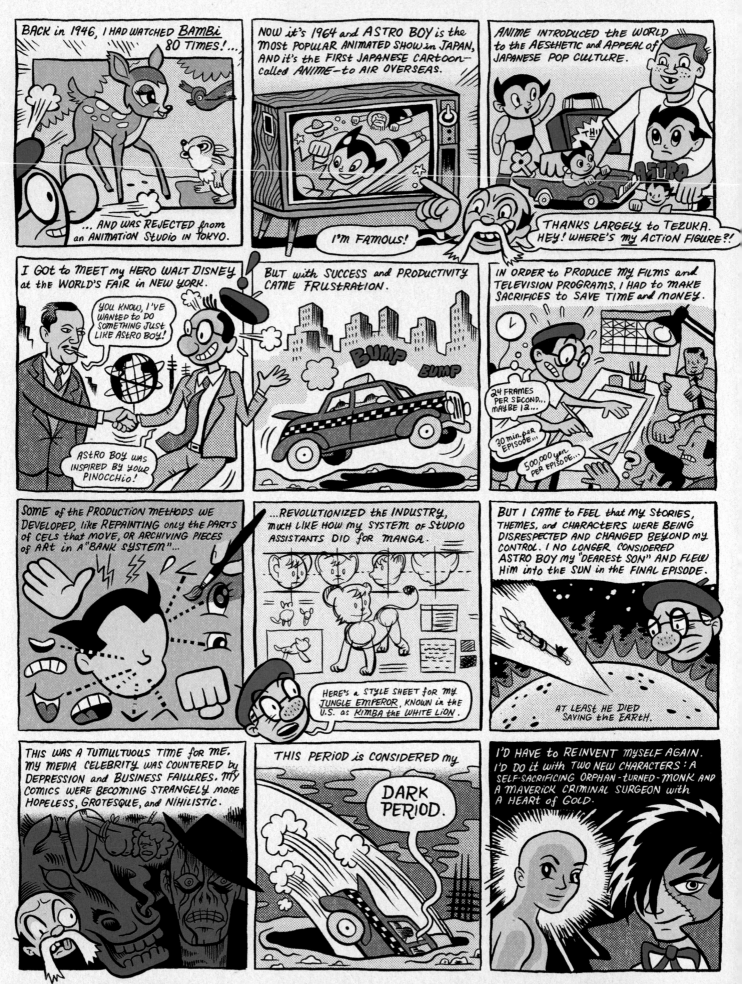

BACK in 1946, I HAD WATCHED **BAMBI** 80 TIMES!... ...AND WAS REJECTED from an ANIMATION STUDIO in TOKYO.

NOW it's 1964 and ASTRO BOY is the MOST POPULAR ANIMATED SHOW in JAPAN, and it's the FIRST JAPANESE CARTOON—called ANIME—to AIR OVERSEAS.

I'M FAMOUS!

ANIME INTRODUCED the WORLD to the AESTHETIC and APPEAL of JAPANESE POP CULTURE.

THANKS LARGELY to TEZUKA. HEY! WHERE'S _MY_ ACTION FIGURE?!

I GOT to MEET my HERO WALT DISNEY at the WORLD'S FAIR in NEW YORK.

YOU KNOW, I'VE WANTED TO DO SOMETHING JUST LIKE ASTRO BOY!

ASTRO BOY WAS INSPIRED BY YOUR PINOCCHIO!

BUT with SUCCESS and PRODUCTIVITY CAME FRUSTRATION.

BUMP BUMP

IN ORDER to PRODUCE MY FILMS and TELEVISION PROGRAMS, I HAD TO MAKE SACRIFICES TO SAVE TIME and MONEY.

24 FRAMES PER SECOND... MAYBE 12...

30 MIN. PER EPISODE!!!

500,000 YEN PER EPISODE...

SOME of the PRODUCTION METHODS WE DEVELOPED, like REPAINTING only the PARTS of CELS that MOVE, or ARCHIVING PIECES of ART in a "BANK SYSTEM"...

...REVOLUTIONIZED the INDUSTRY, much LIKE HOW my SYSTEM of STUDIO ASSISTANTS DID for MANGA.

HERE'S a STYLE SHEET for MY JUNGLE EMPEROR, KNOWN in the U.S. as _KIMBA the WHITE LION_.

BUT I CAME to FEEL that MY STORIES, THEMES, and CHARACTERS WERE BEING DISRESPECTED and CHANGED BEYOND MY CONTROL. I NO LONGER CONSIDERED ASTRO BOY MY "DEAREST SON" and FLEW HIM into the SUN in the FINAL EPISODE.

AT LEAST HE DIED SAVING the EARTH.

THIS WAS A TUMULTUOUS TIME for ME. MY MEDIA CELEBRITY WAS COUNTERED by DEPRESSION and BUSINESS FAILURES. MY COMICS WERE BECOMING STRANGELY MORE HOPELESS, GROTESQUE, and NIHILISTIC.

THIS PERIOD is CONSIDERED my

DARK PERIOD.

I'D HAVE to REINVENT MYSELF AGAIN. I'D DO IT WITH TWO NEW CHARACTERS: A SELF-SACRIFICING ORPHAN-turned-MONK and A MAVERICK CRIMINAL SURGEON with A HEART of GOLD.

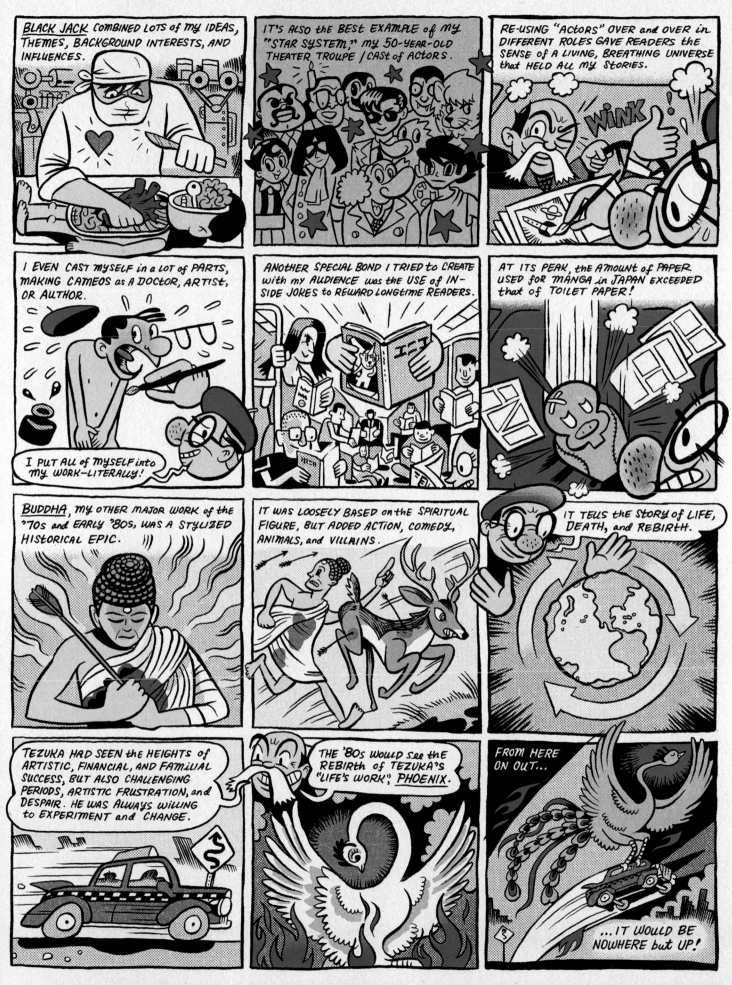

BLACK JACK COMBINED LOTS OF MY IDEAS, THEMES, BACKGROUND INTERESTS, AND INFLUENCES.

IT'S ALSO THE BEST EXAMPLE OF MY "STAR SYSTEM," MY 50-YEAR-OLD THEATER TROUPE / CAST OF ACTORS.

RE-USING "ACTORS" OVER AND OVER IN DIFFERENT ROLES GAVE READERS THE SENSE OF A LIVING, BREATHING UNIVERSE THAT HELD ALL MY STORIES.

WINK!

I EVEN CAST MYSELF IN A LOT OF PARTS, MAKING CAMEOS AS A DOCTOR, ARTIST, OR AUTHOR.

I PUT ALL OF MYSELF INTO MY WORK—LITERALLY!

ANOTHER SPECIAL BOND I TRIED TO CREATE WITH MY AUDIENCE WAS THE USE OF IN-SIDE JOKES TO REWARD LONGTIME READERS.

AT ITS PEAK, THE AMOUNT OF PAPER USED FOR MANGA IN JAPAN EXCEEDED THAT OF TOILET PAPER!

BUDDHA, MY OTHER MAJOR WORK OF THE '70s AND EARLY '80s, WAS A STYLIZED HISTORICAL EPIC.

IT WAS LOOSELY BASED ON THE SPIRITUAL FIGURE, BUT ADDED ACTION, COMEDY, ANIMALS, AND VILLAINS.

IT TELLS THE STORY OF LIFE, DEATH, AND REBIRTH.

TEZUKA HAD SEEN THE HEIGHTS OF ARTISTIC, FINANCIAL, AND FAMILIAL SUCCESS, BUT ALSO CHALLENGING PERIODS, ARTISTIC FRUSTRATION, AND DESPAIR. HE WAS ALWAYS WILLING TO EXPERIMENT AND CHANGE.

THE '80s WOULD SEE THE REBIRTH OF TEZUKA'S "LIFE'S WORK," PHOENIX.

FROM HERE ON OUT...

...IT WOULD BE NOWHERE BUT UP!

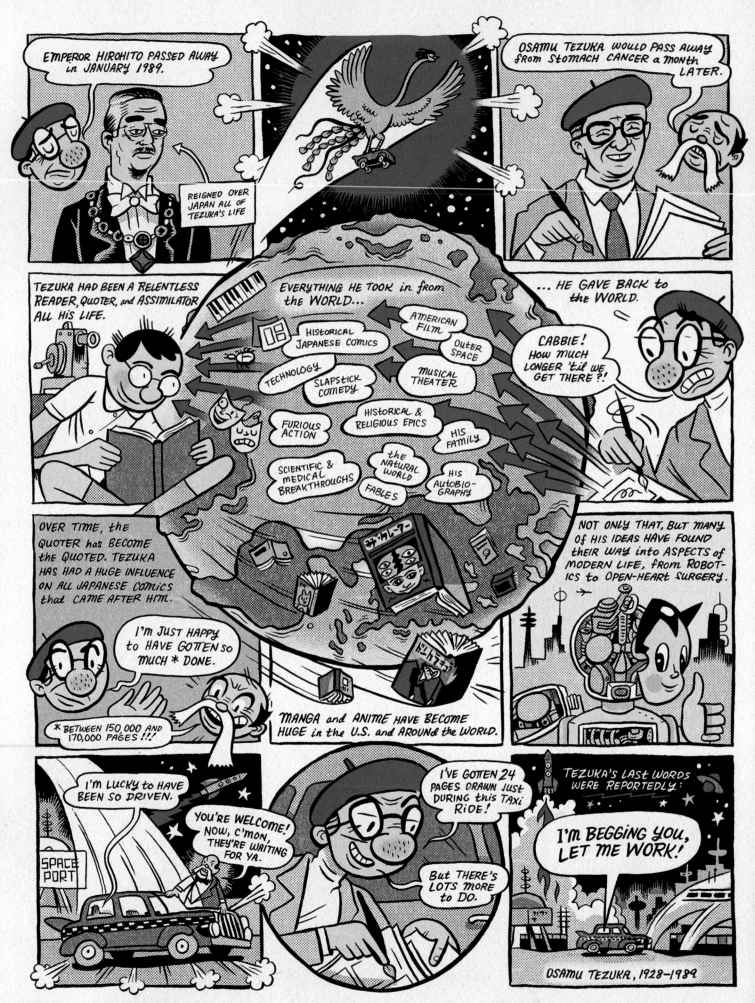

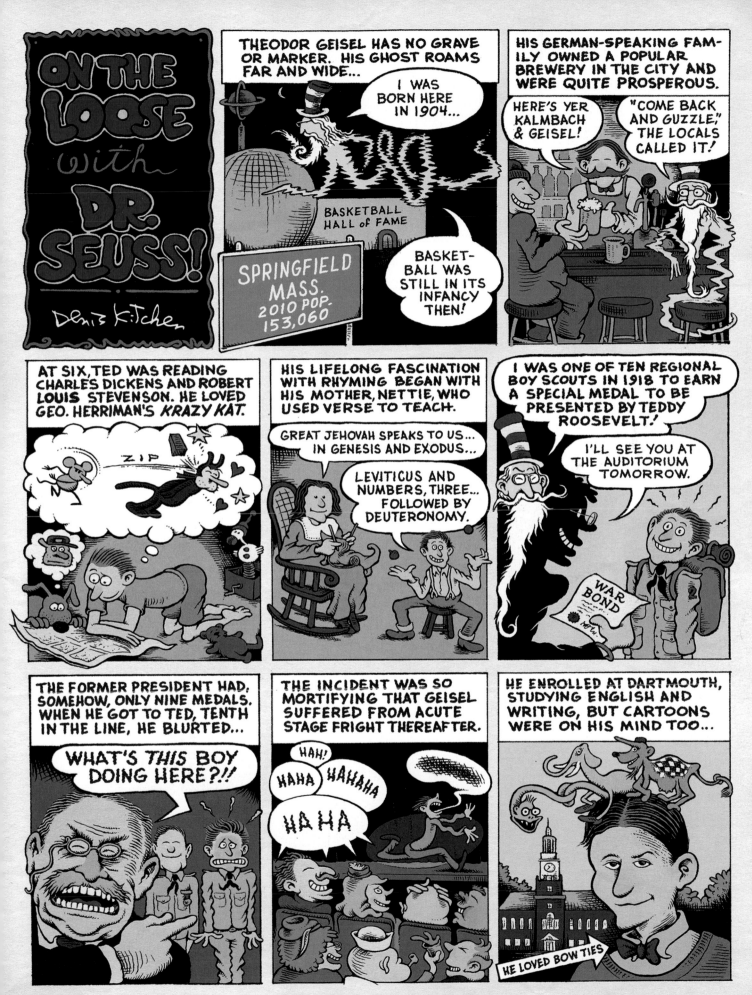

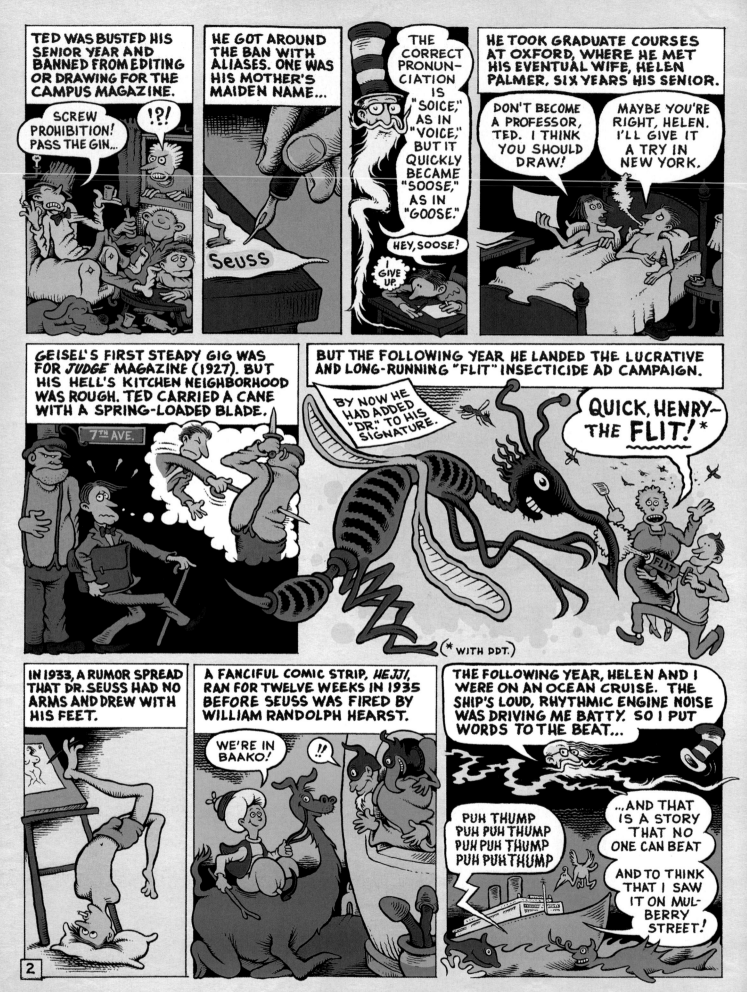

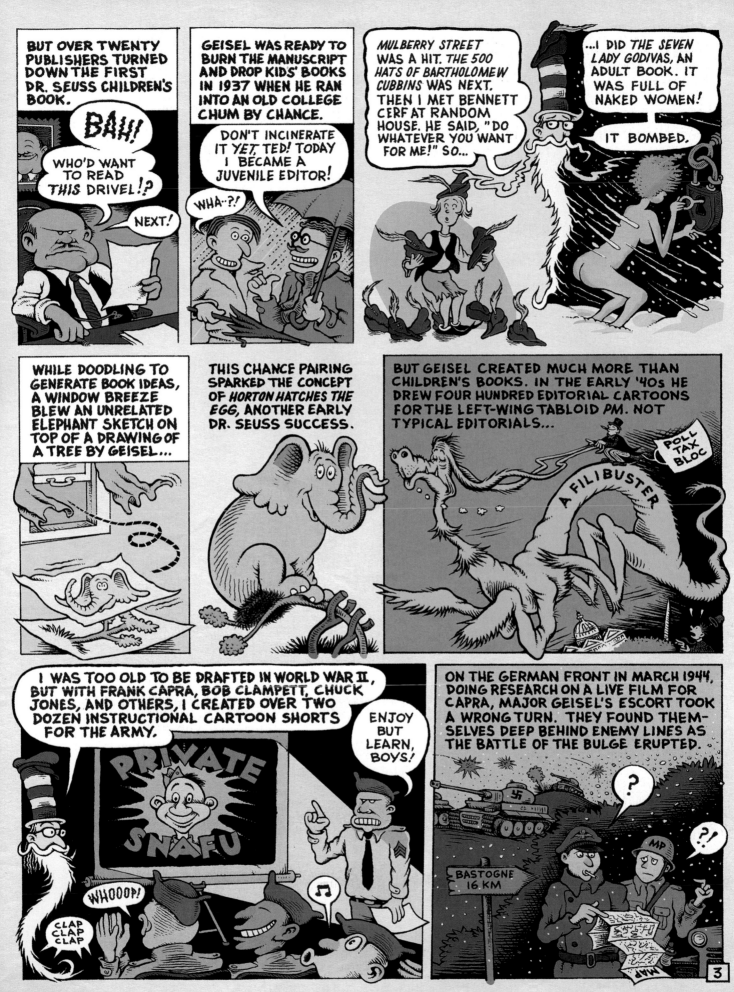

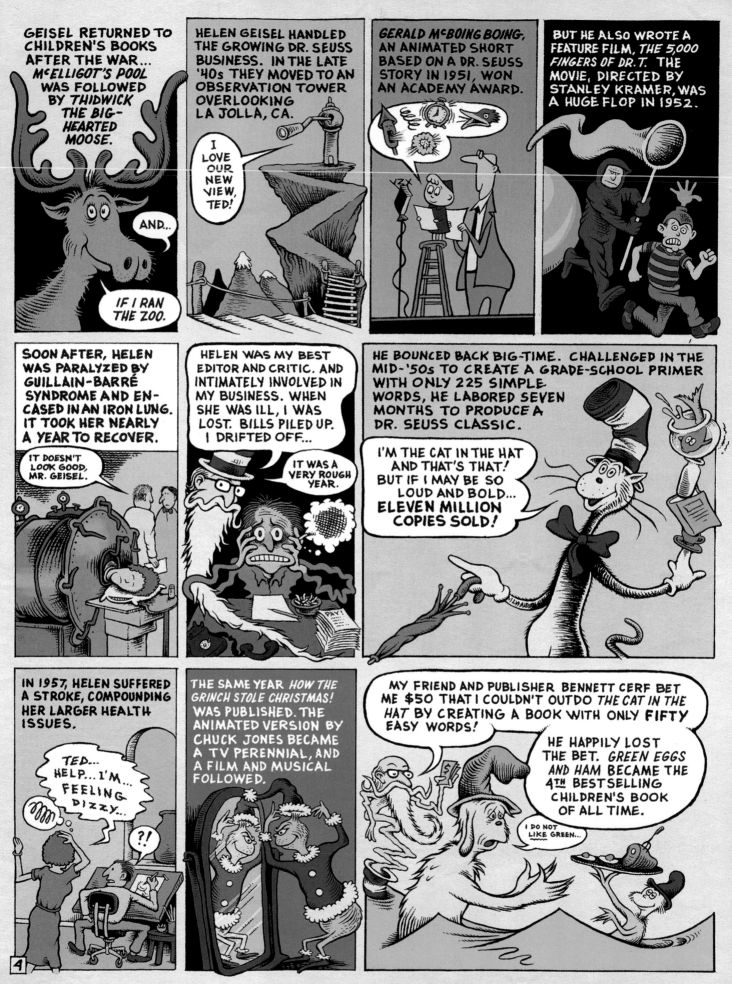

GEISEL RETURNED TO CHILDREN'S BOOKS AFTER THE WAR... *MCELLIGOT'S POOL* WAS FOLLOWED BY *THIDWICK THE BIG-HEARTED MOOSE.*

AND...

IF I RAN THE ZOO.

HELEN GEISEL HANDLED THE GROWING DR. SEUSS BUSINESS. IN THE LATE '40s THEY MOVED TO AN OBSERVATION TOWER OVERLOOKING LA JOLLA, CA.

I LOVE OUR NEW VIEW, TED!

GERALD McBOING BOING, AN ANIMATED SHORT BASED ON A DR. SEUSS STORY IN 1951, WON AN ACADEMY AWARD.

BUT HE ALSO WROTE A FEATURE FILM, *THE 5,000 FINGERS OF DR.T.* THE MOVIE, DIRECTED BY STANLEY KRAMER, WAS A HUGE FLOP IN 1952.

SOON AFTER, HELEN WAS PARALYZED BY GUILLAIN-BARRÉ SYNDROME AND EN-CASED IN AN IRON LUNG. IT TOOK HER NEARLY A YEAR TO RECOVER.

IT DOESN'T LOOK GOOD, MR. GEISEL.

HELEN WAS MY BEST EDITOR AND CRITIC. AND INTIMATELY INVOLVED IN MY BUSINESS. WHEN SHE WAS ILL, I WAS LOST. BILLS PILED UP. I DRIFTED OFF...

IT WAS A VERY ROUGH YEAR.

PAY!

HE BOUNCED BACK BIG-TIME. CHALLENGED IN THE MID-'50s TO CREATE A GRADE-SCHOOL PRIMER WITH ONLY 225 SIMPLE WORDS, HE LABORED SEVEN MONTHS TO PRODUCE A DR. SEUSS CLASSIC.

I'M THE CAT IN THE HAT AND THAT'S THAT! BUT IF I MAY BE SO LOUD AND BOLD... ELEVEN MILLION COPIES SOLD!

IN 1957, HELEN SUFFERED A STROKE, COMPOUNDING HER LARGER HEALTH ISSUES.

TED... HELP... I'M... FEELING DIZZY...

?!

THE SAME YEAR *HOW THE GRINCH STOLE CHRISTMAS!* WAS PUBLISHED. THE ANIMATED VERSION BY CHUCK JONES BECAME A TV PERENNIAL, AND A FILM AND MUSICAL FOLLOWED.

MY FRIEND AND PUBLISHER BENNETT CERF BET ME $50 THAT I COULDN'T OUTDO *THE CAT IN THE HAT* BY CREATING A BOOK WITH ONLY FIFTY EASY WORDS!

HE HAPPILY LOST THE BET. *GREEN EGGS AND HAM* BECAME THE 4TH BESTSELLING CHILDREN'S BOOK OF ALL TIME.

I DO NOT LIKE GREEN...

4

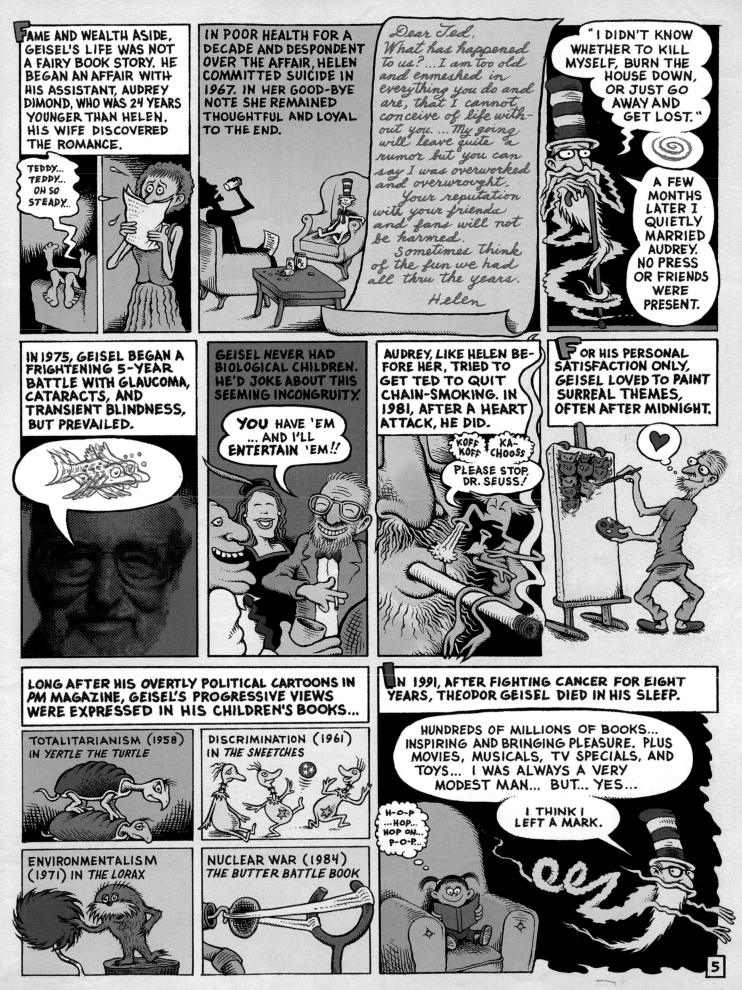

CONTRIBUTORS

Greg Clarke is a Los Angeles–based artist and recovering graphic designer. Born and raised in the L.A. area, he graduated cum laude from UCLA with a bachelor's degree in fine art. Greg's work is internationally recognized, and has graced the pages of *Rolling Stone*, *Time*, *Mother Jones*, *The Atlantic*, and *The New York Times*, as well as the cover of *The New Yorker*. He is a regular contributor to *Blab!*, the annual paean to the graphically unorthodox. He has been profiled in *3 x 3* magazine, featured in Luerzer's Archive's *200 Best Illustrators Worldwide*, and Taschen's *Illustration Now!* Greg has been a consistent presence for the past twenty years in awards annuals such as *American Illustration, Communication Arts,* and *Graphis,* and is a recipient of three Silver Medals from the Society of Illustrators.

Larry Day is the award-winning children's book illustrator of *Colonial Voices: Hear Them Speak*; *Duel! Burr and Hamilton's Deadly War of Words*; and *Worst of Friends: Thomas Jefferson, John Adams, and the True Story of an American Feud*. In 2007, Larry received the Society of Children's Book Writers & Illustrators' Golden Kite Award for *Not Afraid of Dogs* by Susanna Pitzer.

Nicolas Debon was born and grew up in France. After studying visual arts, he moved to Toronto, Canada. There, he worked as a stained-glass designer and began illustrating children's books. His works have been nominated for the Canada Council for the Arts' Governor General's Literary Awards, and he received 2007's Boston Globe–Horn Book Award for *The Strongest Man in the World*. Nicolas now lives back in France, where he works mainly as a cartoonist.

For more than thirty years, **Gary Dumm** worked with Harvey Pekar on his groundbreaking autobiographical comic book *American Splendor*. He is currently at work drawing author Scott MacGregor's graphic novel *A Simple Ordinary Man*, a fact-based tale of immigrants and invention set in Cleveland in 1916.

Laura Dumm was born, raised, and resides in Cleveland, Ohio. Self-taught, she has always been interested in art. Though she works primarily as a painter,

Laura often collaborates with her husband, Gary, coloring a number of his cartoon projects.

Drew Friedman's comics and illustrations have appeared in numerous publications, including *Mad*, *Raw*, *Blab!*, *Weirdo*, *Spy*, *Newsweek*, *National Lampoon*, *Time*, *The New Yorker*, *Rolling Stone*, *Entertainment* Weekly, *The Village Voice*, *The New York Times*, *The Wall Street Journal*, and *Sports Illustrated*. Howard Stern has called Friedman his favorite artist; Kurt Vonnegut, Jr., compared him to Goya; and *Booklist* anointed him "the finest caricaturist of his generation."

Ryan Heshka's illustrations have appeared in *The New York Times*, *The Wall Street Journal*, *American Illustration*, *Playboy*, *Smart Money*, *Communication Arts*, *Blab!*, and the *Society of Illustrators Annual of American Illustration*. His paintings have been exhibited in galleries across North America and Europe. He also creates picture books for children as well as for adults. He lives in Vancouver, B.C., with his wife, Marinda, and cat, Louis.

Denis Kitchen, a pioneer underground cartoonist and publisher, wears many hats. His Kitchen Sink Press (1969–99) published R. Crumb, Will Eisner, Harvey Kurtzman, Milton Caniff, Scott McCloud, Al Capp, Alan Moore, Art Spiegelman, Charles Burns, and many others. In 1986, Kitchen founded the Comic Book Legal Defense Fund, a nonprofit organization that defends the comics industry's First Amendment rights. A monograph, *The Oddly Compelling Art of Denis Kitchen*, was published in 2010. Kitchen has coauthored books on Kurtzman, Capp, and underground comix for Abrams and Bloomsbury, curates art exhibits, represents cartoonist estates, and still draws when Monte Beauchamp calls.

Nora Krug is an award-winning illustrator whose work has appeared in *The New York Times*, *The Guardian*, *Los Angeles Times*, and *Le Monde diplomatique*. Nora's books include *Red Riding Hood Redux* and *Shadow Atlas*, an encyclopedia of ghosts and spirits. Her work has been recognized by the New York Art Directors Club and *American Illustration*. She has received two Gold Medals from the Society of Illustrators, and her comic strip biography "Kamikaze" was included in both Houghton Mifflin's *Best American Comics* and *The Best American Nonrequired Reading* series for 2012.

Peter Kuper's illustrations and comics have appeared in *Time*, *The New York Times*, *Blab!*, and *Mad*, where he has written and illustrated "Spy vs. Spy" since 1997. He is the cofounder of the political graphics magazine *World War 3 Illustrated* and has produced more than twenty books, including *The System*, *Sticks and Stones*, *Diario de Oaxaca*, and *Drawn to New York*. He has also adapted Upton Sinclair's *The Jungle* and many of Franz Kafka's works into comics, including *The Metamorphosis*. Kuper has taught cartooning at the School of Visual Arts in New York City for more than twenty-five years and is a visiting professor at Harvard.

After studying architecture at Princeton University and painting in graduate school, **Marc Rosenthal** worked for Milton Glaser as a graphic designer in New York City before seeking refuge in illustration. His work is seen regularly in national and international publications. He has illustrated many children's books (*Dig!*, *The Runaway Beard*, *I Must Have Bobo!*, *I'll Save You Bobo!*, and *Bobo the Sailor Man!*) and written some as well (*Archie and the Pirates* and *Phooey!*).

Arnold Roth is an award-winning illustrator based in New York City. His cartoons have appeared in numer-

ous publications, including *The New York Times*, *Time*, *Sports Illustrated*, *Playboy*, *Punch*, and *The New Yorker*.

Sergio Ruzzier was born in Milan, Italy, in 1966, and twenty years later he began his career as a professional illustrator. In 1995, he moved to New York City, where he's been creating pictures and stories for publications such as *The New Yorker*, *Blab!*, *The New York Times*, *The Nation*, and many others. He has written and illustrated a number of picture books, including *The Little Giant*, *The Room of Wonders*, *Amandina*, and *Bear and Bee*. His work has been recognized by *American Illustration*, the Society of Illustrators, *Communication Arts*, and the Society of Publication Designers. In 2011, Sergio was the recipient of a Sendak Fellowship, a one-month residency program guided by Sendak himself.

Owen Smith's award-winning illustrations have appeared in *Sports Illustrated*, *Time*, *Rolling Stone*, *The New York Times*, *Los Angeles Times*, and on numerous covers of *The New Yorker*. He has illustrated book jackets, children's books, and designed murals for a New York subway station and the historic Laguna Honda Hospital in San Francisco. Owen teaches illustration at California College of the Arts, and his paintings are displayed in solo and group shows internationally.

Frank Stack was born in Houston, Texas, and received his BFA from the University of Texas and his master's degree from the University of Wyoming. After finishing his postgraduate studies in Chicago, New York,

and Paris, he began a distinguished forty-year career as a professor of art at the University of Missouri. During that time he developed an international reputation as a painter, printmaker, and comic artist. His art has been featured in *American Artist*, *The Artist's Magazine*, and *The Village Voice*. Stack has collaborated with the well-known writer Harvey Pekar on *American Splendor* and on Pekar's critically acclaimed graphic novel *Our Cancer Year*, winner of the 1995 Harvey Award for Best Graphic Album of Original Work.

Mark Alan Stamaty received a BFA from The Cooper Union in 1969. Among the books he has written and illustrated are *Who Needs Donuts?*; *MacDoodle St.*; and *Shake, Rattle & Turn That Noise Down!* His work has appeared in many publications, including *The New Yorker*, *GQ*, *Esquire*, *Slate*, and *The Village Voice*. His syndicated political comic strip *Washingtoon* appeared weekly on the *Washington Post* op-ed page. And his comic strip *Boox* appeared monthly in *The New York Times Book Review*. Stamaty has received many awards and honors, including two Gold Medals and two Silver Medals from the Society of Illustrators.

Dan Zettwoch is an illustrator, cartoonist, and printmaker living and working in St. Louis, Missouri. His work has appeared in *The Simpsons Treehouse of Horror*, *The Best American Comics*, *Kramers Ergot*, and *Comic Art*. His first full-length graphic novel, *Birdseye Bristoe*, was released by Drawn & Quarterly in 2012.

ACKNOWLEDGMENTS

To the last of their kind: Walt Disney, Dr. Seuss, Hergé, Chas Addams, Jerry Siegel and Joe Shuster, Jack Kirby, Harvey Kurtzman, R. Crumb, Winsor McCay, Hugh Hefner, Charles M. Schulz, Lynd Kendall Ward, Edward Gorey, Al Hirschfeld, Osamu Tezuka, and Rodolphe Töpffer—And to the masterful contributors who brought their stories to life: Drew Friedman, Denis Kitchen, Marc Rosenthal, Peter Kuper, Greg Clarke, Ryan Heshka, Sergio Ruzzier, Arnold Roth, Owen Smith, Mark Alan Stamaty, Nora Krug, Nicolas Debon, Dan Zettwoch, Larry Day, Gary and Laura Dumm, and Frank Stack.

To those whose art, writing, music, and movies inspired me during the making of this book: Neil Young, The Meters, Bon Iver, Chet Baker, John Fogerty, George and Ira Gershwin, Moon Hooch, L. Frank Baum, Jim Nutt, Fred Astaire, Jimmy Webb, George Grosz, Henry Darger, Sue Coe, Jackson Pollock, Karl Wirsum, Chester Gould, Basil Wolverton, Boris Artzybasheff, Jim Jarmusch, Otto Dix, Ray Harryhausen, Martin Scorsese, Will Elder, Wally Wood, Jack Davis, Al Feldstein, Virgil Partch, Jim Flora, Ronald Searle, Alex Steinweiss, Art Young, Ubbe Iwerks, William Steig, R.O. Blechman, Edward Koren, Wanda Gág, Beatrice Alemagna, Gustave Verbeek, Saul Steinberg, Frank R. Paul, Charles Bukowski, Studs Terkel, Picasso, Fletcher Hanks, Matt Fox, Jim Heimann, and Steven Heller.

With deep gratitude and appreciation, thank you: Gillian MacKenzie, for believing in my work and agenting this book; editor extraordinaire Anjali Singh, for her guidance, devotion, and belief in this book; and to editors Michael Szczerban and Brit Hvide, art director Jackie Seow, and publisher Jonathan Karp, for seeing it through to fruition.

A special thanks to: Joel Surnow, Gary Baseman, David Michaelis, and Leonard Maltin for their masterful quotes.

Thank you: Glenn Bray, Brenda Beyers, John Carlin, and Mark Alvarado, whose help was invaluable during the making of this book.

This book is dedicated to: Rebecca Ann Hall, who kept the candles burning.